Monet's Landscapes

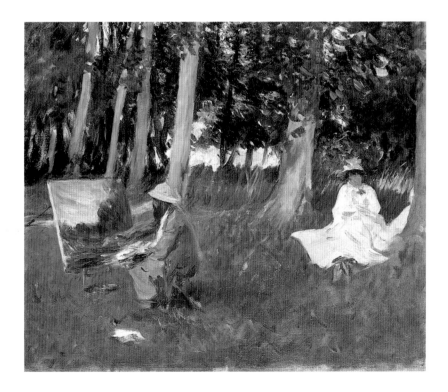

Vivian Russell

A Bulfinch Press Book
Little, Brown and Company
Boston · New York · London

Monet's Landscapes

This book is dedicated to my three French dictionaries.

Monet's Landscapes was edited and produced by Frances Lincoln Limited,
4 Torriano Mews, Torriano Avenue, London NW5 2RZ.

First United States Edition

ISBN 0-8212-2672-X
Library of Congress Control Number 00–105833

Bulfinch Press is an imprint and trademark of Little, Brown and Company (Inc.)

Printed and bound by Tien Wah Press Pte Ltd, Singapore

Page 1: *John Singer Sargent,* Claude Monet Painting by the Edge of a Wood,
1885.
Pages 2–3: *The banks of the River Creuse.*
This page: *Fields near Giverny.*

Contents

6 Preface

8 Etretat

18 Bordighera

38 Etretat Revisited

52 Holland

60 Belle Isle

74 Antibes

86 The Creuse

100 Giverny

112 Rouen

122 Norway

140 Venice

156 Bibliography

156 Index

160 Acknowledgments

Preface

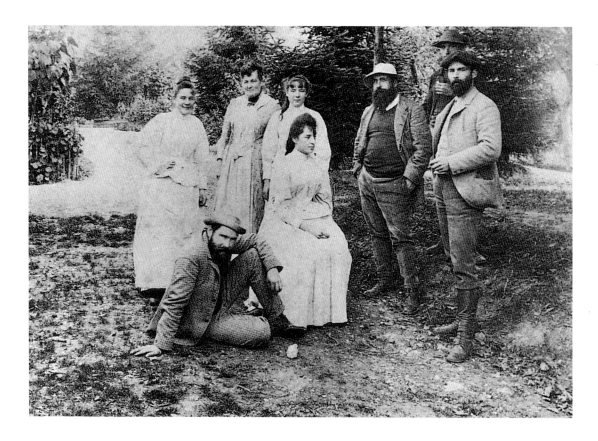

Genius, they say, is forged from the pains one takes. How true this was for Monet. Arguably the most popular painter of our time, he was besotted by the beauty of the natural world and drove himself to distraction trying to express it. His paintings rise before our eyes like a sequence of beautiful dreams. But there was nothing dreamy about the way he pursued his vision of light in a game of chance with the weather as he struggled for recognition, domestic stability and financial security. Through all the tragedies, however angry or disillusioned he became, however much the dream turned into a nightmare, ugliness never found its way into his art.

A prolific painter and prodigious worker, though he loved to read, in the way of most visual people, he disliked writing, and often said so. When he was at home, he confined his correspondence chiefly to business matters, though he was never at a loss for words when it came to the weather which he ranted about, or his own inadequacies as a painter which he railed over. But on his campaigns away from home in pursuit of new landscapes, his wife Alice exacted a letter from him every day, which she said had to fill four sheets of paper. Thanks to her we have a portrait of the artist in his own words. His campaigns were isolating, intense, and immensely difficult. What his letters reveal

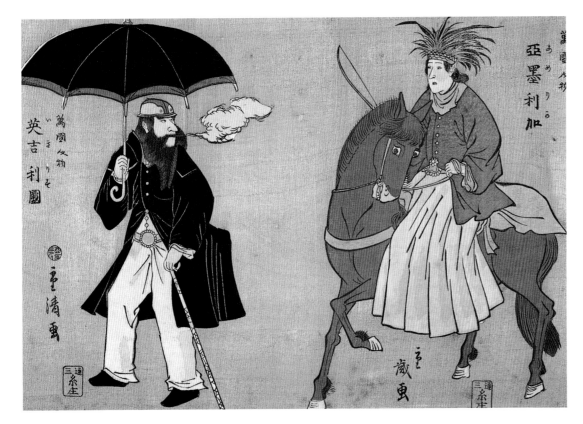

萬國人物 英吉利國 英吉利 清重画 通糸生

萬國人物 あめりか 亞墨利加 重蔵画 通糸生

It is there, at Giverny, that Monet lies buried with Alice, his two sons, Ernest Hoschedé and some of the Hoschedé children. Proposals have been made to place Monet in the Pantheon to rub shoulders with the grand and the gifted of France. Monet loathed honours and decorations of any kind, and I cannot think of anything he would hate more than being taken from his family and the soil of Giverny. And how ironic it would be if Alice's first husband, Ernest Hoschedé, who, having failed in life in his attempts to separate Alice and Monet and win back his family, were in death to finally reclaim them after all.

more than anything is the landscape of emotion and anxiety; of effort and tenacity that underlies every canvas of every landscape he painted.

For all the pain, his campaigns were not without their comic moments. There are flashes of his droll wit, pithily observed character sketches, and priceless vignettes from which Jacques Tati might have fashioned a film, more bizarre and funnier even than *Monsieur Hulot's Holiday*: the tale of a painter, with his beret, his beard and his pipe, encumbered by all the paraphernalia of his craft, careering about Europe by horse and carriage, sleigh, train and boat, ever hopeful of realizing a wholly impractical and

practically impossible idea. *Plein air* painting was a far cry from our digital age, where images can be caught by the click of a mouse.

This book is an impressionistic memoir of Monet's 'voice' and his 'vision' which I have pieced together from extracts of Monet's letters, and by retracing his steps to cliffs, rivers, canals, fields, a fjord and a cathedral square which he made his own. I have not included all the landscapes he painted, but I have chosen those which best tell the story of his journey to the final landscape of his water-lily pond which he made himself, and painted almost exclusively, for the last eighteen years of his life.

Monet was seventy-one years old when Alice died on 11 May 1911. The five volumes of Daniel Wildenstein's Monet – *Biographie et catalogue raisonné* , where all Monet's work has been painstakingly collected, identified and annotated, includes Monet's surviving letters. None of Alice's letters to Monet survive. Marianne Alphant, in her sensitive, evocative and scholarly biography of Monet tells us why:

It is a very hot summer; the old man who survived her, solitary, inconsolable, never leaves the house. He locks himself up in the past, immersed for days on end in Alice's letters which his children see him sorting out, re-reading and crying as he destroys them.

Etretat

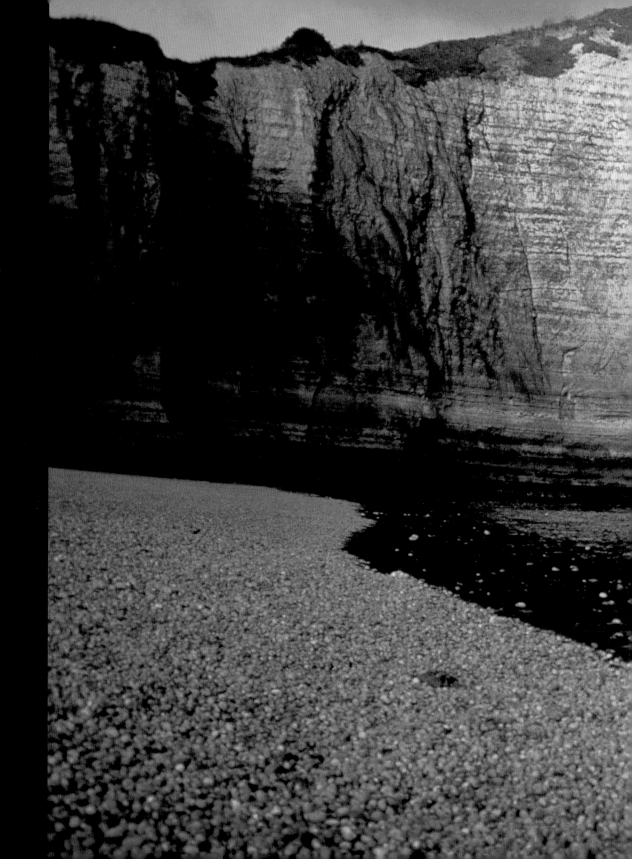

"*Ici, mon cher, c'est adorable,*
and every day I am discovering
more and more beautiful things.
It's intoxicating; I so want to do
it all, my head is bursting . . ."

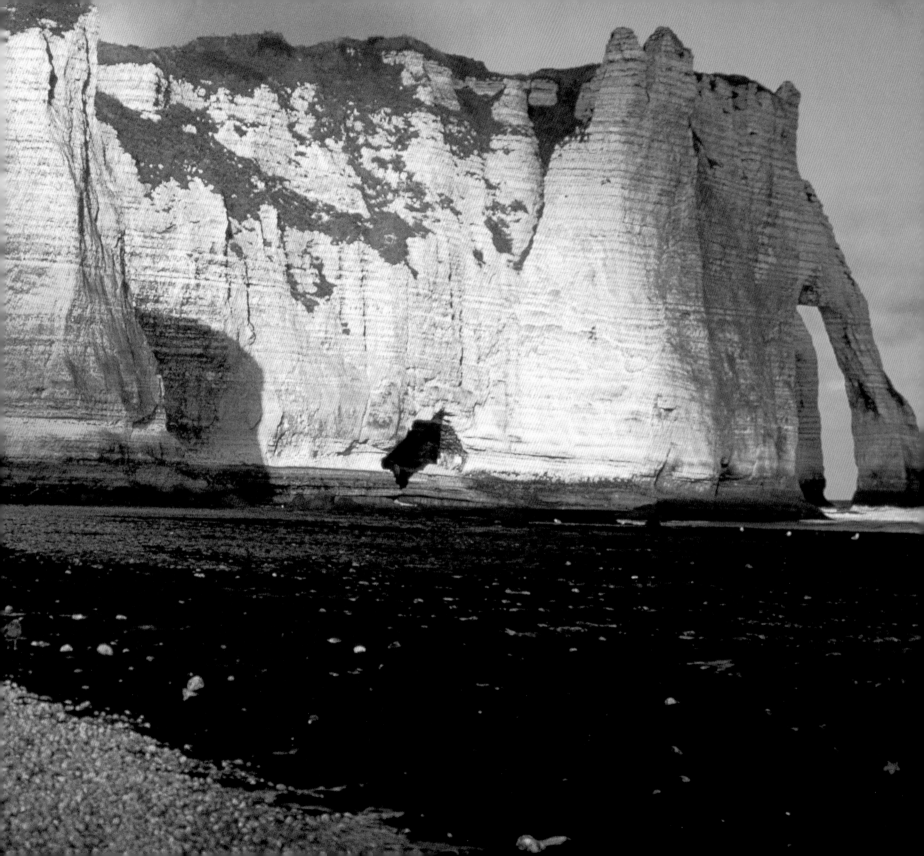

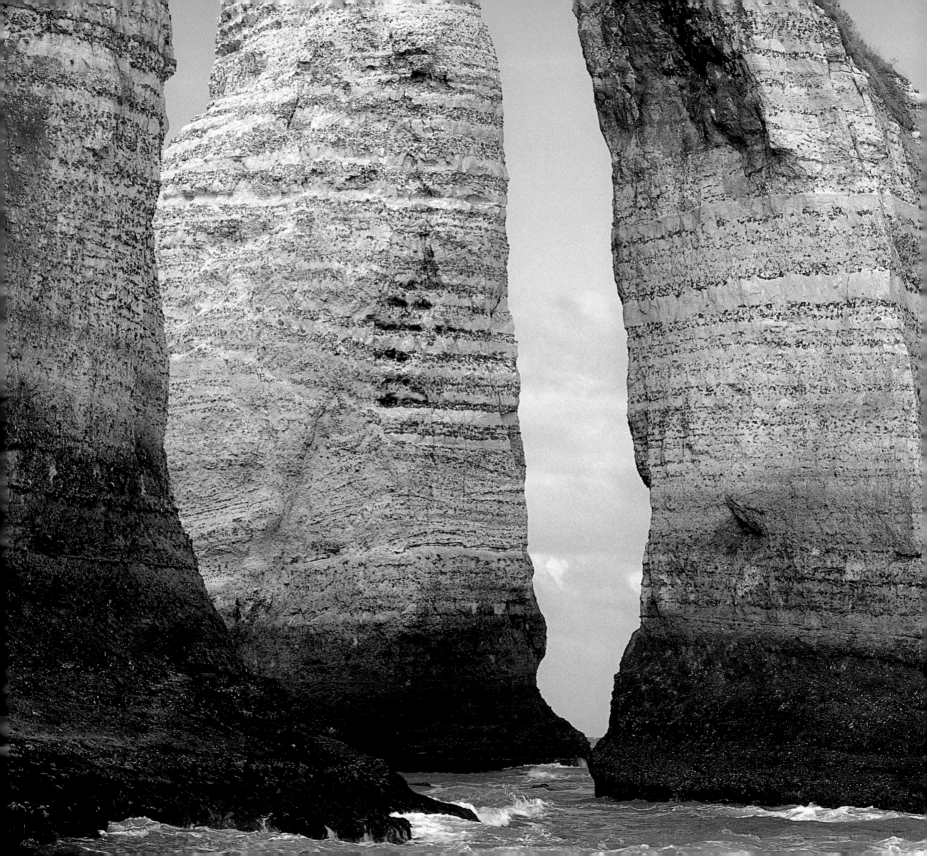

Previous pages: *The promontory of the Porte d'Aval encloses the western side of the bay of Etretat, sixteen kilometres north-east of Le Havre on the Channel coastline. You can see the cave known as the Trou à l'Homme and the Needle just peeping through the arch known as the Porte d'Aval.*

Left: *Detail of the picture on page 9 showing the splendour and scale of the Needle seen through the arch of the Porte d'Aval as they would have appeared to Monet, accessible on foot only when the tide was out.*

Right: *Further west is the portal known as the Manneporte, a detail of which Monet chose to isolate for maximum dramatic impact –* THE MANNEPORTE SEEN FROM THE EAST. *Guy de Maupassant described the Manneporte as 'a huge arch through which a ship could sail'.*

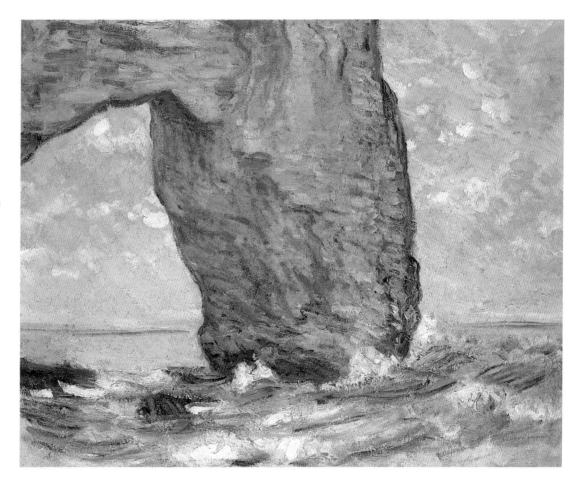

The two dramatic promontories which jut out on either side of the bay of Etretat could be said to represent the first and last of Monet's campaigns there conducted over a period of twenty years, and the sweeping beach they enclose the learning curve upon which he matured as an artist and a man.

When Monet first painted the seaside resort of Etretat in 1864, he was living in the picturesque port of Honfleur near Le Havre in a farm frequented by other painters, amongst whom were his mentors Eugène Boudin and Johan Barthold Jongkind, the earliest pioneers of the Impressionist movement. It was Boudin who, having spotted Monet's caricatures in a shop window in Le Havre, had offered to give the eighteen-year-old Monet his first lessons in *plein air* painting with these words of counsel: 'You are gifted; one can see that at a glance. But I hope you are not going to stop there. It is all very well for a beginning, yet soon you will have had enough of caricaturing. Study, learn to see and to paint, draw, make landscapes. The sea

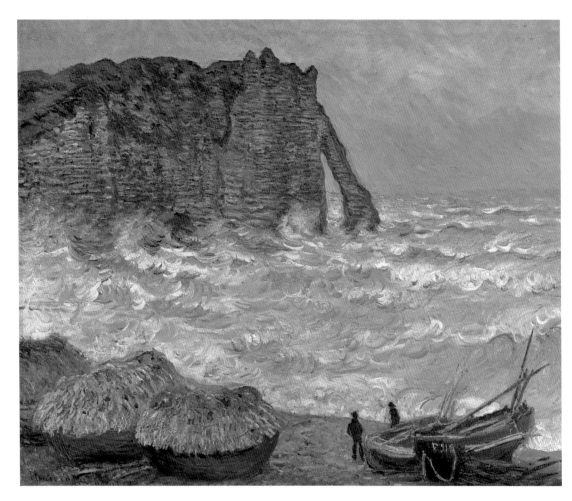

Young and full of ardour for his art, with breathless *élan* the 24-year-old Monet expressed to his wealthy and generous friend, the young painter Frédéric Bazille, sentiments that would echo down the years to describe his lifelong love affair with the visual beauty of the world and his obsessive compulsion to record it:

Ici, mon cher, c'est adorable, and every day I am discovering more and more beautiful things. It's intoxicating; I so want to do it all, my head is bursting ... eh bien, mon cher, I want to struggle, scratch out, begin again, as one wants to do when one sees and understands, and it seems to me, when I see nature, that I will get it all down ... it's through observation and reflection that one finds the way. This way, we work, work all the time.

Four years later Monet returned to Etretat with his mistress Camille, and their son Jean, born the year before. Warmed by a domestic glow he would never recapture, he painted tranquilly. He described this euphoria to Bazille:

I am happy, enchanted ... as I am surrounded by all that I love. I pass my time in the open air, on the shingly beach, even when the weather is foul or when the boats go out fishing ... and naturally I am painting all the time. I think that this year I am going to do some serious work. And then in the evening, cher ami, I return to my little house, to find a good fire and a good little family ... If you could see your godson now, how sweet he is. Mon cher, it's ravissant to watch this little being grow, and I am very happy to have him.

Monet had just sold his portrait of Camille, the subject of his dramatic *Woman in the Green Dress*, and the world seemed full of promise.

and the sky, the animals, the people, and the trees are so beautiful, just as nature has made them, with their character, their genuineness, in the light, in the air, just as they are.' And it was Jongkind who showed the 22-year-old Monet how to put this into practice by teaching him stenographic techniques with which to rapidly record the fleeting effects of the play of light on landscape, of imparting 'knowing spontaneity'. Monet acknowledged his debt to both men, writing to Boudin many years later: 'it was you

who first taught me to see and understand' and attributing to Jongkind 'the final education of my eye'. Another major influence on Monet were the artists of the Japanese woodblock prints whose aesthetic had evolved uncorrupted by Western tradition. Monet admired their gentle exoticism and airy elegance, and their subtle powers of suggestion, but it was their bold and innovative use of composition that is most recognizable in his work.

He had some motifs in mind, he said, that he was going to do '*d'une manière épatante*' – in a most amazing way. By staying away from the chattering circles of the fashionable Parisian art world, he was hoping to find his own voice as a painter: 'What I will do here will at least have the merit of resembling no one else's, because it will be the expression of what I personally feel … the more I go on, the more I realize that we never dare honestly express what we really experience.'

Monet painted Etretat again in 1873, but there is no documentation of this trip other than the one canvas he completed. Ten years elapsed before he returned to paint Etretat for the fourth time, a decade of milestones in his personal life: his marriage to Camille; the birth of his second son, Michel; the death of Camille; and, in its aftermath, his relationship with Alice Hoschedé. Alice, born into a wealthy family, had married the entrepreneur Ernest Hoschedé, by whom she had six children, and had lived in great luxury at her Château de Rottembourg, where she and her husband had been important and enthusiastic early patrons of Monet. The extravagant and unlucky Ernest went bankrupt, wiping out Alice's considerable fortune along with his own. The Hoschedé and Monet families had become friends through their patronage, and for economic reasons, set up house together in Vétheuil, only a few kilometres from Giverny on the River Epte. Following Camille's death in 1879, Ernest spent more and more time in Paris, and Alice and Monet became lovers. When the lease ran out in Vétheuil, they moved to nearby Poissy where there were better schools for the children. Ernest, cuckolded by Monet, made periodic

Opposite: ETRETAT, ROUGH SEAS. *The Porte d'Aval painted from a window of the Hôtel Blanquet. In the foreground are the* caloges, *disused fishing boats thatched for storage, unique to Etretat, and beside them the fishing boats which gave Monet so much trouble.*

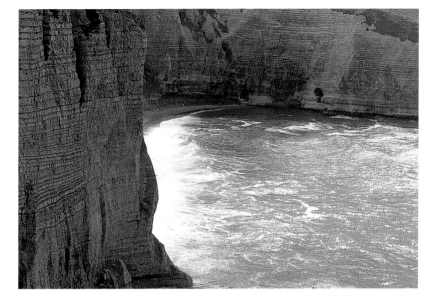

Right and below: *'You cannot possibly imagine the beauty of the sea …'*

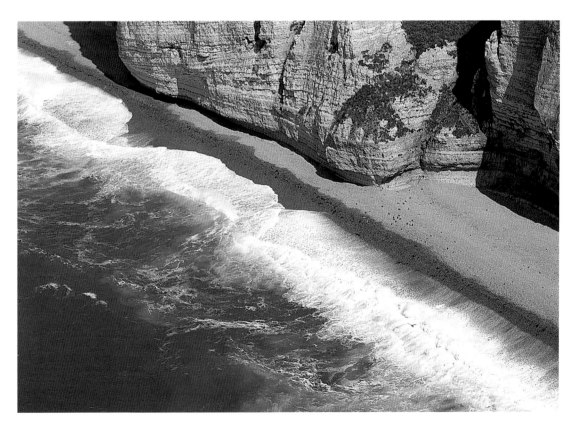

threats to reclaim his family, whom he wanted to return to Paris, but his maintenance payments were at best sporadic, and Alice no longer trusted him. He made emotional appeals to his confused children and this created a tangled, emotive situation for everyone.

It was in these unsettled circumstances that Monet left Poissy on 25 January 1883 intending to paint Le Havre, where he had 'new' and 'varied' motifs already fixed in his mind for his first one-man show, scheduled to open on 1 March in the Paris gallery of his dealer, Paul Durand-Ruel. The pressure on Monet to produce startling and ground-breaking work was enormous, as he was counting on this exhibition to make his mark, to end the anxious, demoralizing saga of his penury and provide both families with financial security. But on his arrival, the weather in Le Havre was terrible, and while he waited for the skies to clear, he went off on a jaunt to Etretat. He was as dazzled as if he were seeing it for the first time, and unable to resist 'being seduced by these wonderful cliffs which are unlike any others' and the sea, 'unbelievably beautiful but what talent it would need to render it', he abandoned his dreams for Le Havre and decamped to Etretat. There, he installed himself in the beachfront Hôtel Blanquet, which had a 'superb view of the cliffs and the boats', which he was counting on painting from his window on rainy days.

This was a landscape haunted by poignant memories, and by the spectre of a large seminal painting of the bay by Courbet. Monet wanted to attempt the same motif, even if it was 'terribly audacious of me to do this after

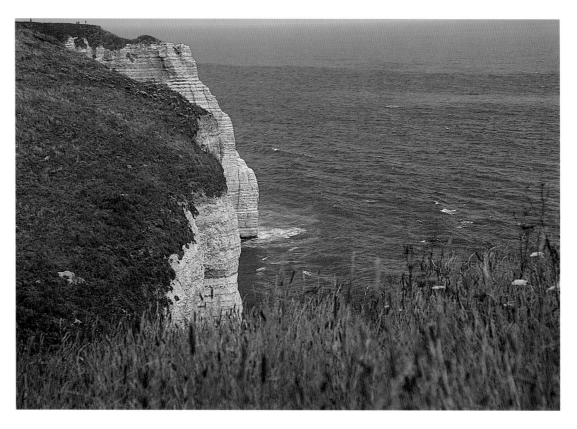

Courbet who did it so wonderfully, but I will try to do it differently'. This challenge made him adventurous. He climbed up and down and along the tops of the vertiginous cliffs, and when the tide was out ventured into the large cave of the Trou à l'Homme where, he said, he had never dared go before, and saw next to it, the famous Needle rising in all its dizzying perspective before him, whereupon he hastily returned to the hotel to fetch his easel. He was elated in his first week of painting. The sun shone and he made sunny studies for his large painting to rival Courbet which he planned to finish when he returned to Poissy in time for the exhibition.

Then it started to pour. This, together with a letter from Durand-Ruel saying he was moving the exhibition forward, changed Monet's mood overnight. He now had less than two weeks left and having started all the studies for his opus under sunny skies he could not start them all over again. As the rain continued, Monet realized he would have to abandon the project, as there was not enough time to get it ready. 'I am very troubled by this exhibition, which is not going to be what I wanted. I am going to do all I can to finish three or four canvases, and even that is doubtful, and once again they will be the usual size.' 'From now on,' he said, 'I shall be working *à outrance* – flat out.'

Opposite and left: The tops of the limestone cliffs of Etretat were like a second home to Monet, who grew up in Le Havre. As a child he loved being outdoors, 'when the sunshine was inviting, the sea smooth, and when it was such a joy to run about on the cliffs, in the free air'.

caring for his two sons on his own. A meeting between Alice and Ernest to decide their future was constantly postponed, and every day as he waited for news Monet's personal happiness hung on the line. His children, Alice said, were missing him. All these pressures whirled around in Monet's head, and built themselves up into a spiral of such anxiety that he could no longer sleep: 'All last night thinking about this confounded exhibition, I listened to the lashing rain and saw myself lost.'

Worn out by worry and stress, he caught a bad cold, 'which is a real nuisance because I am constantly obliged to put down my brush to take up my handkerchief; it's very irritating'. However, he managed the occasional joke, despatching a consignment of lobsters to Alice, with these instructions: 'The lobsters need to be cooked alive – in fact, they insist on it.'

The meeting between Alice and Ernest Hoschedé finally took place on Alice's birthday, 18 February. Emotionally paralysed, Monet was unable to paint either on the day, or in the three agonizing days that followed the receipt of four cryptic lines from Alice.

I have read and reread them twenty times each; *je fonds en pleurs* **– I dissolve in tears; can it be possible – must I get used to the idea that I will live without you? Whether my canvases are good**

It is curious that a man as precise and exacting as Monet should lay down his art at the feet of a god as fickle and unmerciful as the weather; and yet that, of course, was the whole point of it. The reality of the physical world ruled supreme: blue skies or grey, high tides or low; these four variables had to match the canvases he had under way. More fickle still were the whims of the fishermen arranging and then rearranging their boats. He had four studies of the boats under way, when '*pof!* with the bad weather all the boats have been moved higher up the shore', and he had to start all over again. The next day, a storm rolled in and the high waves tossed, turned and scattered the boats across the beach. So, a new canvas started. Then, a few days later, the fishermen arrived, and for no reason Monet could make out, repositioned them yet again, surely aware of but completely indifferent to the frustration of the painter at his easel framed in the window.

The days brought no improvement in the weather and Monet was worried sick. There were so many mouths to feed, to clothe, to educate; there was pressure from Alice's family who disapproved of the impropriety of their relationship to return to the father of her children, leaving Monet to contemplate the loss of a family a second time and the prospect of

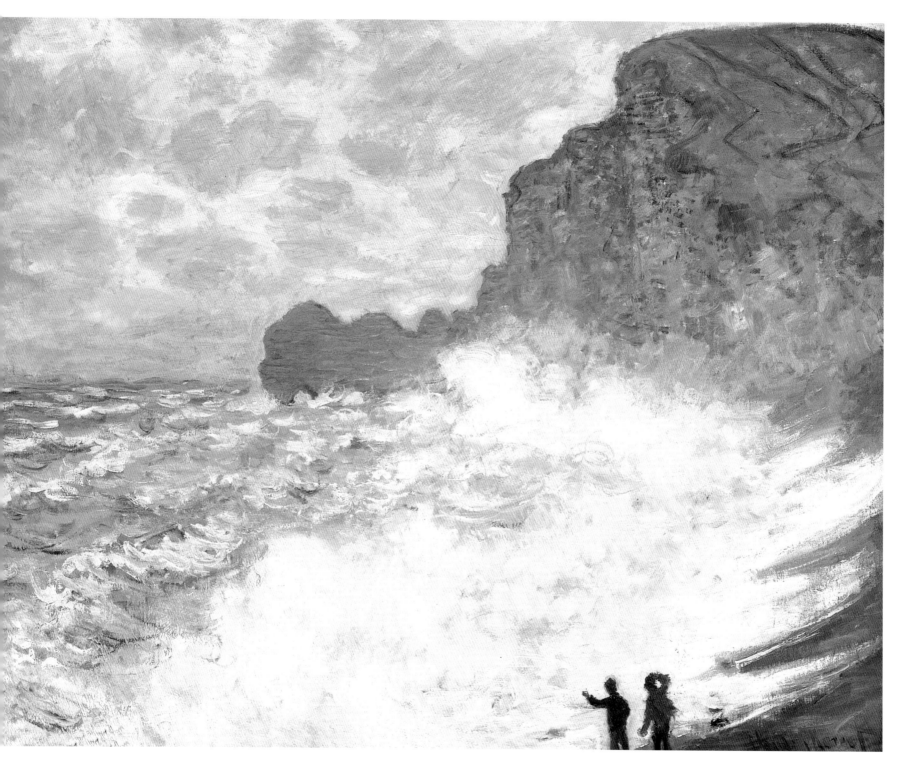

Left: STORMY WEATHER AT
ETRETAT. *The promontory
of the Porte d'Amont in
rough weather.
Maupassant described it as
looking 'almost like a huge
elephant dipping its trunk
into the waves'.*

Right: *Here the silhouette
of the elephant shape of the
Porte d'Amont may be seen
more clearly.*

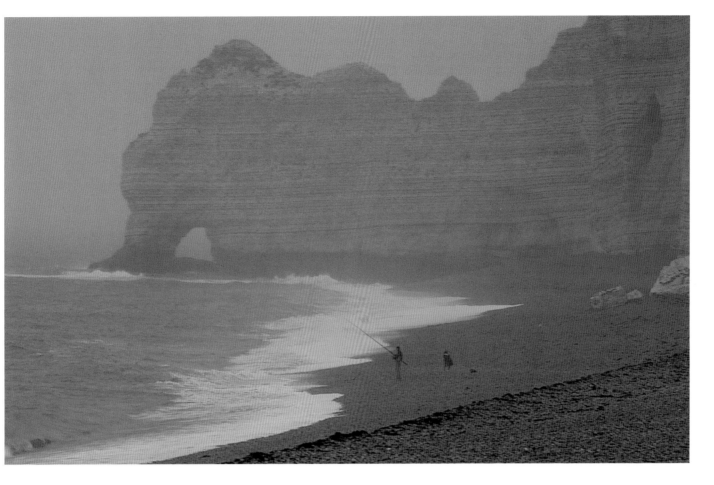

or bad, I don't care. The exhibition is the least of my worries. These four lines hit me like a thunderbolt; I am grounded. In your *dépêche* you tell me to return at once – does this mean you are going to leave me at once? Today I was going to pretend to work, even try, but all my boxes remained unopened beside me on the shingles; I remained stupidly looking at the waves, wishing that the cliff would crush me.

Dependent as he was on weekly advances from Durand-Ruel, for which he had to write begging letters, Monet could not leave until his dealer sent him enough money to settle his hotel bill. What words passed between Alice and Monet upon his return is not known, but Alice had decided to stay, for the time being at least, with Monet. Monet retouched and finished old canvases in time for the exhibition, but not one of his Etretat paintings went on show. Monet deemed this exhibition for which he had had such high hopes to be a complete failure, as it elicited little comment from the critics. Monet blamed Durand-Ruel for failing to organize, publicize and hang the paintings properly. When a review finally appeared, Monet thanked the reviewer, saying: 'The critic must first learn to look at nature in order to see and understand what we are trying to do.' The following month, April 1883, the Monet-Hoschedés left Poissy for a pink-stuccoed cider farm in Giverny. Monet would finish his seventeen canvases of Etretat later that year, lamenting himself to be 'a slave to work and above all, of the weather, which doesn't always have pity on the poor painter'. But he had not finished with Etretat yet.

Bordighera

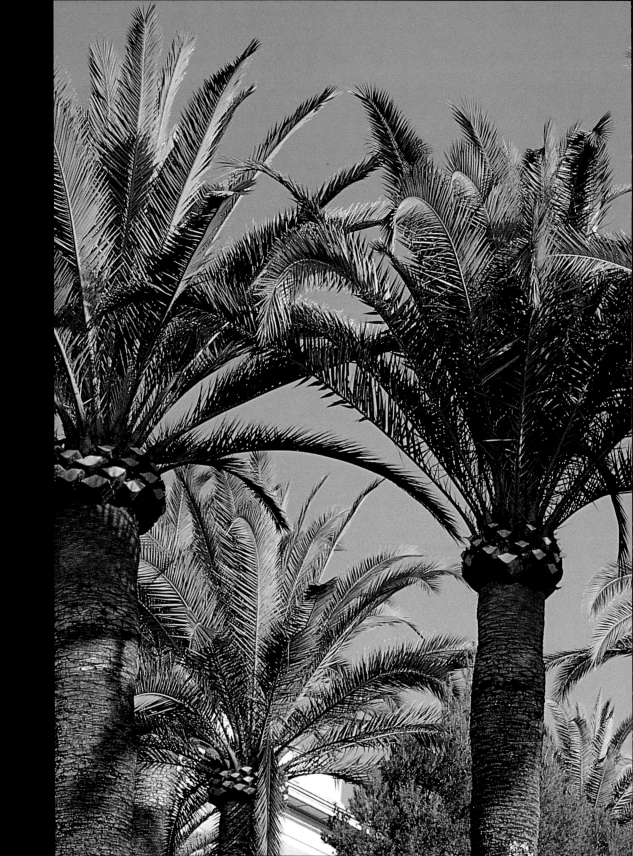

"Every day the countryside is more beautiful and I am enchanted by it . . . the almonds and the peaches mixed amongst the palms; the lemons always in their harmonious colours, and to see it changing every day . . . I rejoice in all this . . ."

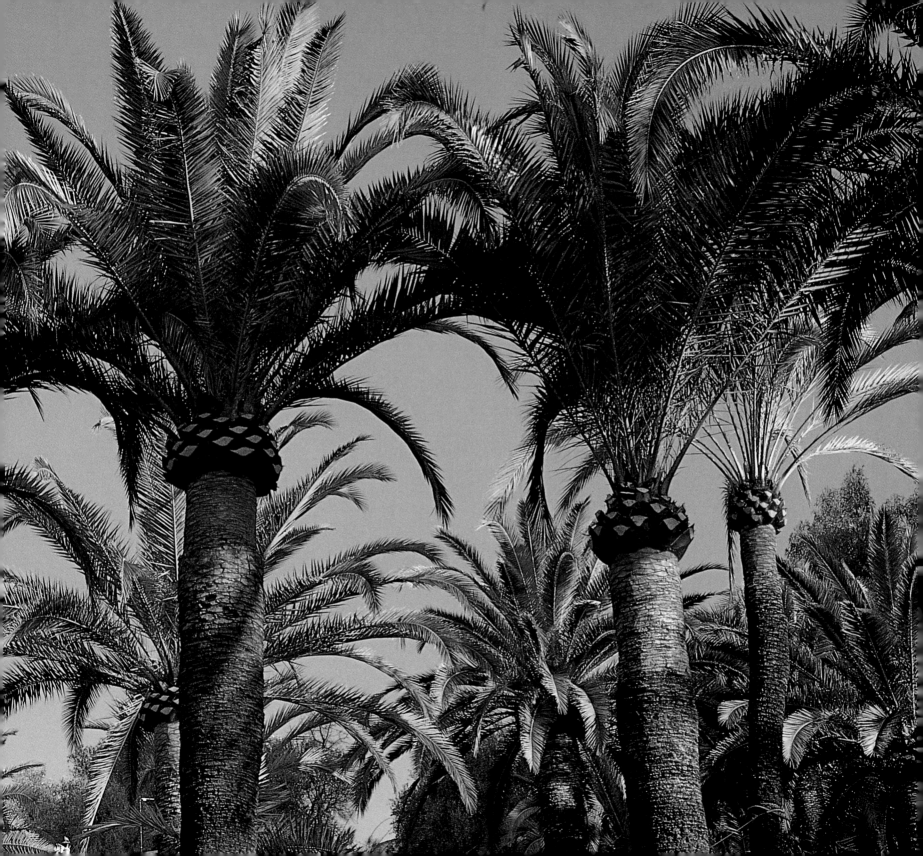

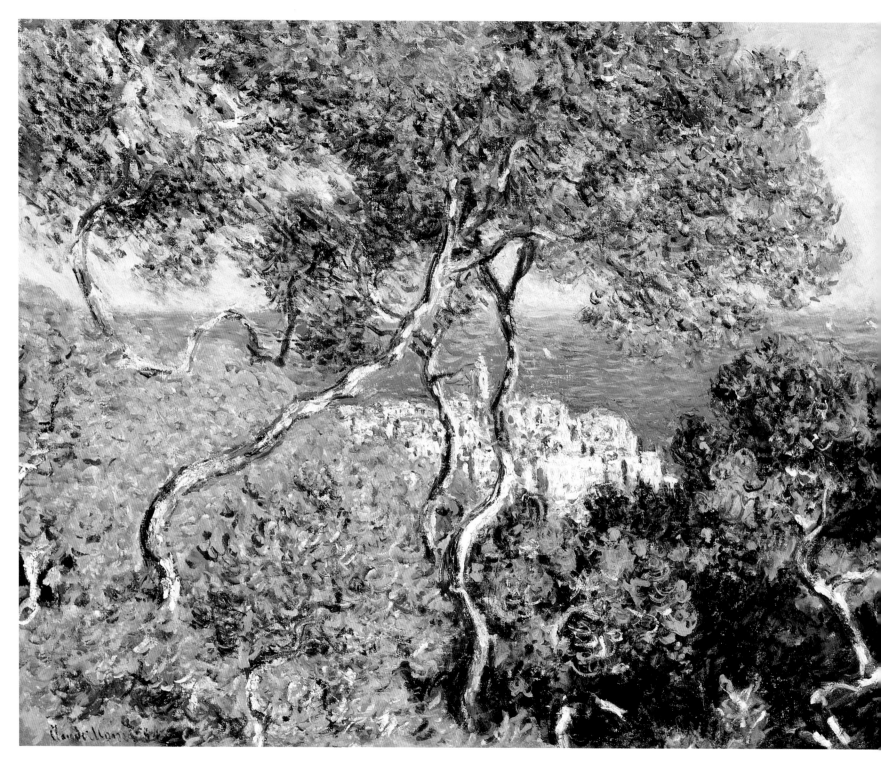

Previous pages: *The palms as they look today in what was Monsieur Moreno's garden.*

Left: BORDIGHERA. *The hilly reaches known as the Mostaccini district of Bordighera, which Monet painted in his first week, positioning himself, he said, amongst cork oaks and pines. It overlooks the Citta Alta, dominated by the campanile of the church of Santa Maria Magdalena.*

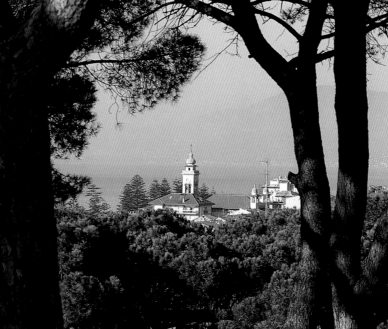

Left: *It is impossible to replicate Monet's perspective of the Citta Alta today (seen left), as the Mostaccini hillside has been swallowed up in a suburban and very private sprawl. A similar view from a public park, overlooking the campanile of the Chiesa dell'Immacolata Concezione, shows the mountains in the background.*

Below: *Monsieur Moreno's garden, enclosed by a wall which still exists.*

As soon as he arrived at Giverny, Monet started planting the first of thousands of flowers in his garden – a passion he shared with his good friend, the painter Gustave Caillebotte, who brought him seeds from his own garden on the banks of the Seine. Initially the flowers served as models for flower and fruit panels commissioned by Durand-Ruel for his Paris dining room. For the best part of seven months, Monet was stuck indoors painting his still lifes and bringing his Etretat scenes to completion. As summer and autumn passed, he found studio work oppressive, and grew restless. 'I'm beginning to ask myself if I'm going mad or whether what I'm doing is neither better nor worse than what I've done before, or simply that it's harder for me to do today what I did so easily before … It seems like a century since I've worked on nature in the open air.'

Finally, in mid-December, the irresistible call of the great outdoors swept him off to the Mediterranean for a change of scene: a painter's holiday with Renoir. The pair travelled all along the coast from Genoa to Marseilles, and Monet painted a couple of pictures of sea and rocks near Monte Carlo, resolving all the while to return in the new year, alone. As he was obliged to ask Durand-Ruel to fund his next trip, he swore him to secrecy, afraid that if Renoir got wind of his plan he would want to come too. 'However pleasant it was to travel as tourists with Renoir, it would bother me to do it as a twosome. I have always worked better in solitude and after my own impressions … the two us going would be disastrous.'

Monet left Giverny on 16 January 1884 with his crates, canvases and paints, 'filled', he said, 'with enthusiasm, and I think that I am going to do some stunning things.' He was bound for the picturesque fifteenth-century Italian town of Bordighera, which had struck him as one of the most beautiful spots he had seen with Renoir. Sprawled on the hilly coastline of the Mediterranean, just across from the French

border, Bordighera was famous for its lemon and orange orchards, and renowned for its palms, which it exported all over the world. Monet had heard about the marvellous garden created by a rich businessman, Monsieur Moreno, where there were 'the most beautiful palms of Bordighera, some superb motifs', and as Monet loved gardens, it may have been the horticultural allure of Bordighera that drew him there. Until recently, Moreno's garden had been open to the public, but when visitors had 'damaged and stolen very valuable flowers' the gates were shut and no one entered without a letter of recommendation. By a fortunate coincidence, while overnighting at the Hotel Terminus in Paris before boarding the train to Bordighera the next day, Monet bumped into an acquaintance with contacts in Marseilles and asked him to use his influence to procure a letter of introduction; and he would ask the same of Durand-Ruel.

When Monet arrived in Bordighera, he was delighted with his 'well-situated hotel', until he discovered at dinner that it was occupied entirely by Germans and he was the only Frenchman. 'At no price would I have stayed.' Monet's objection to the good citizens of Germany stemmed not so much from the rancour of the Franco-Prussian war, which had exiled him from France with Camille and Jean, as from the sonorities of the language itself, which he found excruciating: '*quel jargon*', he would later say, 'and when they try and speak French it's even worse'. He decamped to La Pension Anglaise, not surprisingly 'dominated by the English', but animated by a flamboyant American woman and her daughter, who 'will not be parted from her enormous Rembrandt-

style hat ... as big as a parasol, made of scarlet red fur: she lunches and dines with it on.' Once again, Monet was the only Frenchman, as the chauvinist French 'don't cross the border'.

His arrival there made him the thirteenth person at the dinner table, which alarmed the superstitious residents, and was 'remarked upon, because with the English, it seems that the first person who rises from the table will die within the year, so no one wants to rise from the table alone. Every evening it's the same thing.'

The weather was superb. Gripped by the euphoria which always lasted until he actually got down to the business of painting, Monet started four canvases within the first week, climbing the hilly reaches behind Bordighera, where he positioned himself amongst cork oaks and pines and included them in his view over the rooftops and campanile of the town, and out on to the sea. 'I ascend, I descend and then ascend. Between each study, I take a break, and explore every path, always curious to see new things ... I am going to concentrate on the palms and the more exotic aspects. Elsewhere I will do water, the lovely blue water.' It was just a matter of finishing the first four, and then doing another four, and another four after that. So simple. In the evenings, he told Alice: 'I have my little chat with you, get into bed, beatifically, cross my hands and think of Giverny, squinting out of one eye at my canvases hanging on the wall, then a bit of reading, and *crac*, I sleep.'

He may have had six canvases under way within the next ten days, but the first four remained unfinished. Although he was pleased with the unaccustomed luxury of being able to regain

and pursue his effects under a more stable light than he had ever known, two large flies soon appeared in this otherwise delectable ointment. As a painter of compositional clarity, he found Bordighera cluttered.

These palms try my patience; and the motifs are difficult to seize and arrange in the canvas ... One can walk indefinitely under the palms, the oranges and the lemon trees and also under the wonderful olive trees, but when one seeks out motifs, it's very difficult ... very slow, especially because *les grands motifs d'ensemble* are rare ... I would like to do orange and lemon trees standing out against the blue sea, but I cannot find them as I want them.

Bordighera was choked with vegetation, so that there 'are always sections with lots of detail, terrible tangles to render and I, as it happens, am a man of isolated trees and wide open spaces ... As for the blue of the sea and the sky, it's impossible ...'

He was also blinded by a light so brilliant and so novel to him that he was stupefied by it.

I cannot seize the tone of this country: at moments I am terrified by the colours I have to use. I fear they will be shocking, although I am well under them; it's an astounding light. I already have studies of six *séances* – sessions – but it's so new to me that I can't finish them ... also I waste a lot of colours, as there are trials to be made. It's a whole new study for me, this landscape, and I am only starting to get my bearings, to know where I'm going, what I can do. It's terribly difficult; you would need a palette of diamonds and jewels ... I find myself in an enchanted country. I don't know which way to turn ...

'I am going to concentrate on the palms and the more exotic aspects …'

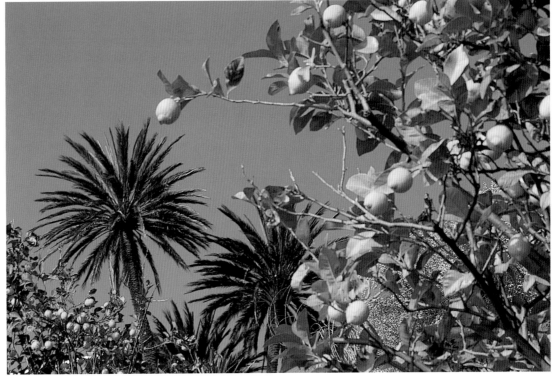

From his bedroom window he had a view of the Alps and the sea. Ten days into his stay, he was woken in the night

by a terrifying racket, of wind and rain, impossible to stick one's nose outside; millions of taps, of fountains … at two in the morning the rain ceased but not the wind, a tremendous wind, and the clouds which hid the mountains dissipated; it was an unforgettable spectacle … all the mountains covered in snow to the summit; for when it rains below, it snows on these enormous heights; so the sun on the top, clouds halfway down and always the sea, and bluer still; no, it's indescribable; as for painting it, out of the question – they are short-lived effects which will never be found again.

Just then, as he was 'locked up and unhappy in my room, dazed before this spectacle', the English guests of the pension sent him a message asking if he would like to join them on an excursion into the mountains. 'We went for a marvellous walk, in ravines, shielded from the wind, and burnt by the sun. We visited three little Italian villages lost in the mountains, Borghetto, Sasso and Valbona; *autant de pays, autant de merveilles,* but too remote to go and paint them.' In the blazing jungle of Bordighera, the mountains and sea seemed all the more tantalizing. 'The sun has come back, superb, but with a terrible wind, a tempest with sun; the sea is unimaginable. Picture the agitated sea of Pourville but a marvellous blue

and froth like silver. I wanted to attempt it, but parasol, canvases, everything was swept away and the easel broken; I had to battle to beat my retreat, furious.' 'I'm afraid I've made a mistake coming here, although it's as magical and seductive as possible.'

But by early February, having worked like a 'fiend', he was beginning to 'get the feel of the place … I now dare to put in all the tones of pink and blue; it's absolute magic,' he told Alice, 'and I hope it will please you.'

His letter of introduction to Monsieur Moreno finally arrived, and on 5 February he went along to present himself to Moreno, who for his part

had already been informed 'that I was one of the most distinguished artists in Paris' and 'welcomed me accordingly'; but, joked Monet, 'we have yet to see the expressions on their faces when they see what I do'. Moreno took Monet on

a delicious walk through the smallest recesses of this incomparable property. Having started other studies is regrettable: a garden like this one is like no other, it's pure magic; all the plants in the world grow there in open ground without, it seems, being tended; it's a jumble of all the varieties of palms, all types of oranges and tangerines.

Moreno gave him a key to the garden, to paint 'when it suits me, and as I thought, there are there the most beautiful things one can see'.

That night, though, Monet had terrible nightmares, 'seeing all my canvases with false tones, bringing them to Paris where everybody confessed to me they couldn't make them out. I was desperate. Durand wanted none of them and I cursed this trip.' Having seen the splendours of Moreno's garden, Monet dismissed everything he had started as a waste of time and paint. That these early trials had prepared him for Moreno's garden did not occur to him. He was highly anxious about his desperate financial straits. Monet and the household in Giverny were entirely dependent on money produced by Monet's weekly requests to Durand-Ruel, who was finding it a struggle to sell Monet's work and was not always reliable or able to meet the sums Monet requested; and the need to return with something spectacular, especially in the light of the failure of his exhibition the year

Above: Bordighera is as famous for its towers and campanile as for its citrus fruit and palms. This is the campanile of the Chiesa di Sant'Ampelio, which bears a striking resemblance to the tower of the Villa Etelinda (right) which Monet cut off in his painting.

Right: The 'jumble of all the varieties of palms' in old Bordighera.

Opposite: VILLAS AT BORDIGHERA. The Villa Etelinda on the Strada Romana with its garden of aloes and palms. It was while painting this villa that Monet accidentally set himself on fire. 'I am beginning to seize this wonderful pink light; there reigns here an extraordinary tone of rose, untranslatable. The mornings are ideal. I am painting now with Italian colours which I have sent for from Turin.'

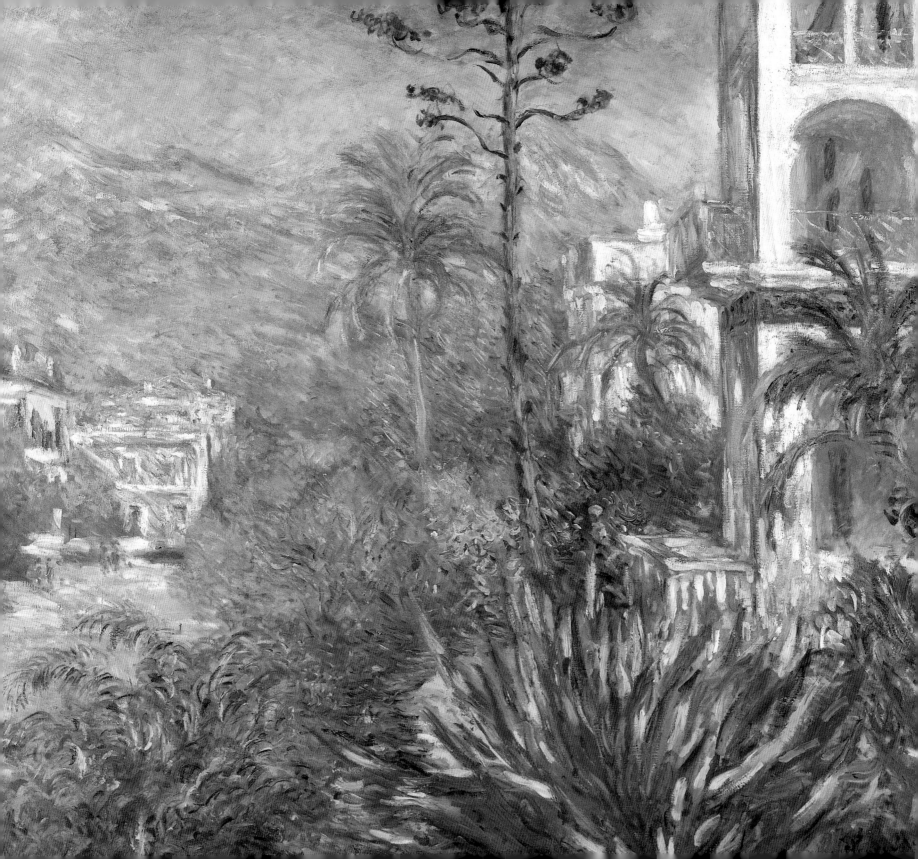

before, was as urgent as ever.

In recent letters Monet had pleaded with Alice to be economical and to report on the sums she had spent so that he could do his accounts. Although this was not meant as a reproach, Alice bridled, and just as he was about to start work in Moreno's garden, a fearful row ensued. They were an excitable pair, as passionate in their disputes as in their love. Alice ran the household admirably, but complained endlessly about her privations, the shortage of money and the responsibility of all the children who were presently under her feet, withdrawn from school because of a typhoid epidemic. She was a young woman of thirty-nine accustomed to luxury, trapped by domesticity, who missed her lover, envied his freedom and his adventures, and was consummately jealous. He had hardly been there a week when he was already appeasing her suspicions that he might be dallying 'avec les miss anglaises'.

Once unleashed, Alice's black moods ran their course, unchecked. He begged her to stop accusing him of being unfaithful, to be reasonable, 'or you will demoralize me completely … You must realize by my letters that you are my life and all my happiness,' he pleaded with her. Alice threatened, once again, to leave him.

Here you are launched into dark, crazy, absurd notions. What have I done, what is going on that prompts you to speak to me like this? Is it the example of Zola's heroine which haunts you or some pressing family reason which obliges you to speak of a separation, you who love me so, and me who could not live without you? … These

letters make me sad, me so eager to read them when I return from work … it would be so comforting to find kind words, expressions of happiness, promises of caresses …

And then he added crossly, 'indeed I expect them, or I'm not writing to you any more'. Alice's reply seems to have been less bitter: 'whilst full of sadness; it is better, because you could not have helped but see all my tenderness for you, all my love'. Exchanges like these traumatized him, and it was in Alice's power to make or break him.

With ruffled domestic feathers temporarily smoothed, Monet worked tranquilly in Moreno's silent, enchanting garden, installed beneath a canopy of olive branches, painting the palms in sunlight and the large olive grove in grey weather; 'everything is blue, yet it is so'. 'In this terrestial paradise you have nothing to worry about,' he reassured Alice, pre-empting any jealousy of Moreno's wife, 'it's terribly calm inside. The son, a child of twelve, is extremely ill and his mother doesn't leave him for a minute.' Moreno, flattered by having so eminent a painter in his garden, took Monet under his wing. He invited him to a concert in Ospedaletti, 'un pied de luxe insense', to hear 'une chanteuse italienne', and during the interval they ate ice-cream on the terrace of the casino. On their return, Moreno took Monet into the garden 'and made me taste I don't know how many kinds of oranges, tangerines, dates, jujubes', for no fruit in this garden was forbidden and sent Monet back to his pension 'laden with flowers, oranges and mandarins, as well as sweet lemons which are delicious to eat'. During Monet's stay, Moreno would also

despatch boxes of oranges and tangerines to Monet and Alice's children in Giverny.

Although Monet often felt isolated in his little room, and was working terribly hard, there were moments of light relief. His prose sketches of the four Scottish spinsters who arrived at the pension in mid-February reveals that the eye of the former caricaturist was as sharp as ever.

They are extraordinary characters: they have 250 years between them and they are travelling on foot, the whole length of the coast. Everyone at the table couldn't help laughing, the English most of all. If you could have seen this _table d'hôte_, and me in the middle of all these people, it's very comical. But the Scottish spinsters turn out to be the gaiety of the _table d'hôte_; they are so amusing. They have come from Biarritz on foot and are continuing all through Italy. They are leaving in a few days, and doing their little _aquarelles_ the whole time, for there is not an English woman who doesn't do them, and you can't take a step here without seeing young and old installed in every corner. There are a few who are dying to see what I'm doing but they are very discreet and circle around me from afar. It's very funny; but I think that if they could see close up, they would be very startled.

When it rained, when he was too weary to work or after he had finished working, he would take the train to Menton to buy his Corporal tobacco, buy newspapers or send Alice flowers, 'just happy to feel myself in France again'. He was determined to stop off in Menton for a few days after finishing in Bordighera, 'to do a few studies I think within my ability … if there's one thing that's terrible for me it's that the sea is

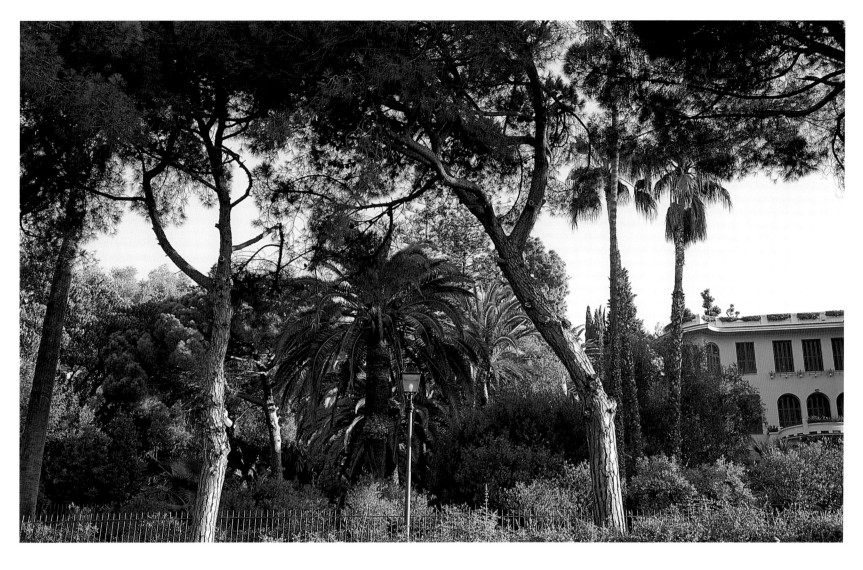

in only two or three of the canvases, and the sea is *un peu beaucoup mon élément*'. He had found that Monte Carlo, with its long reaches of mountains and sea, had motifs that were more complete and easier to compose. One day he went to gamble in Monte Carlo with his English friends from the pension, and in a stroke of beginner's luck made sixty-five francs on the roulette wheel; but hoping to make a hundred francs to send to Alice 'to surprise you with it' he lost the lot and was ten francs out of pocket when he caught the last train back to Bordighera. 'I am not idle in spite of these few excursions,' he hastened to add, somewhat guiltily, feeling he had to justify every distraction to Alice.

The Villa Moreno as it is today,
photographed from the road.
The garden is no longer open to the public.

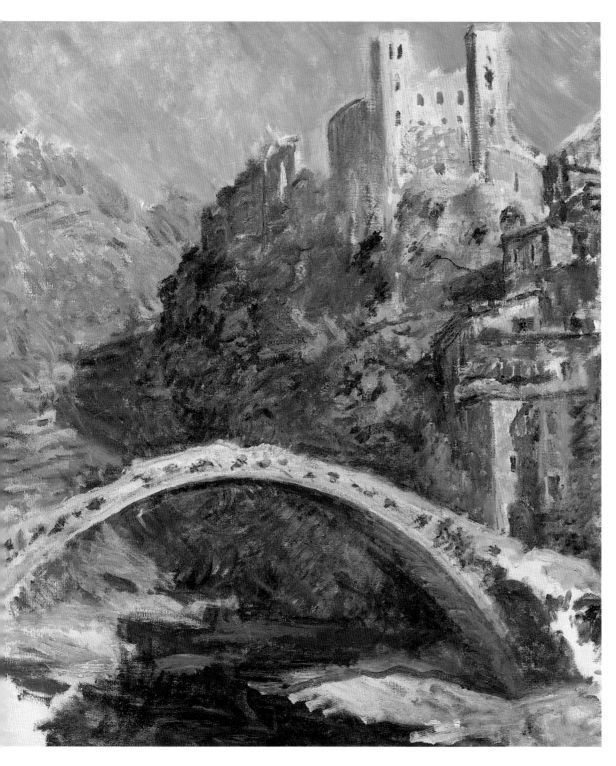

Drawn back into the mountains during a spell of bad weather in mid-February, he made superb excursions with his English friends, and found a motif.

We went off by car to the valley of Nervia to Dolce Aqua, a small town extraordinarily *pittoresque*, took it in our heads to return on foot by climbing an enormous mountain, but on asking the way, the Italian peasants, who surrounded us as if we were curious beasts, told us it was not possible if one was not a local and we would get lost in the cloud. We took a peasant as guide and climbed 400 metres in two and half hours – the beautiful things I've seen are indescribable, sadly all of it too far and inaccessible.

He saw in Dolce Aqua 'a bridge which is a gem of lightness', very like the one he would later build across his water-lily pond at Giverny, and shielded from the wind by the mountains. He returned there by hired car, and worked well on two motifs. 'The bridge is charming and it was calm and as warm as August. I'll go there for as long as this wind lasts and this way I won't waste my time and torment myself. As soon as I stop working I'm always afraid I won't achieve anything; I terrify myself, perhaps mistakenly.'

When he started working in Moreno's garden he was still hopeful of finishing even one of his canvases, but every one was a terrible struggle.

I can't let them go, as I'm seeing more clearly every day … I have so much to do, and lately I find everything I do hideous and am obsessed with the thought that it will please no one. When I think about the two studies I made in Monte Carlo during my first trip – those canvases were

completed in two *séances* at the most – I tell
myself I was *mal inspiré* in choosing Bordighera;
but I have to reach the end and the longer I take,
the more this trip needs to be productive. What is
a fact is that I have never had so much difficulty;
I have canvases of ten to twelve *séances* that don't
seem to have progressed; not one will have been
done *d'un jet* – in a single sitting – is this good or
is this bad? I don't know; it's on my return that I
will able to judge.

He was further aggravated by an enormous boil
'very inconveniently placed as I can neither sit
down nor walk'.

During the last week of February the coast was
gripped by Mardi Gras celebrations. Moreno
despatched a servant to find Monet in the
garden and invite him to attend the Carnaval
de Nice as his guest, and Monet returned that
evening covered from head to foot in flour and
plaster. Back in Moreno's garden the next day,
'I painted to the sound of music. Bordighera is
en fête for Mardi Gras and the echoes reached
me under the palms.' In the evening he watched
'a superb firework display and the death of the
Roi du Carnaval represented by an enormous
dummy going up in flames from his pension.

As February drew to a close, Alice's letters grew
desperate again.

I too am more than weary of this long separation
[he agreed], of this solitude, and I need to see you
courageous so that I don't lose courage myself …
I have a heavy heart tonight. Aside from the pain
I have of being separated from you, I have terrible
preoccupations with my work … It's distressing,
because in spite of this magical landscape,

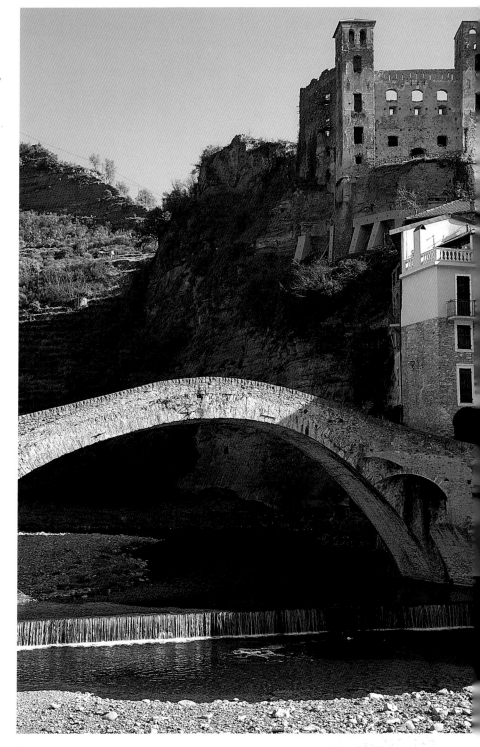

*Opposite and right: The
ruins of the medieval
CASTLE AT DOLCEAQUA on
the River Nervia, only a few
kilometres inland from the
sea, remain essentially
unchanged. Monet
described the bridge as
a 'gem of lightness'.*

it cannot be so for me for long, without you.
I beg you, have patience so that I myself have
more fortitude.

'I understand your sadness, the kind of life you
lead, so interred … But you have all the
children around you; is this then nothing?' But
Alice would not be calmed. He replied to a letter
received the next day:

It's not charitable to speak to me in this way.
Unless I abandon everything here and return
home, I can't do more; I'm already cross enough
with myself for not doing better and above all,
more quickly. You seemed more courageous and
now again you let your imagination run wild with
the temptations I might have, the affairs I must be
having, adding that you don't even care any more.
Is this so, and do you think this doesn't hurt me,
speaking to me of infidelity? Will you never know
me? I curse this trip, I've had enough, I'm furious
that I can't finish all my canvases in two days.
Knowing you to be in this state is odious to me;
I don't know what to say to you, if you believe
in nothing and are indifferent … we need, each of
us, to encourage one another to put up with this
separation, and above all to trust one another …
I understand only too well your *ennui*, always
locked up, and the boring humdrum of running a
household, but don't let yourself be beaten down
like this; if you only knew how much it pains me
… we hurt one another instead of encouraging
one another, it's *absurde*.

The next day, the last day of February, 'in spite
of my sadness' he finally finished two canvases,
studies of olives in Moreno's garden. 'I then
delivered myself to the lemons in a delicious
spot, and as I was painting, I was thinking of

you. Imagine the courtyard of a Normandy farm; instead of apples, oranges and lemons, and in place of grass, Parma violets; the ground is absolutely blue; I am trying to render this.' He finished a third canvas the next day, but 'although I have thirty paintings started, they are not all destined to be finished. God, how this confounded country is difficult; I cannot finish any of my studies; I always think I'm there, and then, when I get back, I see that it's still not right.'

The arrival of March brought warmth:

Bordighera is more and more invaded by foreigners and what we see of painters is crazy. But I am still the only Frenchman. The four famous spinsters, the walkers, have left for Rome, still on foot; they were charming women, we mocked them when they arrived, but they won the empathy of everyone by their gaiety and intelligence. They went off across the mountains, not wanting to take the main road that they frequented during their stay here. Real characters.

Alice's letters were suddenly much more cheerful. Monet was heartened by this and his optimism returned. He was happy in Moreno's garden:

Je suis ici, comme chez moi. **The air is infused with a delicious perfume; it is so hot here the flowers spring from the earth as if by magic. You have seen the anenomes which I sent you for your birthday – the reds and frizzy pinks – they grow wild here. My little Italian who carries my** *bagages* **makes enormous bouquets of them while I work and a quantity of other flowers. How happy we would be here and what a pretty garden we**

Opposite and right: The old palms of Bordighera, grown even taller since Monet's time, cast their long silhouettes over the façades of the old villas in the morning sunlight.

would make! He sent the children new growths of palms which have been made into cornets to serve as flowerpots. I send you my kisses, my caresses, my thoughts of you every hour, I love you, I love you, tell yourself that and take heart.

I have received a letter from [the painter Gustave] Caillebotte [his close friend and gardening chum] asking if I'm going to spend the rest of my life here. It is true that normally I am more expeditious in my trips, but I have to admit that I needed a painstaking study at the beginning. I am beginning to seize this wonderful pink light; there reigns here an extraordinary tone of rose, untranslatable. The mornings are ideal. I am painting now with Italian colours which I have sent for from Turin. I have used all my canvases, my shoes, my socks, my clothes, and I will arrive back in a sorry state; my clothes have been corroded by the sun – only I will return valiant, even though I am worn out at times by this continual battle. Rest by your side will be a great balm.

For much of March, Monet was on a roll, not least because he was able to move into a larger room he had had his eye on for some time.

I was so narrowly installed that I couldn't turn round in the midst of all my canvases, and see them less still … In the light, my canvases seem better in this room which is very big … at the beginning what I did was very bad, but now I've grasped this magical country and it's precisely this marvellous aspect which I'm so keen to render. Of course a lot of people will cry at the *invraisemblance*, at the folly, but too bad, they also say that when I paint in our climate. It was imperative that in coming here I return with its

most striking aspect. Everything I do is 'punch flame or pigeon breast' colours, and even then, I do them timidly. This might make the enemies of blue and pink scream but it's exactly the *éclat* of this magical light that I want to render. Even so, I'm well under the tone. Every day the countryside is more beautiful and I am enchanted by it. I am beginning to get there; and moreover it is more beautiful every day, the almonds and the peaches mixed amongst the palms; the lemons always in their harmonious colours, and to see it changing every day one wants to follow its progression if I wasn't drawn by another place, because at the same time that I rejoice in all this, I enrage at not being able to fasten my suitcases.

He had never been on a campaign that took him so far from home, nor for so long, and in the last weeks of his Bordighera campaign he was torn apart between his desire for Alice and his duty to his art. He sounds like an explorer steering his ship across a tempestuous sea, as desperate to return to the safe harbour of home as he is to return with a cargo of gold.

I am tormented by two things: to see you again and to bring back good things to satisfy Durand-Ruel, to whom I owe crazy amounts of money. For a long time I worked without getting what I wanted; I had to abandon my canvases, start them again, erase them. I was terribly frightened by this fatal delay: as you know only too well, I have to come back with something good – they expect it of me, maybe they expect better things of me than I am capable of doing. Renoir wrote to me, deploring not having come too, as he has been spending his time working and erasing everything he's started. We are becoming very hard on ourselves, yet they will always reproach us for

making no effort … You can't imagine my desire to leave. I am so tired; you know how hard I work once embarked. To do this job for a month is possible, but more than two months it's killing, *je n'en peux plus*, and yet it's going well; it was very beautiful today and I've finished another canvas; I have to finish one a day and I have such a terrible thirst to be near you. You don't know how I desire this homecoming; to share your life, to speak to you, to see you all, it will be the recompense of all these efforts, and all our worries forgotten. I will find my canvases much better, far from this terrible light and certainly there are good ones amongst them … a good painter is never satisfied with himself. What's important is that you are all well, that no one is coughing and I will order in advance two good bottles of champagne and morel mushrooms … and what a good pipe I'll smoke on the divan of the studio! I rejoice in this in advance.

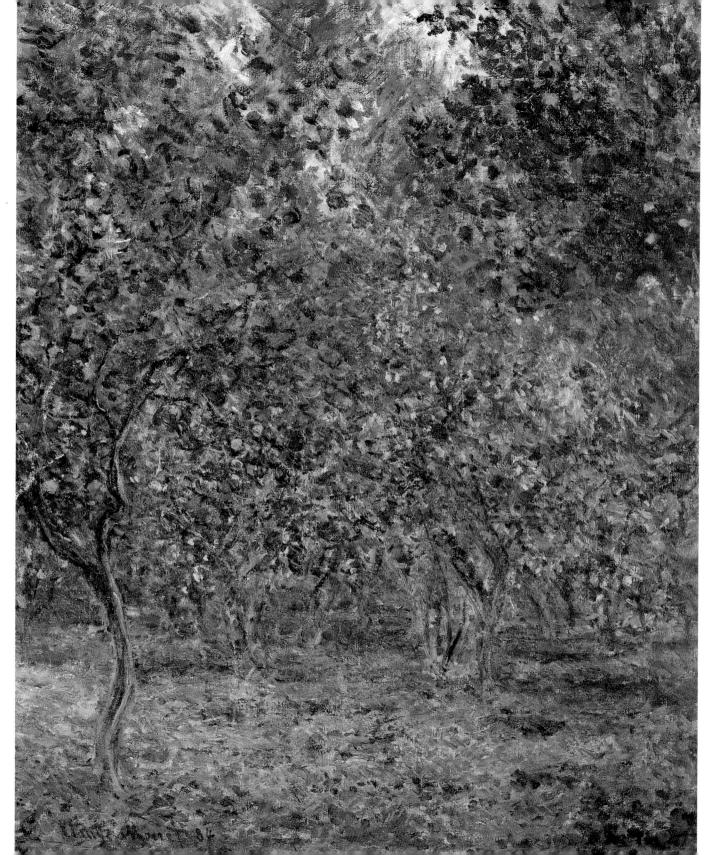

Left: *Oranges and poinsettias. 'There are always sections with lots of detail, terrible tangles to render and I, as it happens, am a man of isolated trees and wide open spaces …'*

Right: UNDER THE LEMON TREES. *'I then delivered myself to the lemons in a delicious spot, and as I was painting, I was thinking of you. Imagine the courtyard of a Normandy farm; instead of apples, oranges and lemons, and in place of grass, Parma violets; the ground is absolutely blue; I am trying to render this.'*

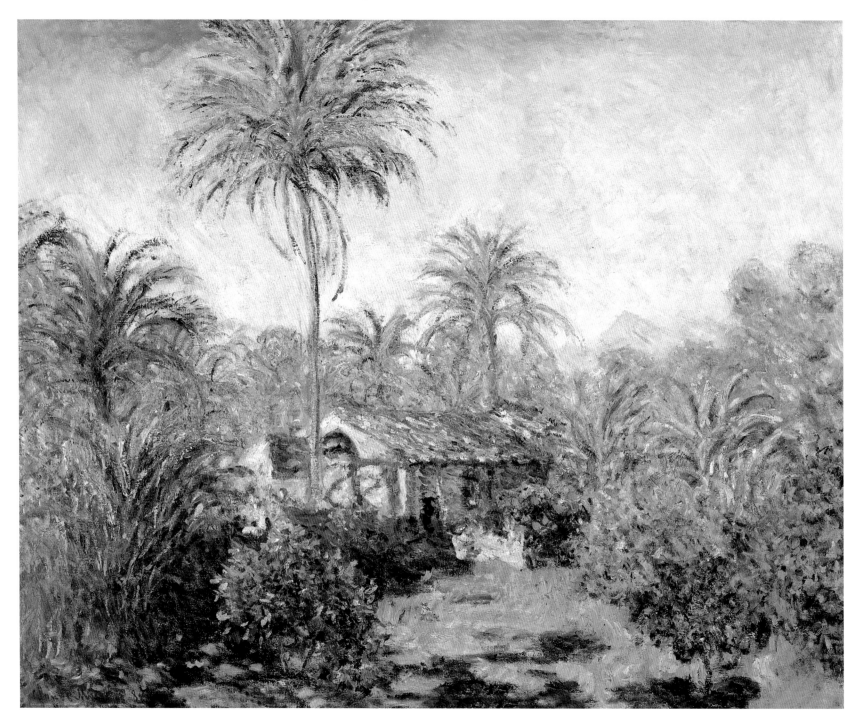

As he raced to finish, he sat on the street near Moreno's garden painting another villa 'dazed with fatigue, asleep on my feet', his burning desire to return home manifested itself in a near immolation. 'I was on fire without noticing it, doubtless a spark from my pipe, and my velvet waistcoat burnt like tinder. It was someone on the street who drew my attention to it, and the dangerous thing was that the fire was reaching my pocket where, *justement*, I had my bottle of alcohol. My waistcoat is in tatters – I will arrive home in rags and very dirty.' Then two days later, on 25 March:

I don't know if what I'm doing is any good, I don't know anything any more; I have worked so much, made such efforts that I am stupefied. If I had the means, I would like to erase it all and start again

as one has to live a landscape for a certain time to paint it; you need to work on it painstakingly, and with great difficulty to arrive at rendering it with confidence; but can one ever be satisfied in the face of nature and above all, here? Surrounded by this dazzling light, one finds one's palette very impoverished; art demands tones of gold and diamonds. Well, I've done what I could. Maybe, when I'm home it will remind me a little of what I've seen … Today, I did something in one *séance*, much better than what I'd worked over in fifteen *séances*, a delicious effect, and it is true that by virtue of toiling and searching, I am master of myself at present. If only I'd arrived in this country knowing what I know now!

The following day he had completed another three canvases:

I say finished, but still not as I want them. But if I stayed here for months it would be the same thing. The effects change, things grow quickly, and I can never be satisfied; it seems to me always that in starting again, I would do better … the truth is that I would like to leave all my canvases and start a new series of things which I think, it seems to me, I would do *à coup sûr*.

As a means of avoiding this temptation, he returned to his pension every evening with a canvas he deemed more or less complete; 'not that it is finished but I won't touch it again, and to be more sure of this I stuff it in a crate so as not to see it again until Giverny … afraid that as I am not entirely satisfied, I will want to give it yet another *séance*, and in my state of nervous anxiety it would not be *heureux*. I really don't know how I do this job. Going from one motif to the other, racking my brains to pour the most that I can of this light into my canvases … it's the work of a madman, and I am exhausted!'

The final few days of March brought 'the most disagreeable weather – neither grey nor sun but a terrible wind. I sat before the motif for hours without being able to apply a single brushstroke. I returned furious, and blinded by the dust. This is not a lucky end for this campaign and will compromise my *séjour* in Menton.' Just as he needed the most support, Alice started her recriminations again:

You will still persist in believing impossible things … these English have been very agreeable company for me and it's completely natural that I tell you so. I don't blame you for your suppositions; I understand that being separated you have suspicious thoughts sometimes, but these

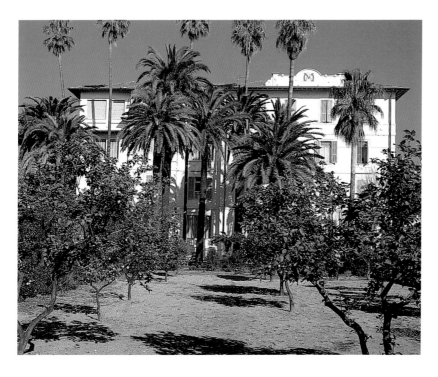

Left: SMALL COUNTRY FARM AT BORDIGHERA. *The farm at Bordighera, situated in a lower part of the Moreno garden. '… all the plants in the world grow there in the open ground without, it seems, being tended; it's a jumble of all varieties of palms, all types of oranges and tangerines.'*

Right: *The oldest palms in Bordighera today.*

must soon pass, or you don't understand anything. We are too close to the *retour* to enter into such *absurde* discussions. The truth is that I love you and love only you, belong to only you and can only be yours, but I am unhappy, and I don't know what I'll do tomorrow if the weather isn't magnificent. I am locked in this cursed room confronted by these canvases I can't seem to finish and which during these moments seem appalling to me, and less than nothing, and I know what efforts I've made to arrive at this poor result ... I am restraining myself on all fours, to stop myself throwing everything out, and pack my bags, pell-mell, and leave – it would not be reasonable to let everything go at the last moment but I'm not lucky and have a terrible thirst to be with you.

In the final days of bad weather, Monet worked indoors on a still life of lemons for Durand-Ruel's dining room. The pension was filling up with Germans – '*quelle sacrée langue*' – and an Englishman with his three daughters, 'who are very sweet but one of them is dying and will not leave here alive; it's atrocious to see, but apparently Menton is the refuge of the seriously ill'. As he put the final touches on his paintings of Moreno's garden on 1 April, Moreno's daughters and their husbands began to arrive – 'I still haven't seen *le bout du nez* of any of these ladies, but I have seen the little boy who is starting to come out into the garden.' Then at last he packed his bags and sealed his crates, all the while 'working on my lemons' and '*dans tous mes états*'.

On 5 April he finally left Bordighera to catch the train to Ventimiglia for Menton with all his luggage and four large crates of canvases – only to be asked by the customs official for his

certificate from the Italian Academy 'without which no paintings leave Italy as proof they have not been stolen from museums'. He was told he must go to Genoa, and present himself to the Academy with his canvases to have them inspected; the Academy would make a list of all their titles and subjects. 'I went into a black rage and was obliged to take the whole lot back Bordighera.' All he was permitted to despatch to Giverny was one 'crate full of clothes, shoes, vases, little pots, dirty linen, and pebbles, a notebook made of palm leaves, an old blanket' he had bought, 'which incidentally, is a very pretty colour'. He appealed for help to Moreno, who somehow arranged for Monet to present himself at the mayor's office and note down all the titles and subjects of the fifty canvases. He was absolutely beside himself.

I am in a state that is impossible to describe, and to make sure that none of the canvases can be substituted, and that I don't make off with a single Raphael, they put seals on each crate – and all this, doubtless, will be insufficient; so, to avoid the same officials at Ventimiglia, I am taking two cars and leave in one hour by the Corniche road in the hope that the Italian customs there will be satisfied with this, and if they don't let me through, one of the cars will return with the crates of canvases to Moreno's house who will take new steps, and I will continue on my way to Menton with my suitcases and paintbox.

'I have succeeding in passing *avec armes et bagages* by a miracle,' he reported to Alice the next day as breathlessly as a blockade runner who has succeeded in storming the border.

Just at the moment I left Bordighera, with my two

cars, which looked like I was moving house, one of the seals on the crate broke – impossible to raise the mayor on a Sunday – I was furious with the driver – I didn't want to leave – but he suddenly fell upon them and tore them all off telling me in his funny French that all this was a joke and that he would take charge of getting me through the Italian border and I wouldn't have to pay him, if my crates did not pass through.

Monet slipped through the border without incident and remained in Menton for ten days, where he painted half a dozen canvases of the sea which had so long eluded him, returning to Giverny on 16 April. 'I won't leave you again for a long long time,' he wrote to Alice before leaving, and he was true to his word. A year and half would elapse before he left Alice's side again for any length of time.

Right: THE OLIVE TREE WOOD IN THE MORENO GARDEN. '*One can walk indefinitely under the palms, the oranges and the lemon trees and under the wonderful olive trees, but when one seeks out motifs, it's very difficult ...*'

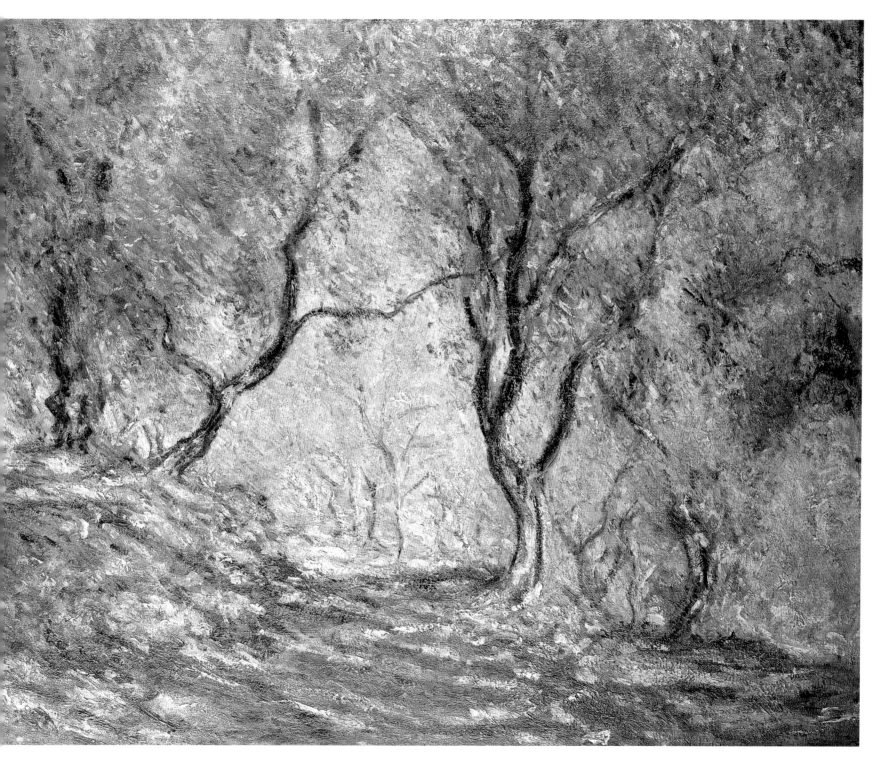

Etretat
Revisited

"I've decided to go off to the
seaside . . . I'll go to Etretat to do a
few beautiful marines for you . . ."

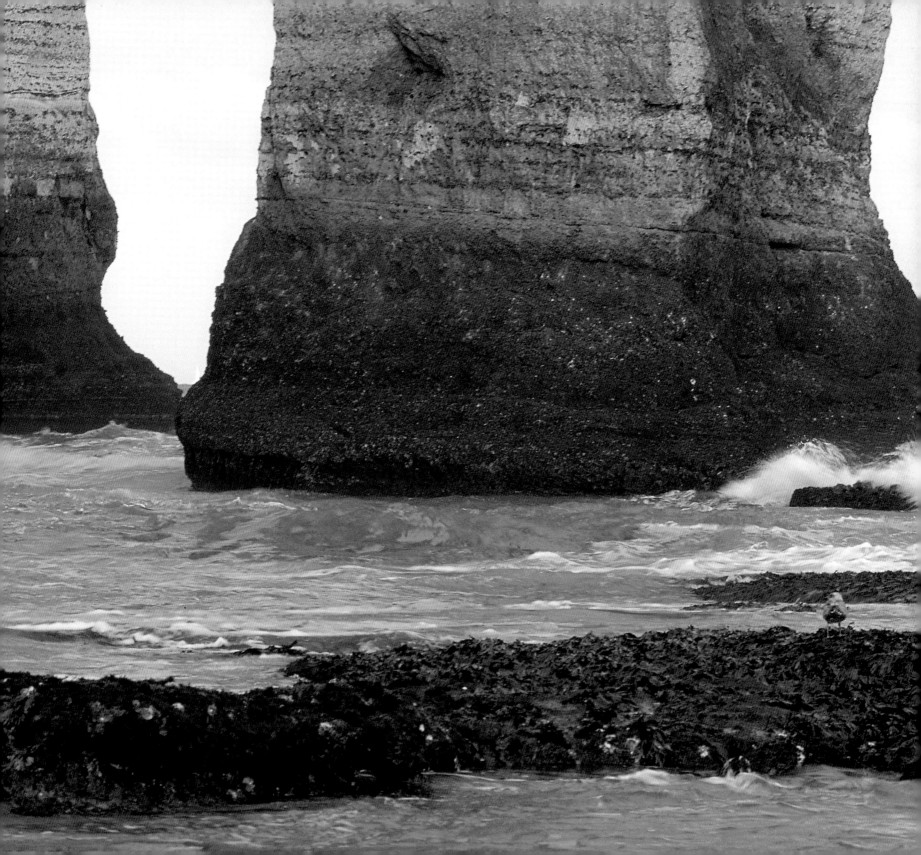

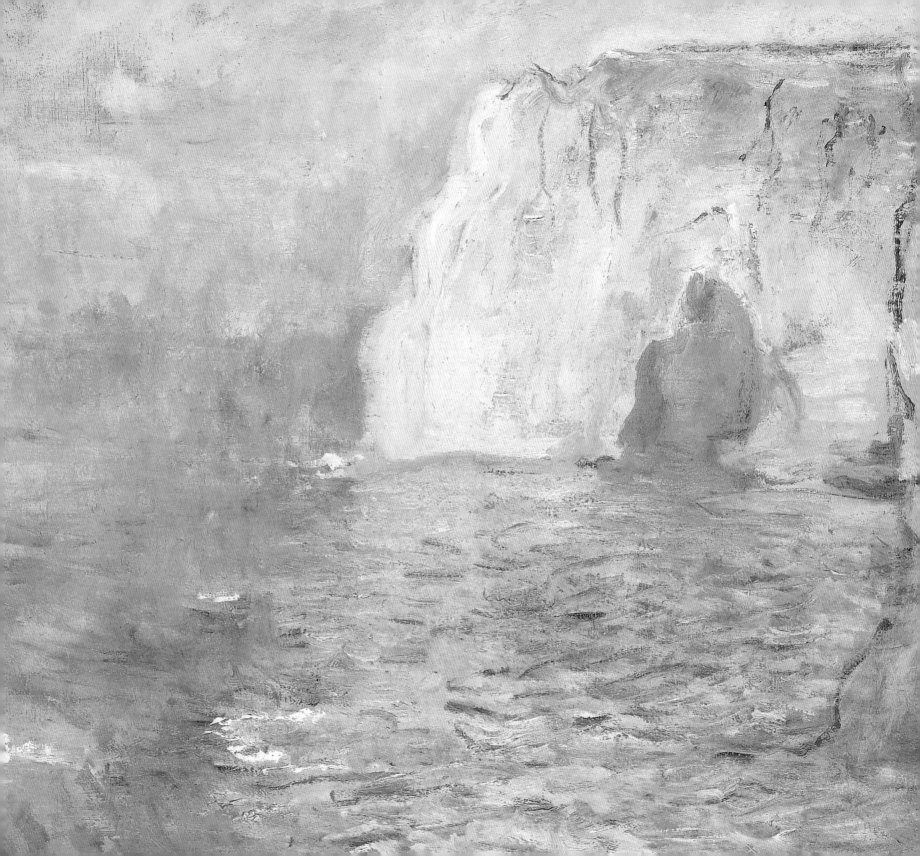

Previous pages: *If, as Maupassant suggested, the western promontory of the Porte d'Amont is like an elephant dipping his trunk in the water, the eastern promontory (shown here) could be likened to a set of elephant's feet.*

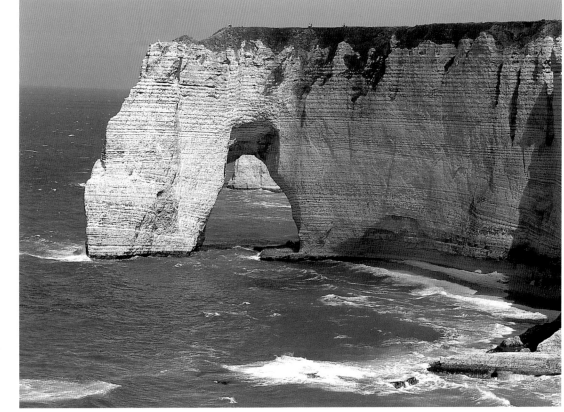

Right: *The Manneporte. 'This morning I went under the Manneporte to try to do this very beautiful motif of green water.'*

Left: THE MANNEPORTE, REFLECTIONS ON THE WATER. *Monet painted this from the top of the cliffs, some two kilometres west of Etretat, during the initial sunny days of his campaign there, using the pinks and blues of Bordighera. The rock known as the Needle is shown peeping through the arch.*

During the summer of 1884, Monet completed twenty paintings from his Bordighera campaign in his studio and, after sending them off to Durand-Ruel, took his family for a holiday by the sea, returning via Etretat to finish two earlier canvases, where he 'would have stayed if I hadn't had my children and if the weather had been good'. During 1885 he concentrated on rural and village scenes near home; Giverny in snow; and his first studies of spring poplars, summer poppy fields and late summer haystacks.

His financial situation at the end of the summer

of 1885 was lamentable, and although Durand-Ruel put on a brave and optimistic front, he had lost a lot of money on the stock market. Behind the scenes he was racking his brains as to how he could continue to finance and make a go of the Impressionists. He decided that Brussels and New York were his best options, and to that end moved heaven and earth to organize a huge exhibition of the Impressionists in New York for the following spring. Monet was less than enthusiastic. 'I have to confess I would regret seeing you go to the land of the Yankees,' he wrote sourly, 'and want to reserve my choice for Paris, as it's only there that there is still a bit of

taste left.' Durand-Ruel wanted more paintings from Monet, but Monet was having difficulty finishing anything and was 'wasting a lot of time touching and retouching' his Giverny scenes instead of 'abandoning them and starting new ones'. It was the same restless irascibility that had preceded his Riviera trip with Renoir.

Then, in September, having long promised his family an 'excursion', he was off again: 'I've decided to go to the seaside … I'll go to Etretat to do a few beautiful marines for you … I am leaving full of ardour … and this time will not make the same mistakes.' Monet took his whole family on a two-week holiday, as a guest of his early patron, the famous baritone Fauré, who put one of his houses at Monet's disposal. When Alice returned to Giverny with the children on 10 October, Monet moved into the Hôtel Blanquet, and over the autumn and winter of 1885–6 he confronted those staggering cliffs and a shattered personal life for the last time.

Etretat, in *fin de saison*, had emptied quickly, leaving Monet with the locals, the poet Guy de Maupassant and a young acolyte Marius Michel who followed him everywhere, for company. But no place was ever empty enough for Alice, who remembered a certain Madame Chaufferette she had noticed walking about and enquired as to her whereabouts. 'She is still here,' replied Monet, 'always out walking. I haven't met her; I only know she is the daughter of a marine painter and the wife of Achard from the Opéra Comique: she has a pretty bad reputation.' A woman of ill repute settled the question for Alice, who spoke no more about it.

With most of the hotel rooms vacated, Monet

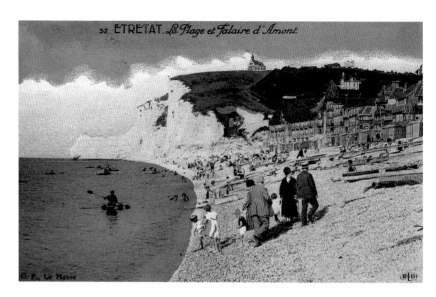

Right: *The curve of the bay of Etretat sweeps around to the 'elephant-like' Porte d'Amont promontory. Originally a fishing village, Porte Etretat grew popular as a holiday resort from the 1830s for holiday-makers, drawn by its fantastic chalk cliffs* (opposite), *promontories and sheltered bay – the only aspects Monet chose to paint.*

had the use of several windows, including one in the stairwell from which he could survey the panorama of beach and bay like a captain on the bridge of his ship. After a few days of initial rain, 'the sun shows itself radiant, and the sea calm … Etretat is becoming more and more stunning. It's *the* moment – the beach with all those beautiful boats, it's superb and I am furious that I am not adroit enough to capture it all. One would need two hands and hundreds of canvases.' Monet's paintings of the beach and cliffs of Etretat in those first few days sparkle with his hard-won mastery over the pinks and blues of Bordighera, and have a lightness and clarity that exceed even that of his Riviera paintings. But his real passion in his last study of Etretat was that of the big fishing boats, which were only deployed during the herring season. They were exciting because they were a new motif for him, and he spoke of them constantly.

The boats are getting ready for the herrings, the beach is transformed, very animated – it's very interesting … I have just watched the departure of the big fishing boats, all together; it's wonderful and I am going to treat myself to a sketch of it every day … Last night, the local population was in turmoil until one o'clock in the morning because of the storm which rose when all the boats were out and we waited up until they returned; it was very strange and very emotional.

Highlights of his autumn in Etretat unroll as a series of cinematic vignettes. Monet being driven across the sand at low tide to the Manneporte in a little oar-driven boat. Monet sitting painting on a cliff near the spot where the local grocer Lenoir was catching skylarks, 'of which there are heaps at the moment', offering Monet six for his lunch. Monet striding up and down the terrace of the casino by the light of the moon, trying to digest his dinner having made a real pig of himself: '*Quel repas, bon*

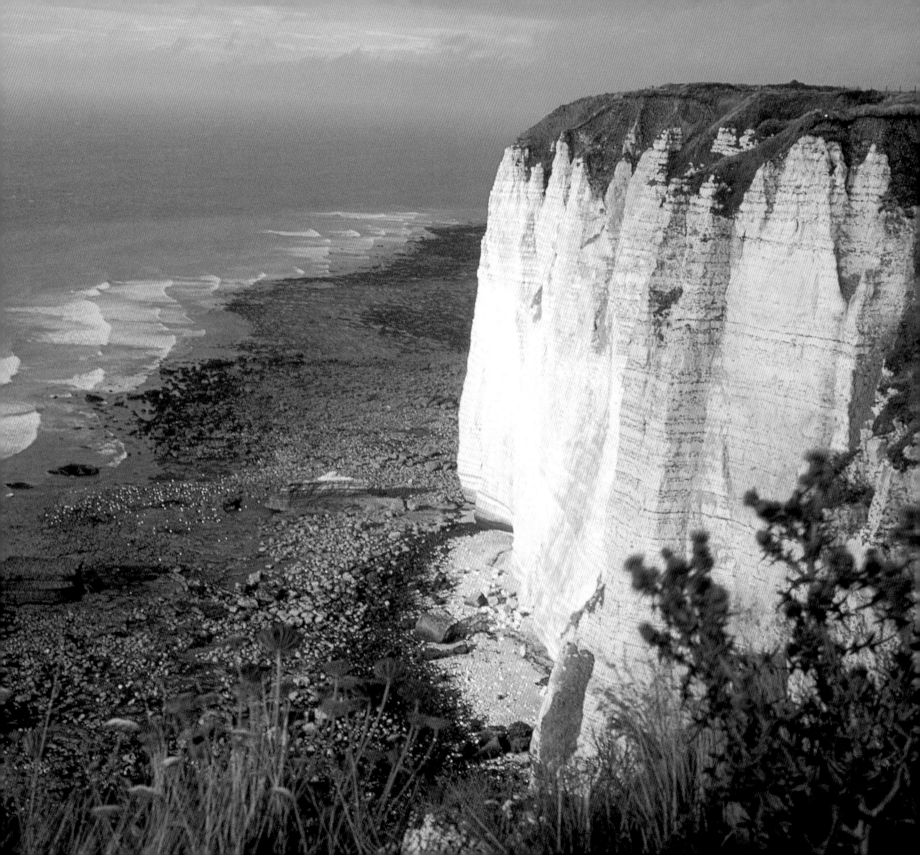

Dieu. A stunning *sole au gratin* and the exquisite goose, the whole lot went down – it's shameful to gorge oneself in this way … it's disgusting.' Monet showing Maupassant his paintings: 'he feigns enthusiasm but I am not convinced that he understands much about it. But the *Effect of Rain* absolutely stunned him.' Monet leaving the hotel three times in one day, setting up his easel and three times being driven back by wind and rain, and having to return. Monet sleeplessly tossing and turning in his bed, terrified that the pounding rain and gusting wind would bring the house down.

'You ask me how I occupy my time during bad weather,' he wrote to Alice. 'My God, it's very simple: I look all over the place for somewhere to work, and then go inside, go from one room to the other like a soul in torment, look for hours out of each window, then go out and get wet *et voilà* …' Going to bed at night must have been like pulling the lever of a fruit machine, wondering anxiously where the variables would fall and how he was going to make the best of the line up he would find in the morning: 'high tides, low tides, calm or agitated seas, grey skies or blue … and the boats never in the same place'.

The high jinks with the fishermen continued:

I was furious earlier on with these fishermen; they were supposed to go out fishing at four o'clock, and I had arranged to be there to do a sketch; I install myself on the shingles preparing the sea, and I wait; seeing them busy, getting ready. I stayed, but night fell without them leaving and I learned that with the barometer descending they are not going, whereas on the open sea one can see others leaving.

Alice was besieged by bills, debt collectors and bailiffs knocking at the door, all forwarded to Monet. He owed rent, long overdue, and knew that as soon as he was seen out and about in Giverny, his landlord would be threatening him with eviction if he did not pay up. The only way he could meet such a sizeable sum was to deliver work to Durand-Ruel, and so it became imperative that he concentrate solely on the motifs he could bring to completion; he was effectively exiled in Etretat for as long as it took:

The fishermen go out each day, but I can't take advantage of them unfortunately, I have so many studies to finish … there are only really beautiful things to do with this fishing and I can't look at it all without regret, but I resist. For the moment my ambition is to finish a few of my studies, as I feel them, my favourites, to finish as best possible the

others and finally to return to Giverny … **My time is spent wishing they will improve in the days to come, and I look sadly at my studies which could have gone so well … it's true that with a few good *séances* all these canvases could be turned round quickly … It is true that I love the sea, but I love you too, and would love to be near you.**

He needed canvases for another exhibition as well. Flattered by an invitation to submit work by the prestigious, avant-garde art Société des XX de Bruxelles, whose show was to open on 1 February 1886, he wanted to send five canvases showing himself 'under different aspects', as he had intended to do during the previous Etretat campaign. But how was he going to do it? 'Me who has so few things and I will have to give so many to poor Durand, whom I have made wait for so long.' There was an even more worrying

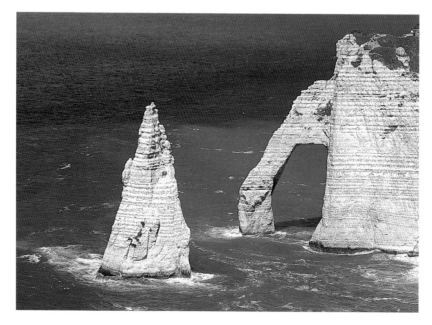

Left: *The Porte d'Aval, the Needle and the 'beautiful green water' in high tide, in summer.*

Right: THE ROCK NEEDLE AND THE PORTE D'AVAL, *painted from the direction of the Manneporte on a winter morning. 'One needs so many things to find one's effects again, with the tides high or low, calm or agitated; never, I think, have I had so many difficulties, such variable weather.'*

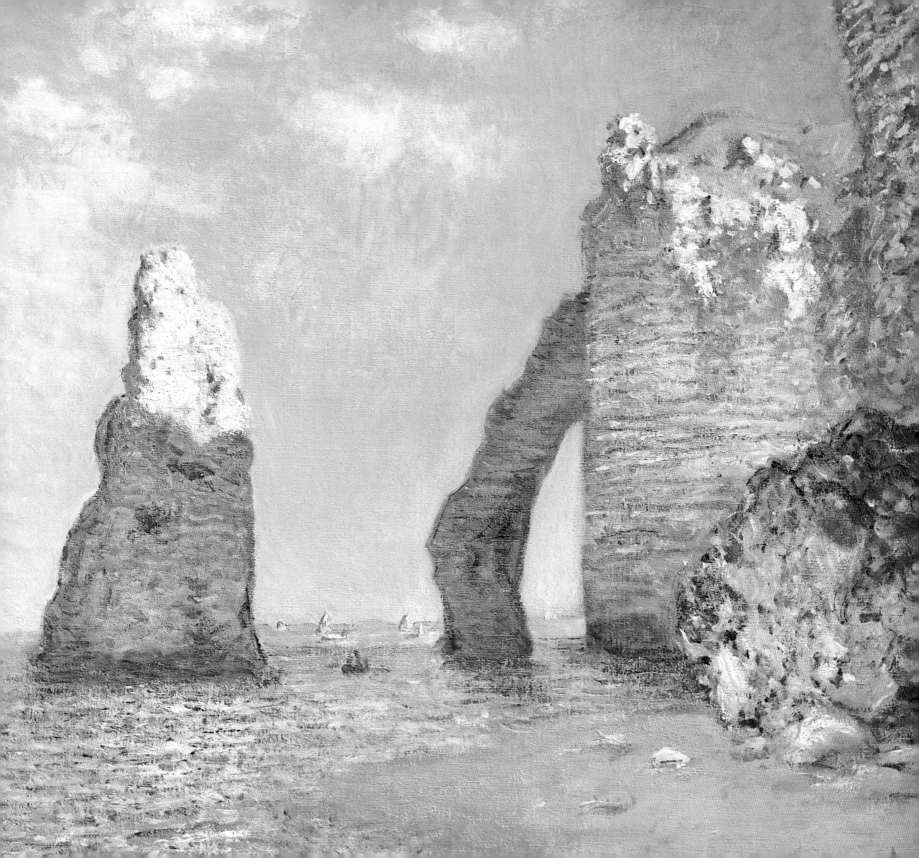

crisis: Durand-Ruel was embroiled in a law suit, having publicly denounced another dealer, Goupil, for selling fakes. Pissarro, Renoir and Monet all saw bankruptcy at the end of it for Durand-Ruel, which would mean total catastrophe for them. 'In your shoes, I would let them get on with their affairs and get on with my own without worrying about their fake paintings,' Monet advised his dealer. Worse still, Monet heard that Durand-Ruel was selling some of his paintings at a loss in order to raise cash to keep him going. 'You have put such effort into pushing the prices of my canvases up and now you let them be sold for less than you paid me for them. Please excuse me, but I don't find that logical … I see we have not reached the end of the struggle, *hélas* …' 'My God,' he wrote to Pissarro, 'what a life we lead, and when will we have *la vie tranquille*? Painting is difficult enough without all these worries.'

As 14 November, Monet's forty-second birthday, approached, complicated discussions were under way in his correspondence with Alice as to where it should be celebrated. Should she come to Etretat or Monet to Giverny? In the week leading up to his birthday, it turned into a running gag with Alice promising daily to come to Etretat, and daily failing to show up. With no other women in deserted Etretat to worry her, she found other reasons to be vexed.

Left: *The shingly beach where Monet experienced some of his happiest and also most difficult hours, 'wishing', he said, 'that the cliffs would crush me'. The cliffs could be as warm and inviting as they could be sinister and foreboding, mirroring Monet's emotional states, which swung like a barometer from sunny euphoria to dark despair.*

Isn't it funny [wrote a confused Monet] that while I think so tenderly of you, and demonstrate this as best I can, you remain in your dark thoughts. Every day I hope for you, and you tell me that I would prefer to come rather than to have your visit … I don't dare raise your hopes of me going to see you, especially when the weather is *passable*, and I am afraid that in leaving here there would be a fine sunshine, whereas if you came here, I could always work; in coming to you I lose the day of departure, the day of the return, and the time at Giverny. I have lost so much time that I think and hesitate, in spite of all my desire …

'Decidedly,' he wrote two days later, 'I just can't make it out. What to do and what to say to you? Every day I hope to see you arrive, and every morning it's a fresh disappointment. If you are unsure that you will make me happy in coming, I don't know what else to write to you. I spent my whole day hoping for you, as they say here. *Bref*, I have telegraphed you and I am absolutely counting on you tomorrow.' For all his ardour, Monet could not resist adding: 'tonight the fishermen brought in 200,000 herrings'. The next day dawned yet no Alice materialized. 'So,' he told her that evening, 'finally, you will be here tomorrow. It's not without chagrin, I had so hoped to have you today, but this morning I receive your *dépêche*; new disappointment … Today I worked well, better than usual; maybe it's the joy of having you here tomorrow.'

Alice finally arrived on the eve of Monet's birthday and the couple, free from parental cares, delved into a tryst of three idyllic days. On her return to Giverny she wrote him a letter of such intimacy that she asked him to destroy

it. Monet read it over and over, before regretfully complying. 'I too was very happy with those three happy days and hope for many more.' Buoyed by her visit, he painted with *élan* over the next few days. 'This morning I went under the Manneporte to try and do the very beautiful motif of green water; I want to make a success of it because it's very beautiful, but very difficult I think. I've had a good day, all told; I even did the departure of the boats which have just left … a thousand *tendresses* and kisses to the children, and thank you again for coming to see me.'

Ten days later, Monet nearly drowned.

In spite of the gusting winds and a furious sea, but also because of them, I was counting on doing a rich *séance à la* Manneporte, and I have had an accident: do not be alarmed, I am safe and sound, since I'm writing to you … I was working in full spate, under the cliff, well shielded from the wind, in the spot where you came with me; convinced that the tide was going out, I was not frightened by the waves which lapped a few feet away from me. *Bref*, completely absorbed, I did not notice the enormous wave, which suddenly threw me against the cliff, and I fell into the foam, with all my kit! As the water held me, I immediately thought myself lost, but finally I managed to crawl out on all fours, but in what a state, *bon Dieu*! My boots, my huge stockings and coat soaked; my palette, which had stayed in my hand, had slapped against my face and my beard was covered in blue, in yellow, etc. *Mais enfin*, now the shock has passed, it's nothing, the worst of it is that I lost my broken canvas very quickly as well as my easel, my bag, etc. Impossible to fish anything out. *Du reste*, it was crushed by the sea … *Enfin*, a lucky escape,

but how infuriated I was to find myself unable to work once I'd changed, and my canvas, on which I was relying, lost. I was furious. I telegraphed to Troisgros to send what I was missing and to make a new easel for me for tomorrow. The cause of all this, as I am very prudent, and never go out without checking the exact hour of the high tide, is that, having seen the agenda in the hotel which gives the times of the tides, I didn't notice that yesterday's sheet hadn't been torn off, so that the tide was coming in rather than out, as I was convinced it was.

He had not caught cold because 'wet as I was, it was a heavy load to carry'. Weighed down by his sodden clothes, he found that the effort of ascending the 'stair' of the cliff kept him warm. Afterwards though, with only a summer jacket and no sweater or stockings, he was cold, and 'I was so upset by it all that I had a fever all night and couldn't sleep, with nightmares, I who never have them.' He sat at his hotel window painting with his three remaining brushes until reinforcements arrived: 'but *mon Dieu*, this wretched painting only gives me trouble and what a job I do, because no one realizes the efforts I make, even for so little result'.

November slipped into December. 'I am working hard, but as you know, I can never be satisfied with myself *in situ*.' As bad weather was forecast, Monet returned to Giverny for a week, bringing with him his Etretat canvases, to see them 'elsewhere'. He could not tell if his paintings were good or bad until he saw them in his studio, as entities in themselves, in their frames and hung on the wall. So imagine his horror when he went to Paris that week and

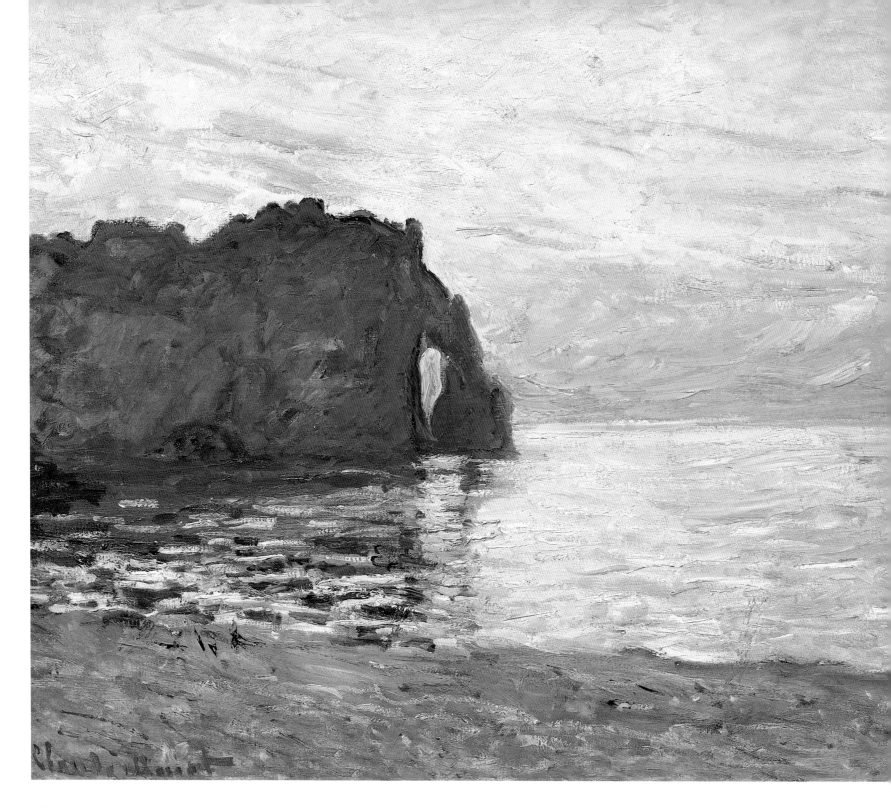

48

called in on the dealer Georges Petit, who told him that one of Durand-Ruel's enemy dealers, as an act of revenge, had asked Petit to sell him his Monets in order to strip off their frames and hang them in a sale 'naked'. It was considered the ultimate humiliation. These mafia-style tactics in the dealer wars in which Durand-Ruel had become mixed up only spelt disaster for the very painters he was meant to champion and Monet perceived Durand-Ruel with his wars and his plans for America as a sinking ship that would bring everyone down with him.

Petit reassured Monet that he had refused the offer, but, in a sort of blackmail, made Monet an offer Monet himself was hardly in a position to refuse. He told Monet that he would buy several paintings from him immediately, and invited him to participate in his sixth International Exhibition on the condition that none of the paintings Monet entered belonged to Durand-Ruel. In what is widely regarded as a betrayal, Monet, at his wit's end with financial worry, accepted, thus compromising Durand-Ruel's chance of a sale.

On Monet's return to Etretat a week later, the weather was filthy, the beach and his boats were covered in fishing nets, and he learned, as he had feared, that the weather had been splendid after his departure. '*Bref*, I would have done better to have stayed another two days with you, and I would have done better still to have stayed here because work was most pressing.' He went for a walk 'to revisit all my motifs' and returning to the hotel looked at all his canvases. 'It is certain that if it were fine I could wrap this up quickly because this break has helped me see their faults as well as their qualities.' But the

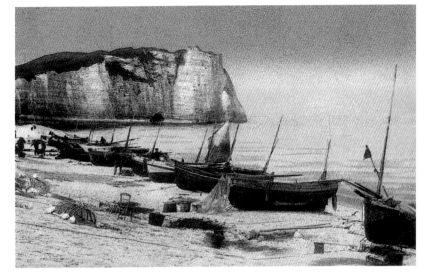

Opposite: THE FALAISE D'AVAL AT ETRETAT, SUNSET, *painted from the terrace of the casino.*

Right: *The cave of the Trou à l'Homme is clearly visible. When the tide was low and it was windy, rainy or stormy, Monet painted from inside the cave, which offered a sheltered view of the bay of Etretat and the Porte d'Amont.*

sun had sunk quickly in the winter sky, and he saw 'with terror, that the sun no longer falls on my Manneporte – thus there will be canvases impossible to finish … Here they are forecasting snow, which would be the limit.' Although the sun shone the next day, 'I won't, I fear, be able to save many canvases, so changed is the illumination of the sun. This certainly will not be a good campaign.' On the night of 9 December, 'the whole town was woken up by terrifying gusts of wind: thunder, hail, the whole works … frost in the morning, and by two in the afternoon it was snowing.' All Monet could think about was that he should be in Giverny completing his snow scenes.

If this continues I am going to throw in the towel here; if a few of the canvases are worth the trouble, I will return to finish them in March … I am absolutely disgusted, in the few days since I've been working again. I've done nothing but rubbish, it's a wasted journey; everything has

changed and the days fly by, too short, and yet I need more canvases than ever, and very good ones, for Durand, for Petit and Brussels. *Enfin*, if we have a beautiful winter I could possibly make up for it. But what a lot of trouble for nothing. You must find me very tiresome, it's true, but I am worn out… all this trots unceasingly round my mind and torments me, exacerbated by having worked so badly.

Finally on 13 December Monet cut his losses and returned to Giverny to finish what was finishable in his studio and delivered a dozen paintings of Etretat and Giverny to Durand-Ruel, in the new year. To Monet's astonishment, Durand-Ruel immediately asked for more. Bewildered, Monet could not understand why.

But do you need quite so many for America? You must, however, have a huge quantity. It is true to say that you conceal them well, as we never see them, which in my opinion, is a shame … It's not

that I don't want to give you any – if I had some I'd give them to you, but I wouldn't be cross if you exhibited them. For instance, my Italian canvases, which are unique amongst those I've done, no one has seen them and what has become of them? If you take them to America they will be lost to me here. *Enfin*, no doubt you have your own ideas, but ... you must understand that it's worrying and a little hurtful for one's *amour propre* to be always producing only to see one's work vanish.

Monet wanted recognition in France, and feared that in being taken to America he would disappear from the eye of the French public, the 'vitality of our business affairs' compromised. 'I would like to believe in your hopes for America ... but I fear that once you have been there, we will be forgotten here, and I would like you to have here new things, always new things of ours.' Durand-Ruel finally admitted that he had had to borrow the money to pay Monet for his paintings, and that many of these paintings were sitting in a vault as security to guarantee these loans until he could repay them.

The land- and seascape of Etretat, which Monet had begun to paint at the age of twenty-four, full of idealism, of real excitement, found him twenty-two years later on the same shingly beach, painting the same chalk cliffs, and asking himself what it was all for. The journey from illusion to disillusion had been cruelly played out across the sweeping curve of this bay. His recent work was locked away, effectively pawned, to finance even more paintings Durand-Ruel could find no market for in France. Potentially, the only way out of this ludicrous conundrum was for his paintings to be taken thousands of miles away, sold if he was

lucky, only to vanish in the bowels of what was to Monet a vast anonymous hinterland. What was even more ironic was that in February 1886 he found himself in Etretat in the same circumstances that he had experienced in Etretat during February three years before, obliged to bow to Hoschedé's marital and patriarchal prerogative over his wife and children.

It was customary for Hoschedé to celebrate Alice's birthday *en famille*, and Monet, who avoided contact with Hoschedé, had resented having to leave Giverny before his arrival. Monet and Alice rowed over this, and this time talk of separation was serious. Knowing that Hoschedé – backed by Alice's family and her daughters, especially Marthe, who feared that their marital prospects would be compromised by this flagrantly scandalous liaison – would press for the return of his family, Monet was jealous, afraid, and felt excluded from the family circle which, after all, included his own two sons. He arrived for the final leg of his Etretat campaign on 19 February, the day of Alice's birthday, 'completely annihilated'.

I hope that you were well celebrated, and that this has put a bit of balm on your heart; forgive me all the hurt I cause you in spite of myself; pity me because I am *bien malade* and think that I love you. It's horrible weather, very melancholic; I have not had the heart to unpack my crates ... when I entered this sad little room, I was grounded; I couldn't sleep, pursued by my sad thoughts and horrible nightmares. Today I walked all day in the room, so as not to see anyone and to tire myself out a bit ... and you, what are you going to write me? ... You ask me to think it over and make a decision; *hélas* this is exactly why

I'm in the state I'm in, I think of nothing else, weighing the pros and the cons. I can't, like you, take in the idea of a separation; I think of the children whom you love and who love you, but I also see all that divides us and will more and more divide our life together which I had thought so peaceful. *Allez*, I am very unhappy, very sad, disheartened; the painter in me is dead.

One of his friends in Etretat, with whom he often dined, had asked to see his canvases. 'I have had to unpack all my crates, and I find my canvases even more awful than I thought, and yet I will have to finish one or two, bad or not, for this unhappy Durand, for *enfin*, one must, in spite of my state of mind and my sorrow, one must make money, *hélas!* Anticipating an endless round of family celebrations at which Hoschedé would rightfully preside as paterfamilias, Monet was so demoralized that whatever decision Alice made,

I am lost, our life together upset for ever, and to live without you is not possible for me ... if I see the causes for the pain without finding a solution, it's because there isn't one. Your letter on Sunday puts our situation in a nutshell, your joy in the happiness and success of your daughters, etc. etc. but as you say, I don't have the right to share your joys; all the pain is there, and I am not allowed to see you all, to be proud of you, *non*, this is not for me. I knew it very well, at the start of our love, that I had nothing, nothing to say about all this, but after all the years we have lived side by side, this is hurtful, and will only get worse, I know what I will have to suffer ... tomorrow, I will have been here eight days, what painful days; working would be impossible for me, even if the weather was fine. Tomorrow I am going to pack my bags,

ready for any eventuality, depending on what you have decided …

Two days later, Alice, having turned all the tables on Monet, now set them all up again:

It has done me good, as I was anxious to know your decision, seeing you so resolved. *Hélas*, it doesn't change our situation. I am willing to attempt to try once more, not having the strength to live without you, but I can't say I will return a happy man. I have suffered too much all this time and my mood is still sombre; it's for you to take courage and support me in my good and my bad moments; don't reject me, as I am more in need of care than reproaches. You are kind to want

to come and find me, but you will not find in me what you think; the Monet of the past is dead, I feel it; if he resuscitates, it will only be little by little … if I spent one or two days with you, I would become illusioned once again, thinking you were mine alone, when on the contrary I have to persuade myself that you will become less and less mine; *enfin*, I will try to take courage … tell yourself that I love you, and certainly more than you think.

Monet never opened his paintbox during these two miserable final weeks. 'I have so little heart to work that I don't dare touch any of the canvases.' He returned to Giverny early in March, never to paint Etretat again. Two weeks

later, Durand-Ruel sailed to New York with forty-eight of Monet's canvases on board; and with that, Monet's fortune was to change. This was not a ship destined to sink.

Left: *View of the bay of Etretat taken from the beach. 'It is true that I love the sea, but I love you too, and would love to be near you.'*

Holland

"I have come here invited by a
 gentleman . . . who wanted to
 show me the floriculture here,
 enormous fields in flower . . ."

Monet's garden looked much the same in the
spring of 1886 as it had in the spring of 1883
when he moved in. Monet had made a potager,
and had dug and planted borders around the
house and the poultry yard. But the rest of it
remained as it had been conceived: an apple
orchard bisected by a long pair of double
borders known as the Grande Allée.

In the seven weeks between his return from
Etretat in March and his short trip to Holland
in late April, Monet painted this garden orchard
for the first time. The following spring, it was
not the orchard he painted but a long border,
mass planted with peonies and tree peonies, and
by the winter of 1888, what he called '*les grands
agrandissements*' were under way in which
substantial portions of his orchard areas were
dug up and replaced with geometrically
arranged long and short rectangular beds.
The timing, the layout and the planting of
the Giverny garden all point to the influence
of the Dutch bulbfields.

Monet was invited to Holland by the newly
appointed Embassy Secretary in the French
Delegation at the Hague, Baron l'Estournelles
de Constant, through a mutual friend, the
collector Charles Deudon. Aware of Monet's
love of gardens and landscape, Deudon
thought the Dutch bulbfields offered a perfect
combination of the two and arranged the trip.

Monet arrived by overnight train on 27 April,
greeted by the Baron, who was as excited by the
novelty of this coloured landscape as he was
about showing it to Monet: 'I have come here
invited by a gentleman whom I didn't know,
a friend of Deudon's, an admirer of my work,

who wanted to show me the floriculture here, enormous fields in full flower …' wrote Monet in the only surviving letter of the briefest of his campaigns.

Monet stayed only twelve days. He was familiar with the light, having painted there twice before. He had sought refuge in Holland in 1871 from the Franco-Prussian war with Camille and Jean, settling in Zaandam to paint windmills, canals and boats throughout the summer and autumn. 'There's enough here for a lifetime of painting,' he wrote to Pissarro. He had made another brief trip three years later to capture canal scenes in Amsterdam, but he had not seen the kaleidoscope of colour that stretched for hundreds of acres across the sandy silt soil of the low-lying polders, reclaimed from the sea.

Travelling northwards from the Hague by steam tram, Monet set up his easel in Sassenheim, halfway between Leiden and Lisse. There, a magical technicolour carpet unrolled itself across an entirely flat vista to the horizon, punctuated only now and then by a farmhouse, a windmill or a canal. It was a stylized landscape whose serried ranks of thousands of rows of tulips, narcissi, daffodils and hyacinths had been planted with military precision into long strips of pure colour. He was dazzled. The scale, scope

Previous pages: *The technicolour carpet. The long streaks of purple hyacinths remind one of the long lines of aubretia which edge the borders of Monet's garden in spring.*

Left: *Dead-heading the tulips to strengthen the bulbs.*

Right: *Monet planted his iris beds in long concentrated blocks of colour.*

and vibrancy both enchanted and challenged him: 'It's wonderful but maddening for a poor painter; impossible to render with our poor colours.' No painter had ever attempted to paint with this palette before and the lessons of Bordighera were of no use to him here.

Blessed with stable, sunny weather, he completed five canvases within a week, all of which were immediately sold two months later. 'The [paintings of the] tulip fields near the Hague,' wrote his biographer, Gustave Geffroy, 'are meadows of flowers tightly massed, growing flush to the soil, resplendent in their

Above: BULBFIELDS AND WINDMILLS NEAR LEIDEN.

Right: *Visitors to the famous Kukenhof garden near Lisse look out from a preserved polder windmill to the inspiration for Monet's garden borders.*

variegated blossom of fiery greens, of golden yellows, in purpled reds and of vermilion. Each flower loses its distinct shape in these prodigious masses, only contributing to the streaks of colour of these luminous furrows which run off into the distance.'

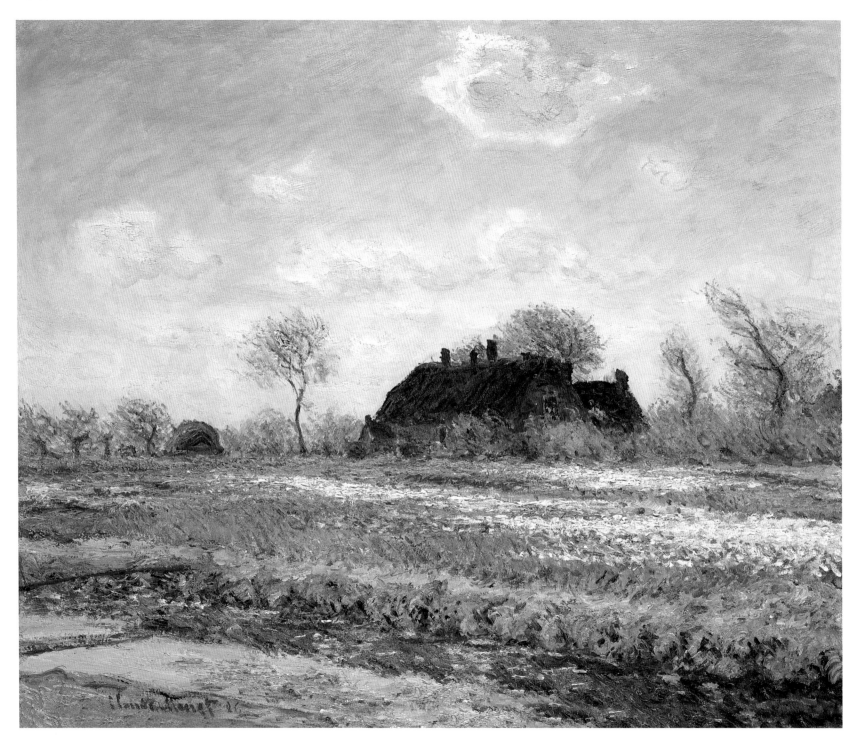

One of the five canvases was bought by Winnaretta Singer, American heiress to the Singer sewing-machine fortune, who caused a stir by winning it over a rival bidder, the Prince de Polignac, who had also been desperate to acquire it and was much vexed. 'I cursed her execrable name!' exclaimed the Prince when he recounted the story to Marcel Proust. 'But several years later, I married her and thus came into possession of the picture.' It was hanging on the wall of their Paris salon when Proust visited them. He later recalled: '… what delightful hours. The sun fully illuminated the most beautiful painting of Claude Monet that I know: *A Field of Tulips near Harlem.*'

The symmetry and uniformity of colour of this surreal mosaic closely resembles the fabric of Monet's flower garden. He distilled and adapted its structure and planting using long rectangular borders in which he counterpointed, harmonized and concentrated the colours of his flowers, most famously with his iris beds, but also with gladioli, delphiniums, dahlias, asters and campanulas, edging them with a long hem of aubretia or shorter irises; in the shorter rectangular borders known as the paintbox beds, he experimented with massing all kinds of flowers to study their effect before moving them into his main borders.

Monet's journey to Holland may have been brief, but it remained so vivid in his mind that the art critic the Duc de Trevise recounted that thirty-four years later, whilst he was walking around Monet's garden with him, Monet spoke passionately on only two occasions, one of which was when he talked about how much he loved the uniformity of the tulip fields in Holland,

and of another fleeting impression which had struck him there: '… when the flowers are picked in full bloom, and thrown into a heap and in the canals one suddenly sees yellow patches floating like coloured rafts in the reflection of the blue sky …'

Monet never revisited Holland and today everything save the fields themselves has changed. One of the spots where Monet set up his easel is now beside the Rijnsburg motorway; the windmills he painted have been pulled down, and glasshouses and houses have been erected across the fields he painted. Even the piles of tulip heads are kept well away

from the canals. But this image too found its way into his garden, where you will find it in the rafts of water lilies floating on the reflected sky of his pond.

Opposite: TULIP FIELDS. *Monet found the image of the rafts of dead-headed tulip blossoms floating along the surface of the canal in the reflection of the blue sky particularly enchanting.*

Below: *To keep the water clean, the tulips are grown further away from the canals, and are no longer piled up along their banks as they were in Monet's time.*

Belle Isle

"I am in a superbly wild place, amongst a heap of terrible rocks and an unbelievably coloured sea."

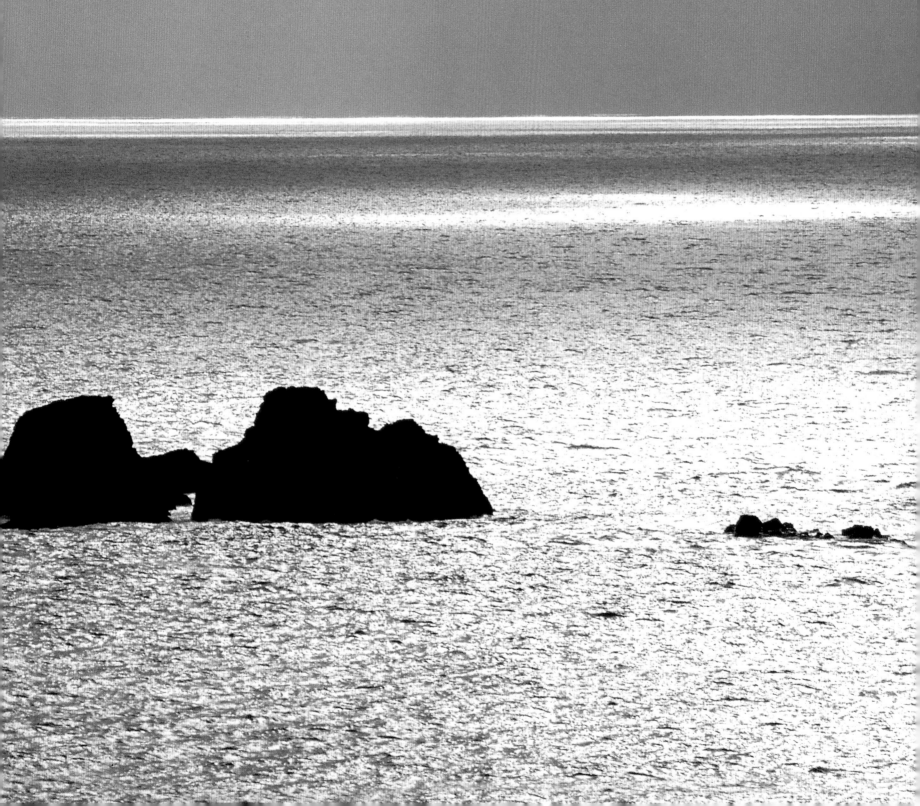

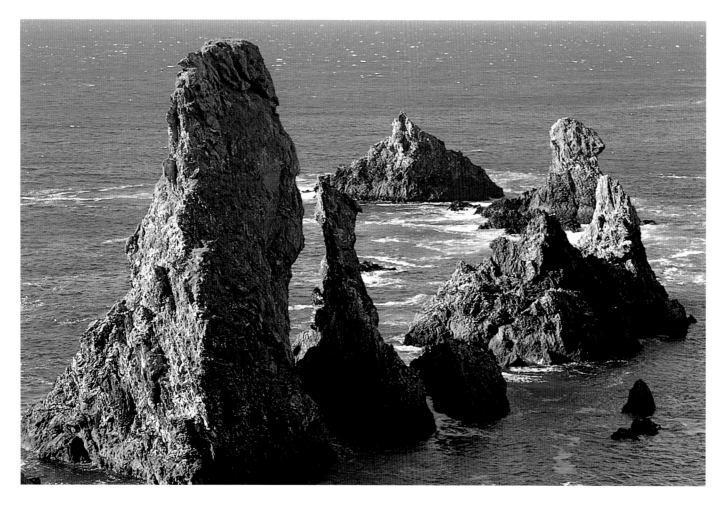

Previous pages: View from the Côte Sauvage, which Monet called 'La Mer Terrible', on the western coast of Belle Ile en Mer, looking across the Bay of Biscay to the north Atlantic Ocean and to New York.

Left: *The Pyramids of Port Coton. In Normandy, rocks like these were called Needles but in Brittany they were called Pyramids.*

Right: PYRAMIDS AT PORT-COTON, ROUGH SEA. *'His talent was able to conquer this granite earth and these redoutable waters. For the first time, that terrible sea found its painter and its poet.' – Geffroy.*

Monet and Alice's relationship, which was hanging by a thread while he was in Etretat, had been soldered together since his return, and they seem to have made a pact not to destroy each other when they were next apart for a long time. Monet had sold well in the Société des XX exhibition in Brussels, Petit's sixth International Exhibition had attracted *le tout* Paris and Durand-Ruel was encouraged by the sales in his spring exhibition at the American Art Galleries in New York City to talk about returning to

America. After his short trip to Holland in the spring, Monet painted very little, held up by the weather and by Alice, who was ill; he regarded the summer of 1886 as a *'saison manquée'*.

He had planned, after accompanying Alice and one of her daughters to take the waters at Forges les Eaux on the Seine, to return to Etretat in September for some final retouching. But when the time came he could not bring himself to go back there. Perhaps the thought

of it made him sick, for he suddenly turned up on Belle Isle, an island off the coast of Brittany. 'I have just arrived here,' he wrote to Durand-Ruel on 12 September. 'This will surprise you, as you must be thinking of me *en plein travail* at Etretat. I found myself so unwell on my return from Forges les Eaux that I could not make up my mind to go there, and as the days passed, I suddenly decided to make my famous planned trip to Brittany.'

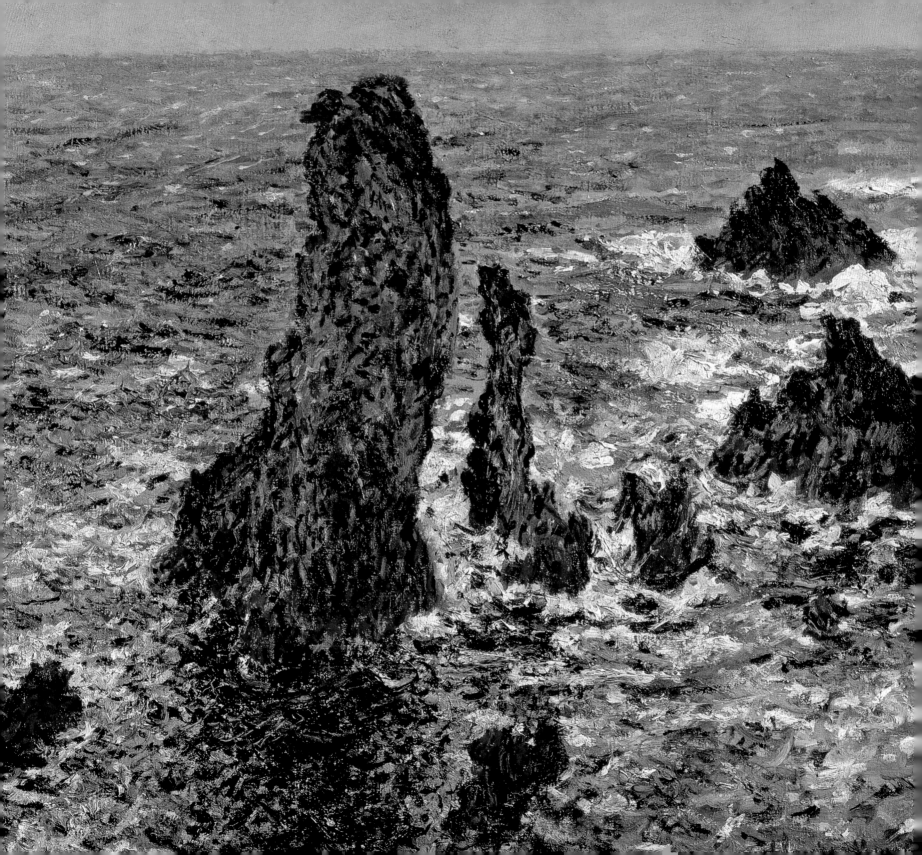

Left: *Woodblock print by Katsushika Hokusai from* THE THIRTY-SIX VIEWS OF MOUNT FUJI *in Monet's collection in Giverny. The rocks of Belle Isle are usually compared with Hiroshige's rocks thrusting out of the sea, but in this image the momentum of the wave also rises out of the water like a rock, expressing the tremendous force of water.*

Opposite: *Detail of the photograph on page 62.*

He was familiar with the Channel, acquainted with the Mediterranean; now the wild Atlantic rollers beckoned. He had been toying for some time with the idea of going to Brittany, inspired in part by Renoir, who was painting near Dinard and enthusing about it, and by Boudin, who had also painted there. His plan was to access the opportunities offered by Belle Isle, visit his friend, the writer and critic Octave Mirbeau, who had rented a house in Noirmoutier in the Vendée, and from there conduct a reconnaissance trip along the coast to St Malo, 'until I find the place which will grip me', and where he would return at a later date to paint.

Once in Belle Isle, Monet lost no time in making the seven-kilometre crossing from the port of Le Palais on the east of the island ('not the interesting side') to the west, where its most famous stretch of scenery, a rugged, jagged strip of sea and rocks less than a kilometre long, squarely faced the infinite reach of the Atlantic. It was known as the Côte Sauvage or 'La Mer Terrible', and, said Monet, 'it's aptly named, not a tree for ten square kilometres, rocks and wonderful grottoes; it's sinister, diabolical, but superb, and thinking I won't find better elsewhere, I want to try and do a few canvases there …'

Monet found lodgings near by, in Kervilahouen,

a hamlet comprised of a handful of fishermen's cottages: 'I have found a clean room with a fisherman who runs a little bar and who has agreed to cook for me, all of it for four francs per day; I think I will only live on fish – lobster mostly as the butcher comes once a week and the baker too – *enfin*, I can't demand the cuisine of the Café Riche.' He had alighted on Belle Isle, as he had in Etretat the year before, like a migrating bird on the tail of a late summer thermal:

Since my arrival I have not seen a cloud, and it's terribly hot; also I couldn't resist bathing (without a costume) in a delicious spot in extraordinary water – the water of Etretat is mud by comparison. I hope that this weather lasts, because according to what they tell me, when it is bad, the waves are so awful it is impossible to approach the rocks, so I wouldn't be able to do anything, but even so, it must be jolly beautiful. The whole coast is filled with extraordinary seabirds, and in front of every house there are tame ones; as for the fish, there are all kinds of varieties, and excellent ones we don't know, but what dominates is the lobster …

No sooner had our naturist installed himself in his new lodgings, lunched and set off to paint,

than it clouded over – 'this start was enough to change the weather' he noted wryly – and he found himself embarked on a rustic adventure which 'couldn't be more primitive'. He reported to Alice after his first night:

My only neighbours are hundreds of rats and mice who make such a racket above my head in the granary that I had a hard time getting to sleep, and a pig who is below my room; you can smell it from here. As for reading, it is very difficult because I only have one candle as light, but I will have candles bought for me at Le Palais, as I am obliged to write during the day ... This morning it is raining. I hope it won't last, as that would be lugubrious in these conditions; besides, I don't want to immortalize myself here, fifteen days at the most, the time to do two or three things ... as it's not raining much, I am going to have lunch and then start something else in grey weather; maybe that will bring the sun back.

The bravura with which he announced, yet again, that he could polish off a brand-new landscape in a fortnight seemed necessary for a confident launch, however unrealistic. It was all the more audacious because in the first week he had no porter, and was obliged to carry his easel, canvases and paints himself, which was not only exhausting but also severely restricting in terms of the number of canvases he could carry. Yet he remained optimistic, predicting that 'a dozen days will suffice if the weather doesn't change too much because the tides', which had given him such problems in Etretat, 'don't alter much as the sea is so deep along the coast'.

He was not as 'all alone in a lost corner of the world', as he imagined. 'In the neighbouring

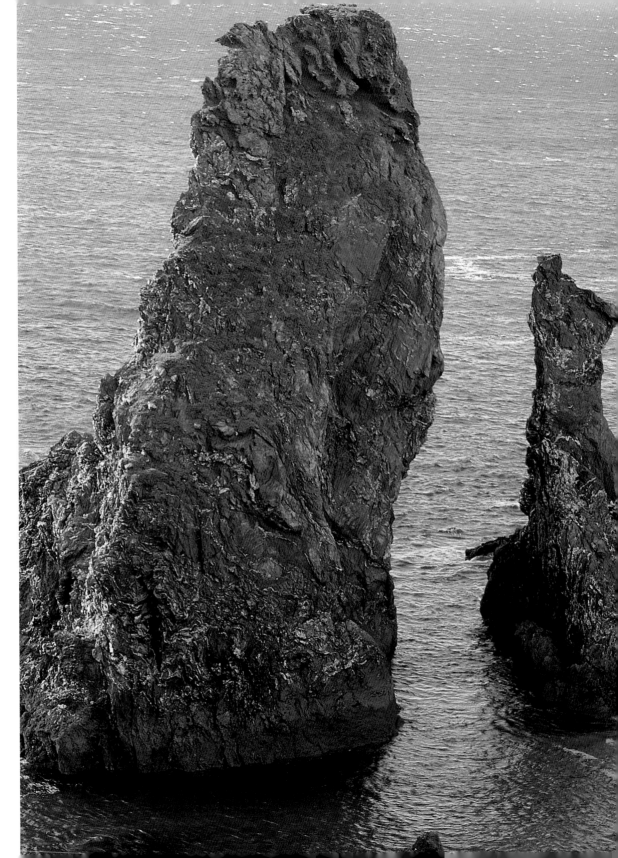

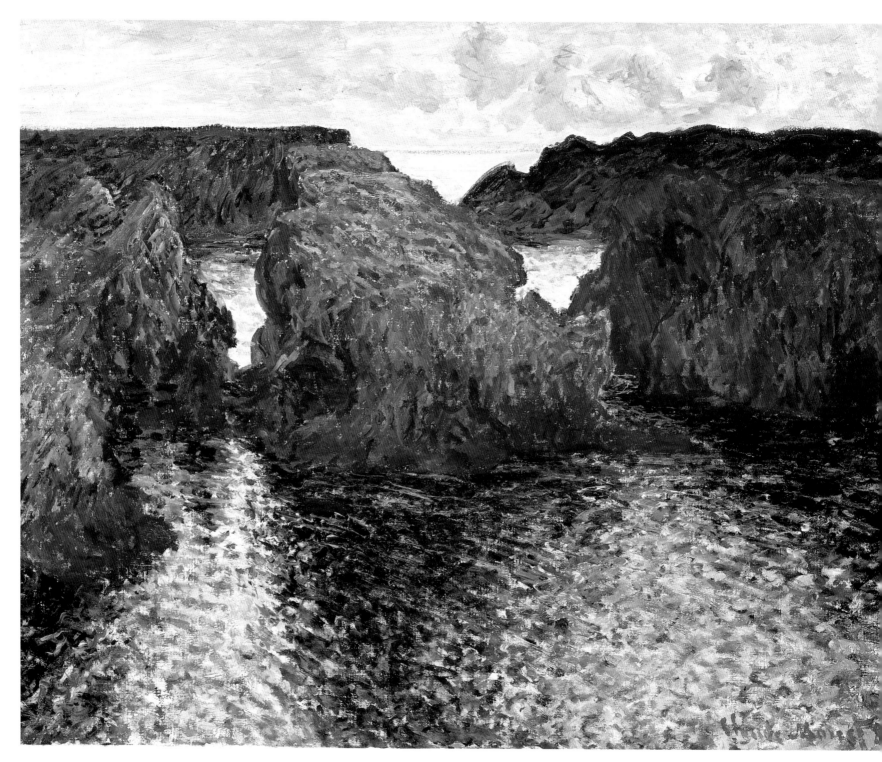

hamlet,' he wrote to Alice soon after his arrival, 'there is an American painter and his wife; he circled round me yesterday whilst I worked and in the end asked me if I wasn't Claude Monet (the prince of the Impressionists); it was a great joy for him.' The American painter was John-Peter Russell who, together with his 'very pretty Italian wife who I assume is his model', had rented a house on the island for the summer. 'As they know the locals they are going to try and find me a porter but I doubt they'll succeed as all the lads are either at sea or in the fields.' But the Russells did succeed: they found the famous Poly, 'an old sailor, a real character, very amusing and obliging'. Of all Monet's porters, he became Monet's favourite, and so respected by Monet he was the only porter he ever mentioned by name, let alone painted.

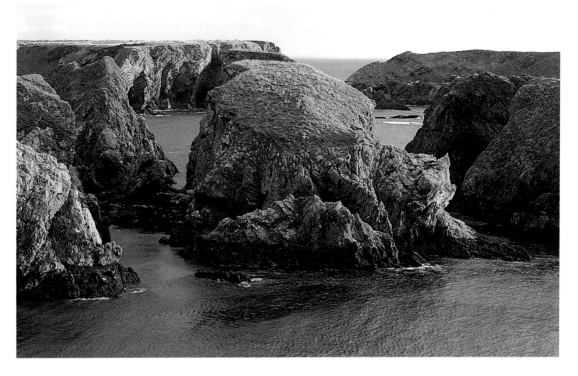

The 24th of September and the illusion still in place: 'all my canvases are covered; it's only a question now of bringing them up to scratch'. He estimated that eight more days would suffice if the weather did not change too much. Things were going well for him. Monsieur and Madame Marec, his *aubergistes*, could not have been more accommodating and, in an effort to vary his diet of lobster, sent for bread and meat, and fruits from Le Palais; soon Monet was eating figs with every meal. But, he said, it was impossible to find cigarettes and asked Alice to send him twelve packets 'because I am unhappy without them … Sadly', he told her on her feast day, 'I can't send you anything; there is nothing here except lobsters and rocks'. He and Alice were on their best behaviour. Although matters had calmed down on the Ernest front, there were still Alice's black moods and jealousy to contend with, but she had promised to resist

them. Alice duly remained sanguine about Monet's description of John-Peter Russell's 'very pretty' Italian wife and she and Monet went out of their way not to be vexed with each other when letters did not arrive daily, blaming the vicissitudes of the post which was always the case anyway. The doubt and torment of Etretat behind him, Monet was sustained by a new equilibrium of understanding and trust:

Your letters and your nice thoughts touch me more than you could believe; you have often misunderstood and judged me, and we should never have had difficulties in spite of my tempestuous character. I hope that there won't be any more clouds when I get back and you can sleep in confidence. You haven't any reason to

Opposite and above: ROCKS AT BELLE ISLE *in the southern part of the Côte Sauvage. '… the colours decompose and unite by some kind of alchemy, before these cliffs which give the sensation of the weight of the earth, before this sea where everything is in continual motion …' – Geffroy.*

worry – neither here, nor more so when I will be in Noirmoutier, or anywhere else. I am absorbed by my studies, and have no other thoughts or desires than you.

'I am in a wonderfully wild place,' he wrote to Caillebotte, 'amongst a heap of terrible rocks and an unbelievably coloured sea,' which was superb, but so different to the Channel that

at first 'I had to get my bearings but I am beginning to understand this landscape and what to extract from it.' He described the rocks as 'a mass of grottoes, of points, of extraordinary needles, but one needs time to know how to tackle this'.

As September closed, 'a devil of a wind' kicked up and the new moon brought '*un temps de chien*', and with it another surprise rendezvous: 'getting back tonight for supper, I found my usual place taken by a man and a woman who were dining and were in earnest discussion with the *aubergiste*, talking rooms and arrival times.' The mystery man turned out to be the art critic from *La Justice*, Gustave Geffroy, who 'has written some very fine articles about me and whom I had thanked. It's funny to be so far and make such encounters; I'm not complaining, because once the work is finished, it's dire here, especially as the days are furiously diminishing.' It was the start of a lifelong friendship. Monet would nominate Geffroy as his official biographer, and curiously, they both died on the same day.

The storms that had buffeted Monet at Etretat were tame compared to the storms on Belle Isle that October. Monet witnessed the sea at her most epic and elemental for the first time:

Never have I seen her so raging; and furious as she is, she preserves her beautiful green and blue colour … *quel spectacle!* She is so unleashed that one asks oneself if it's possible she will ever be calm again; besides, by virtue of being so agitated, she is beginning to lose a bit of her emerald colouring; how I wish you were here to see this! … It was a joy for me to see the sea in all its fury;

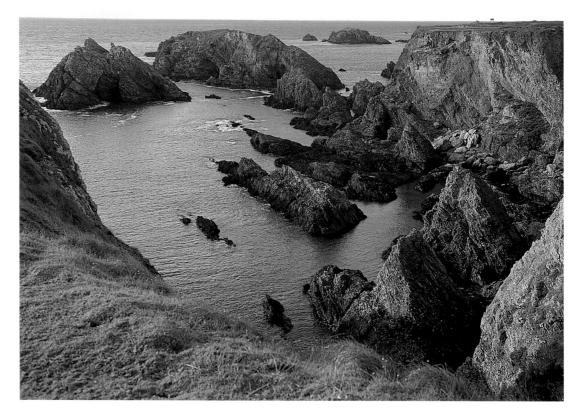

it was like a drug and I was so carried away that today I was devastated to see the weather calm down so quickly.

The appalling storms sent Geffroy and his companion packing. 'I alone know how to cope with these days of terrible weather; I would even find them superb if I weren't so anxious to finish and return to you.'

Monet sat out the storms reading Tolstoy's *Anna Karenina*, smoking the new pipe he had asked Caillebotte to buy for him. When there was really no way of braving the driving rain, he would do a few sketches of the barren, sodden,

Above: *Taken from the same viewpoint as Monet's painting* THE CÔTE SAUVAGE. *The local name given to these small bays is misleading: only the Port Goulphar was both safe and deep enough to harbour a boat (right).*

flat, windswept landscape from the window of his room. Desperate to work, he had a waxed oilskin coat made for him, tarred like Poly's, sometimes waiting for hours in order to paint for half an hour. Trying to find a sheltered spot presented enormous problems. 'The wind is so strong that my porter and I have enormous difficulty advancing …' and then 'battening

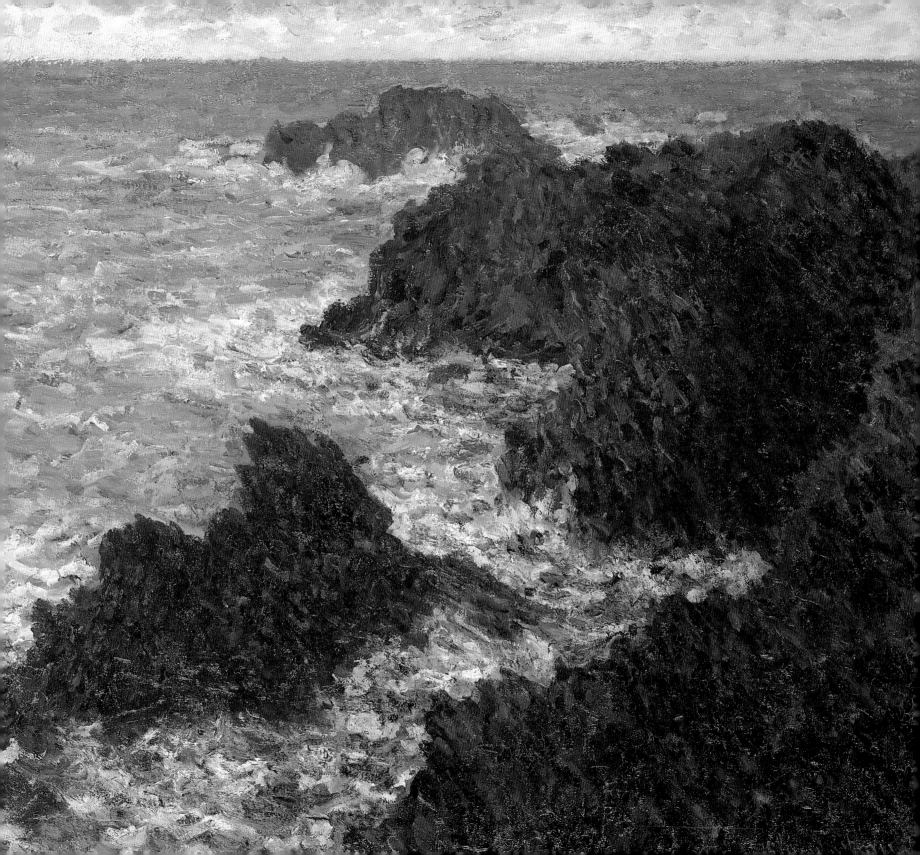

fears that this desolate landscape, with its rocks, isn't my *affaire*, and thinks I should be in Pourville; he even tells me that I would be better off going to America, which in any case, he says I will go to one day with him; it's becoming an obsession.' Durand-Ruel also urged Monet 'to return to the Riviera and finish the winter there, because he says, my *affaire* is the sun'. Monet replied to his dealer:

You know that once I get down to it, nothing stops me. I'm not sure that what I bring back will be to everyone's taste but what I do know is that this is the side of it I am passionate about … one should try everything and it's for exactly this reason that I congratulate myself on doing what I am doing. I am enthusiastic about this sinister landscape precisely because it gets me out of what I'm in the habit of doing, but I have to confess, I have to force myself; rendering this sombre and terrible aspect is very trying. It's all very well being a man of the sun, as you say, but one shouldn't always be singing on the same note.

canvas and easel' and tying himself to the latter as if to a mast, 'I bravely worked' in some discomfort, 'forced to pass my time out in the rain, feet in the water, I was frozen … Luckily my porter is as tough as leather and nothing terrifies him … He is fifty-nine and the most intrepid of them all here.'

At day's end, whilst Poly took a direct route home with all his painting equipment, Monet returned by the longest route to the auberge at Kervilahouen, where he dined and lingered to hear the news. Water was coursing through the streets of Le Palais, the flooding so high that it was impossible to get in or out of the houses on the port. The sailors talked of the boats and lives lost and the wreckage that had been found; a captain, recounting his day, impressed Monet: 'when one sees the state of the sea, to think that little boats like that can get through it and out of it; I was in admiration before this man'. Back in his room, there was his correspondence to attend to; letters to Alice alone took him

an hour to write. He asked her to send him a pair of warm felt slippers. He was cold in his unheated room, his clothes 'permeated with humidity – I don't think about it outside, but once in my room, I freeze'. Then, 'my pipe and a last *coup d'oeil* at my canvases and *dodo*'; only to lie awake, hail and wind pounding the house so fiercely he thought he was going to 'leap' into the air, and on less violent nights, 'the wind continues still, the house trembles, one would think oneself at sea'.

A distinct sense of *déjà vu* resonates from his letters: 'I don't want to immortalize myself here as I did last year in Etretat, and only being able to work between long intervals on each study yields nothing of worth.' The constant stopping and starting on his 'eight serious canvases' interrupted the momentum of his concentration, and to occupy himself, he repainted, retouched and overworked his paintings. Alice and Durand-Ruel were urging him to abandon Belle Isle. 'Like you, Durand

When the sun finally shone on 28 October, Poly could not accompany Monet to the sea because he was busy killing a pig, and try as he might Monet could not secure his easel and canvas against the wind. He returned 'furious'. A couple of days later, he was excited by heavy early morning fog, as 'I am also a man of fog. I went off with blank canvases, but no sooner had I done a mediocre sketch than it dissipated …'

As the sun sank lower and every day more rapidly, no longer illuminating parts of his compositions, he started to abandon his canvases one by one:

It's a heartbreak for me as I see other things I could add. *Enfin* I will have to mull all this over, seeing them with you beside me on that poor old sofa … It's getting harder and harder for me, because I want to finish, and for this I need to find the effect, which is often impossible … and then very often, the weather changes while I'm on the spot; you can imagine how worried I get, but, as I know I have to get to the end, I am obliged to alter a few canvases … I am sure that Giverny will seem very lovely to me with its yellow trees, having saturated my eyes with these rocks, but you know my passion for the sea, and this one is so beautiful … trained as I am, and observing it unceasingly, I am sure I would arrive at doing very good things if I were to live here for several more months. I feel that each day I understand her better, *la gueuse* – the she-devil, and certainly this name suits her here, as she is terrible; she has tints of a glaucous green and aspects that are absolutely awful. *Bref*, I'm mad about her, but I know well that to really paint the sea, one has to see her every day, at every hour and in the same place to know her life in this spot; also I am redoing the same motifs, four even six times over the same.

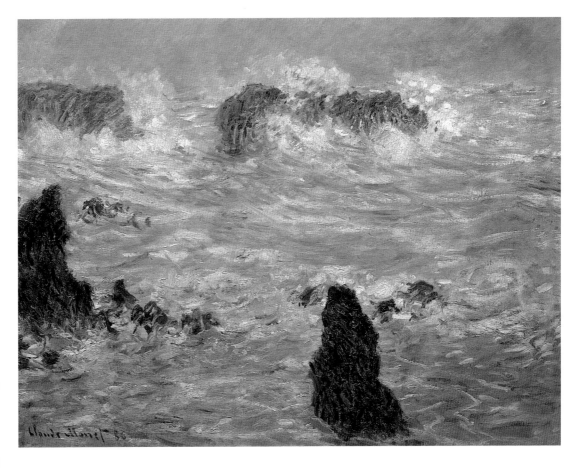

Monet had been painting in 'series', that is to say, the same composition rendered in different lights, since his early days at Argenteuil. But in Belle Isle, he made use of this technique more fully than he had ever done before. Amongst his forty paintings, there were nine 'series': five versions of the storm and raging sea, six versions of the Pyramids, six versions of Port Goulphar, three versions of the Lion, three versions of Port Damois, and so on. This was more than a pragmatic response to the arduous and capricious nature of the weather: it was a new approach to his work – the long, slow, disciplined study of a single motif. It was a style he made a genre in the 1890s, with his triumphant haystacks, poplars and Rouen cathedral series, and would take to its quintessence in the meditative studies of his water-lily pond.

But for the moment, time was a luxury he could not afford. He was, as in the previous year, six months behind with the rent, and on his return to Giverny would have to finish and 'quickly separate myself from my canvases' in order to pacify his landlord and settle his other debts. 'What a dirty business money is! One always thinks one has enough of it, and then one needs more.' The last day of October was momentous because he finally finished his first canvas, but importunately, Mirbeau, fed up with waiting, sent Monet a telegram to say he was coming to fetch him, which only intensified his anxiety and frustration. Mirbeau, his companion, the

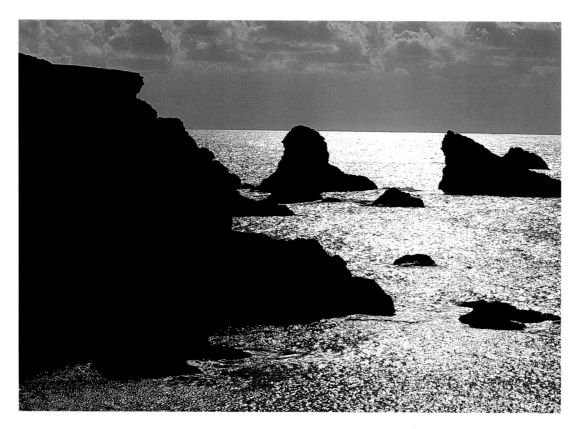

These easy, flattering references to Mirbeau's mistress were unwise, for they blew his truce with Alice. Two days before Monet's forty-seventh birthday, the children all wrote to him with their best wishes, but his Alice was in a rage.

I came in tonight, harassed, wet, soaked, disgusted, discouraged [Monet replied], but was quickly cheered by the sight of all these letters and thought of nothing but all of you and saw myself in Giverny; then opening this letter, it was over. What a hard tone and short shrift! You haven't accustomed me to this since I've been here, and the tears came in spite of myself ... what is curious about you is that you always need something to complain about; first you complain of neglect, not receiving a letter; then as soon you have the certainty that not a day passes without my thinking unceasingly of you, your jealousy is even greater ... had I not filled you in on the details of my visitors and their stay, you would have found it bad; I give you them, and you still find it bad ... I have such a clear conscience, that these suppositions, as soon as there is a skirt near me, sadden me. If you only knew that apart from you, women mean nothing to me ... I fervently hope that your next letters will be different, because I've already got lots of worries with my canvases and this atrocious weather. For a long while I was convinced I was going to bring back good things; now it's different, every day is a canvas I have to renounce completing, yet another I spoil, and I curse being committed to this fixed visit, it paralyses me and I curse Noirmoutier and my promise to go there, but I know he would take umbrage if I didn't go; I owe him a lot and I am afraid I will offend him ...

talented and sophisticated actress Alice Regnault, and a friend all arrived on 4 November in high seas, after a long boat journey from the Vendée, and all of them sea-sick. Mirbeau loved Monet's Belle Isle canvases, but then 'it is true that he is such a fanatic!' As terrible weather returned, Monet could not work and Mirbeau could not leave, and so,

since they've been here, it's been parties and feasts; the beautiful Alice, who is really very sweet and very good, supervises the cooking and presents us with excellent dishes which are a change from the usual. But in spite of these attractions, I only wish for fine weather and their departure, because

I need to work, and I need total tranquillity. Every day the Mirbeaus try to leave but their friend is very cowardly, and has an enormous fear of the return journey, especially when he hears us talk of the danger, but he doesn't dare ask Mirbeau to go back by train, which they don't want to do, and all this is very amusing; also, our meals are the jolliest. The reigning Alice continues to cook, and has turned the *aubergiste* on her heels. Today she was dressed for travel, that is like a man, and *ma foi* – my goodness, most effectively; it was a revolution hereabouts, especially when she was seen killing a crow. There was such a procession to come to see her that she had to unpack her suitcase and put on her dress on again!

Thus chastened, Alice calmed down. Monet kept postponing his departure later and later into November – 'it will be another few days of hope for me and a few days less spent in proximity to this pretty creature; *sacré bleu*, don't fear anything of me!' He had to paint in thunder and rain, battered by hailstones which pounded on his canvases with such ferocity that 'at times I feared my canvases would be smashed'; and on his face and hands which hurt long after he stopped painting. But November also had its little adventures: he ate porpoise for the first time, which he said tasted like steak, and went fishing for conger eel 'in the *aubergiste*'s dinghy by the light of an extraordinary moon, but we were well rocked, as the sea isn't exactly a lake'.

During his final days Monet did a portrait of the intrepid Poly: 'the whole village turned up to look at it, and what was amusing was that everyone complimented him on his luck, thinking I had done it for him; I don't know how I'm going to get out of it.' He extracted himself diplomatically by giving Poly a photograph of himself, with which Poly was entirely pleased. Monet left Belle Isle on 26 November to see Mirbeau – 'it's a real sacrifice that I'm making here'. He made the crossing in a rough sea with forty canvases aboard. 'I have never seen a lovelier sunset; it seemed as though we were navigating on a sea of fire; it was wonderful.'

With the situation with Ernest Hoschedé still unresolved, Monet wrote to Alice from Mirbeau's house where he stayed for four days before leaving for Giverny unsure of just how warmly he would be received by the Hoschedé children. 'I hope I won't find myself this time,

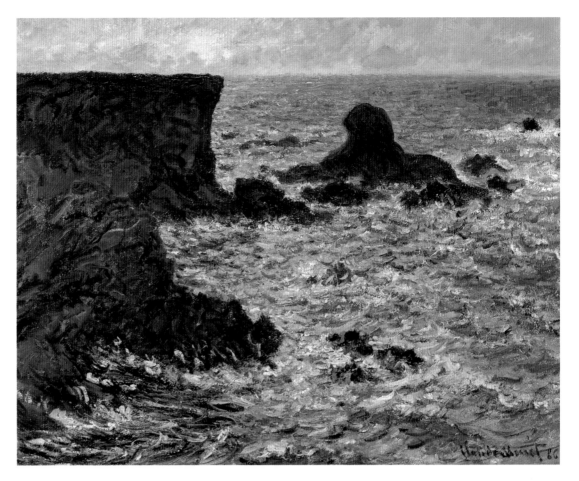

like other times, isolated and a stranger, which has so often upset me. I return full of joy to see you all again, I think it is shared.'

Monet submitted ten Belle Isle paintings for Petit's International Exhibition the following spring of 1887. In his review for *Gil Blas*, Mirbeau said of them: 'One can say that he has *veritablement* invented the sea, for he is the only one to have understood and rendered, with its changing aspects, its enormous rhythms, its movement … its odour.'

Above: ROCKS AT PORT-COTON, WITH THE LION ROCK.

Opposite: *Monet's magnificent Lion sits like a sphinx at the northernmost reach of the Côte Sauvage.*

Antibes

"It's so beautiful here, so clear, so luminous! One swims in blue air, it's *effrayant* . . . What I will bring back from here will be softness itself, of white, of pink, of blue, all this enveloped by this enchanting air . . ."

'Of Juan les Pins, I can't yet judge, having seen very little, but up to now, I am not very carried away with it,' wrote Monet on the morning of his arrival on the western side of the Cap d'Antibes peninsula.

It was not a good start. He had arrived '*à bon port*' from Paris via Avignon, Marseilles and Cassis in glorious sunshine on 13 January 1888, '*malgré la date fatale*', overnighted in Toulon and from there taken the local '*train omnibus*' to the small beach of Juan les Pins. The train's leisurely pace had allowed him to savour the sublime sensuality of the Riviera coast bathed in a ravishing light. Dazed by its beauty, he was already 'panicstricken' by the 'choice of beautiful spots', Agay and Le Trayas especially, and his arrival in the rain at the Château de la Pinede was an abrupt wrench from sun and solitude.

The hotel, or the castle, since that's its real name, is admirably situated; I have a huge room with a view over pretty gardens and the sea, but a terrible thing, it's a house of painters; *le père* Harpignies is here with some students; then the pension is rather high, twelve francs a day. These are many reasons why I would want to leave unless I find marvels here; and to top it all, the weather is filthy, torrential rain – thus it's impossible to see anything and take in the place.

Previous pages: *Antibes taken from the same spot on the beach at Ponteuil where Monet set up his easel to paint it*.

Left: *Monet's hotel in Juan les Pins: his room looked out from one of these windows.*

The Château de la Pinede had been recommended to him by Maupassant, who had stayed there, and who lived in Cannes, where he kept his famous yacht *Bel Ami*, immortalized in his book *Sur l'Eau*. The proprietress was Madame King, a friend of the Manets and Degas, and popular with other artists. Monet expected to find artists there, but did not expect to find himself in the lap of the Paris Salon, the art academy who had scorned, derided and often refused work submitted by the early Impressionists. The old master of this conservative circle was the seventy-year-old *père* Harpignies himself, who, with his hangers-on, was to be avoided like the plague.

'Decidedly this place is not for me,' he wrote to Alice later that evening. '*Le père* Harpignies and other gentlemen wanted to show me the marvels here; it's very beautiful no doubt but leaves me cold, because even in bad weather, one can always get the feel of a place.' He had only one thought, and that was to leave as soon as possible. He went to Agay the next day, to find himself a *gite*. 'It is a wild place with only one or two houses, quarries and a train station, and I'm sure that there I'll find plenty to do … One thing is for certain, I'm not staying here; also the people who are here, though very friendly, bore me *absolument*. I have no time to waste, not wanting to stay longer than the beginning of March.'

'I am still at the Château de la Pinede,' he wrote two days later, having returned from his reconnaissance trip to Agay, which he found beautiful but not very varied. 'I have to be vigilant that I don't succumb to repetitions.' Desperate to find new quarters, he then went all

the way to Monte Carlo where he overnighted, not, he quickly added, having 'set foot in the casino'. In the morning he walked some twenty-five kilometres to Nice, through Eze, Beaulieu and Villefranche, where he found two places he liked and could easily install himself 'with a chance of working well', but the accommodation there was too expensive. Try as he might, he could find no escape from his well-meaning but stupendously irritating entourage.

'Still at the Château de la Pinede and still no decision,' he wrote on the following day because on his return by train to la Pinede from Nice, he caught a glimpse of the peninsula from the eastern side, and

noticed some very beautiful things near Antibes which I am going to look at first thing tomorrow morning, when I will finally make a decision … All the people here (the painters) are idiots who had showed me (from their stupid point of view) the least good places, *et voilà* this morning, following my instinct, I discovered superb things … the weather is beautiful and it would be a crime to hit the road once again … I am penning this very hastily, because I have to unpack all my cases and get myself organized for work. I have five or six superb motifs to do and very quickly, if the weather stays this resplendent; it's enchanting.

Monet's hotel was situated a hundred metres up the road from the beach of Juan les Pins and overlooked the Golfe Juan, the red mountains of the Esterel in the distance and Agay. What he had seen from the train was the view from the other side of the peninsula, of medieval Antibes set against the backdrop of the Alps. He decided to paint it from two vantage points: one from

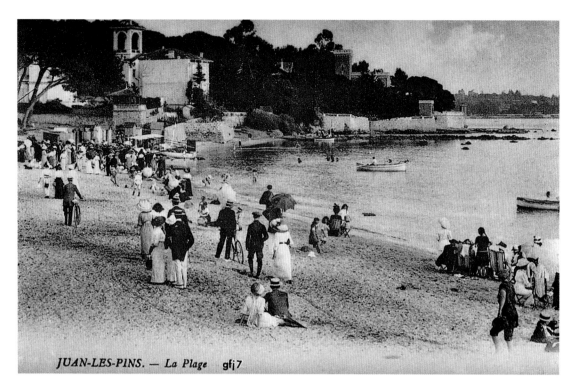

JUAN-LES-PINS. — La Plage gfj7

Left: *The beach of Juan les Pins as it looked at the turn of the century. Maupassant wrote '[it] will perhaps, in time, be the prettiest resort of the whole coast'. I do not think he would think so if he saw it now.*

Opposite: *The famous pines from which Juan les Pins takes its name.*

Monet that these pompous and complacent painters were so comfortably off doing so little, whilst he was always short of money doing so much.

As Monet started work, an unexpected hiccup arose that could happen only to him: 'I have to write to Castagnary,' he told Alice, referring to an early supporter of the Impressionists, now director of the Musée des Beaux Arts in Paris.

Figurez-vous, there is a new espionage law which forbids whomever it may be to make even a small sketch, near or far, of a fortified town, and this is the case of Antibes, which, precisely, I want to paint from different aspects. I have to ask him to obtain an authorization from the Ministry of War, because it would be devastating to be forced to abandon what I've started. It seems that recently a French artist was arrested for this and had to spend the night in the cells.

A letter of authorization arrived a week later, along with a letter from Renoir, who was forever trying to join him and whom he was forever trying to throw off his scent.

This morning I received news from Renoir who I was always afraid would turn up here; he is installed in Aix chez Cézanne, but complains of

the beach at Ponteuil and the other from the Salis Gardens which surrounded the chapel and lighthouse of La Garoupe on a plateau at the highest point of the peninsula. And so, on 20 January 1888, he began work: 'I am painting the town of Antibes, a small fortified town gilded by the sun, detached from beautiful blue and pink mountains and the chain of the Alps eternally covered in snow. I will need fortitude to put up with the society here, *de fameux idiots;* happily the food is excellent.' His plan was to do three or four canvases, 'working slowly, not wanting to start a large number of canvases, so I won't be held up too long here,' and then go on to Agay. Does this sound familiar?

The household here will become impossible:

every day there are new arrivals, painters and *peintresses*, all students of *le père* Harpignies. It's amusing to listen to them, all in ecstasy before their master, and I think then, of Pelouse; it's by this means that these people sustain each other. Naturally, for them, I am a curious beast to observe at close range, and they all want to see what I'm doing, no doubt to disparage me. But I am going to work on a completely different side to their *patron.*

Pelouse was an affluent society painter who had married into Alice's family and was held in high esteem by them as the paradigm of social respectability and good taste. Naturally they disapproved of Monet because he did not measure up to any of these criteria. It riled

the cold and asks if where I am it is warm and if it's beautiful. Naturally, I am not going to encourage him to come, and won't tell him I'm going to Agay; I've too great a need to be alone and left in peace.

In the event, Renoir, whose relationship with Cézanne has been said to be 'explosive', went to Martigny, south of Aix, and seemed perfectly happy there; there was no more talk of joining Monet.

Four years had elapsed since Monet last glimpsed the French Riviera. Durand-Ruel had told him he was a man of the sun, so here he was. He now sought to refine and apply the techniques he had taught himself during those three months of grappling with the light and colours of Bordighera. He had lovely weather during the first few weeks, warm and stable, and described his 'infatuation with the snow-covered Alps' and the light almost as a holy communion in letters to Alice, Whistler, Geffroy, Berthe Morisot and fellow painter Paul Helleu:

It's so beautiful here, so clear, so luminous! One swims in blue air, it's *effrayant* ... I see very well what I want to do, but am not there yet. It's so clear, so pure of pink and blue that the least wrong touch makes a dirty stain ... I struggle and battle with the sunlight, and what a sun it is here! One should paint this place with gold and gemstones. It's wonderful ... What I will bring back from here will be softness itself, of white, of pink, of blue, all this enveloped by this enchanting air; it has nothing to do with Belle Isle ... after Belle Isle, it will be tenderness itself ... here there is only blue, pink and gold ... so difficult, so tender and so delicate and me, who is so inclined to the brutal!

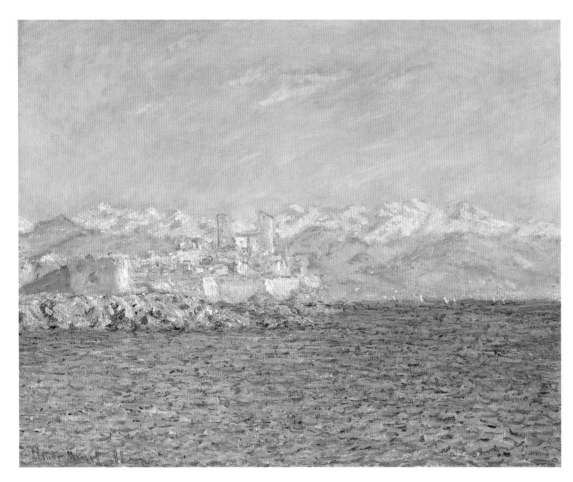

having his violoncello brought here to play music with his pupils; it may be pleasant, but could also be tedious; that will depend on their music ... what I hear said here by all these imbeciles and the opportunistic attitude to painting of these people, like Pelouse, is proof that the war is more than ever mounted against us; and note that I have nothing to complain about in my relations with these very amiable gentlemen, as soon we stop talking about painting.

It was so cold one evening that

after dinner we were in my room with several gentlemen smoking when the chimney caught fire; it had never been swept; what an event, the whole house upside down, and there was so much smoke that I had to sleep in another room. Apropos of these gentlemen *les pensionnaires*, I had to get cross with one of them at dinner yesterday, who every evening sought to provoke me into gossiping about my fellow painters. *Bref*, I turned red with rage and told him not to address another word to me; it chilled the air, but as he's an insufferable idiot and very badly mannered, I had everyone on my side and he meekly shut up. It's lucky that during the day I am *tranquille* and that all those people work with their *patron* far away from me ... I am more and more horrified by the entourage – I have never seen anything more stupid. Also I no longer utter a word at the table ... I am more and more infuriated seeing these worthless painters who are here; they do their *séances* regularly, begin and end on one fragment, and once their *séance* is finished, don't give it another thought. I loathe being in such a milieu.

A rainy day in early February gave him the chance to be in his room in the morning 'looking at my canvases; it's a good thing, really, to quietly look at what one has done, as I always return after dark. All in all, I am not displeased and I have six canvases which will be good things.' He had started fewer canvases than usual – 'my dream of Agay is too much in my mind, and also Cassis on the way home'.

Monet was happy when he was working, but when night fell he had to face interminable

evenings in the hotel with the 'narrow-minded or backward' painters which, like it or not, he had to make the best of – and certainly there were comic moments, convivial even. 'In the evening the men smoke in a separate room, and then discussions on art which are priceless!' To fill the hours, the painters thought of various entertainments:

Tonight, we inaugurated a game of *cuistre 31*; I won seventy-four francs, but I was late going to bed. *Le père* Harpignies, a great musician, is

It rained on the day of a planned excursion to the Carnaval de Nice, so the painters cancelled

their trip and asked Monet to show them his canvases instead. 'Whilst these people don't understand much, they were amazed by the feeling of light and landscape, because they, in spite of the radiance here, only do dull things … Then in the afternoon, with a few courageous ones, we went for a walk in spite of the rain. I saw magnificent things and decidedly this *cap* is more beautiful than I thought. To make up for missing the Carnaval de Nice we wanted to dress up in disguises in the evening and dance, but it didn't catch on; we played music instead and 'yellow dwarf' and baccarat, where I lost ten francs.'

'Tonight,' he wrote on 4 February, 'I am tired, worried and I have to admit, my sight is fading and I can no longer read at night; all the lines become muddled as I write; I am trying to smoke less but it's hard … Perhaps it's all due to overwork.' A week later he finally relinquished his dream of going to Agay. 'I'm all churned up – me who thought I would do several spots and *des merveilles!*'

Opposite: OLD FORT AT ANTIBES (I), *showing the Alps that straddle the border between France and Italy, of which Monet spoke so often in Bordighera and finally had a chance to paint.*

Right: *View from what was the Salis Gardens to the old Antibes. The Salis Gardens have gone, replaced by luxurious villas, and only the chapel and lighthouse remain. The view has suffered too, the Riviera coastline being choked with marinas and housing development.*

Having fallen out with Durand-Ruel's son Charles, left in charge whilst his father Paul courted the Americans across the pond, Monet was now almost entirely reliant for income on the dealer Petit, who sent Monet only 500 of the 2000 francs he owed him, feigning absence or illness. Monet knew this was untrue because the mother of one of the painters in the pension lived in Paris and saw the Petit family every day. Petit also refused to pay Monet's paint merchant Troisgros, 'who in vain has presented himself *chez vous* more than twenty times'. Worse still, Monet learnt via the painter's mother that Petit had double-crossed him by giving his gallery

space, promised to Monet, Whistler, Berthe Morisot and Helleu for their joint exhibition that May, to someone else without telling them. At the same time, another event struck terror in his heart. A collector of his work, a Monsieur Leroux, had been certified insane and was forced to sell – the market would thus be flooded by eight of Monet's paintings. 'It will be my downfall; I am sick over it.' Monet sent telegrams to Petit, to Durand-Ruel and to Theo Van Gogh, who worked for the Boussod Gallery, asking them to keep up the prices of his

paintings during the auction.

You know that I'm always afraid of finding myself without money, and if this continues, this is what is going to happen to me. It is almost the end of February, and nothing worthwhile here has been accomplished … and in the middle of all this, living with strangers, some nicer than others, having to hide one's worries and being understood by nobody!

As it turned out, his prices were supported, and

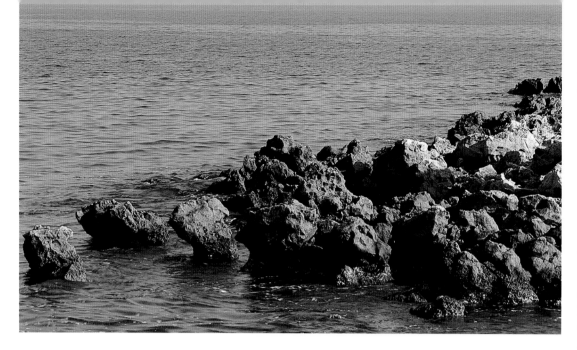

Left and right: THE SEA AT ANTIBES – *painted somewhere, I believe, between the Plage de la Garoupe and the Cap Gros on the eastern coast of Cap d'Antibes.*

I am working non-stop – I so desire to be done with it and be near you it drives me on like a fever. The sun has suddenly come back, superb, but with a devil of a wind. The weather is truly beautiful but very changeable; the wind varies constantly which has a great import on the state of the atmosphere and above all, the sea, and I haven't got one canvas without a lot or a little of the sea. I went off to work, but couldn't hold my canvases, which were blown inside out, the palette covered in sand; I don't have my Poly here to make it all stay in place. Certainly I have to ride out life here, be amiable, play, laugh, and above all, listen to things which revolt and disgust me more than ever of the world and of painters. Oh yes, I was better off at Belle Isle, and how I prefer my conversations with the fishermen! Also, were it not for the great desire to see you again, how happy I would be to inter myself at Agay, all alone.

he was delighted that the newspapers noted how well his paintings did by comparison to others.

After Monet had sat out a bad patch of varied and bad weather during February, the inevitable happened.

It is not raining today; the sun is out but so different to the one I was painting … the weather has returned superb, *mais hélas* my motifs are all changed and I have great difficulty retrieving them: some are no longer lit the same and in others there is so much snow on the mountains that it's a different thing entirely; I have been obliged to start again … with all these worries, I am beginning to be seen as a ferocious and terrible man …

The vicissitudes of weather continued.

… my canvases more than compromised … I

cannot continue with my 'Views of Antibes'. I have to leave them as they are – the sun has turned so much that it's something else entirely and I prefer to paint over them. I no longer hesitate to do my canvases in all weathers; it's the only way I'll be able to extract myself from here and pass the time, because, and I can't say it often enough, I am excruciatingly bored with the people here.

In early March, the good, settled weather returned. 'I am hoping to finish even one painting tomorrow but this devil of a sun has walked on so much that many things have to be modified and others have be restarted.' He was now working on a motif of rocks and sea somewhere along the eastern shore of the peninsula and had started on the pine grove on the beach of Juan les Pins, only a couple of minutes' walk down the road from la Pinede.

Monet had not seen Maupassant during his stay because Maupassant had already left Cannes for Paris when Monet arrived, 'to take his brother, who is absolutely mad, to the Dr Blanche, so I don't yet know the *Bel Ami*; I would have consented to forfeit a day's work to go out to sea.' Towards the end of March, when Maupassant had returned to Cannes, Monet went there to spend the day with him. The sea was too rough to sail on, but he had a haircut as 'I looked like a savage'.

He was finally released from the torture of *le père* Harpignies and his court of acolytes on 10

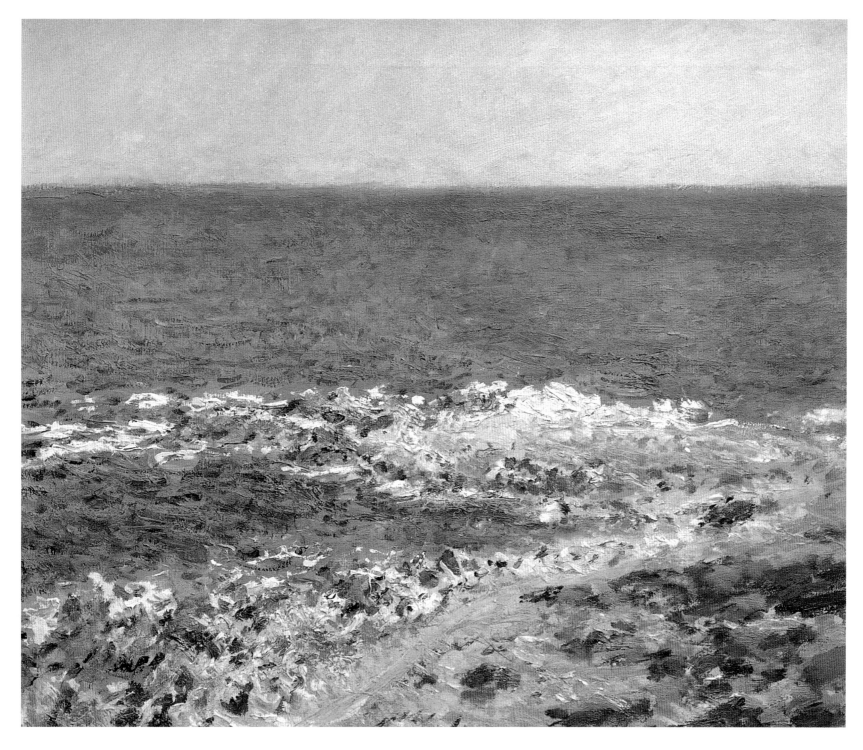

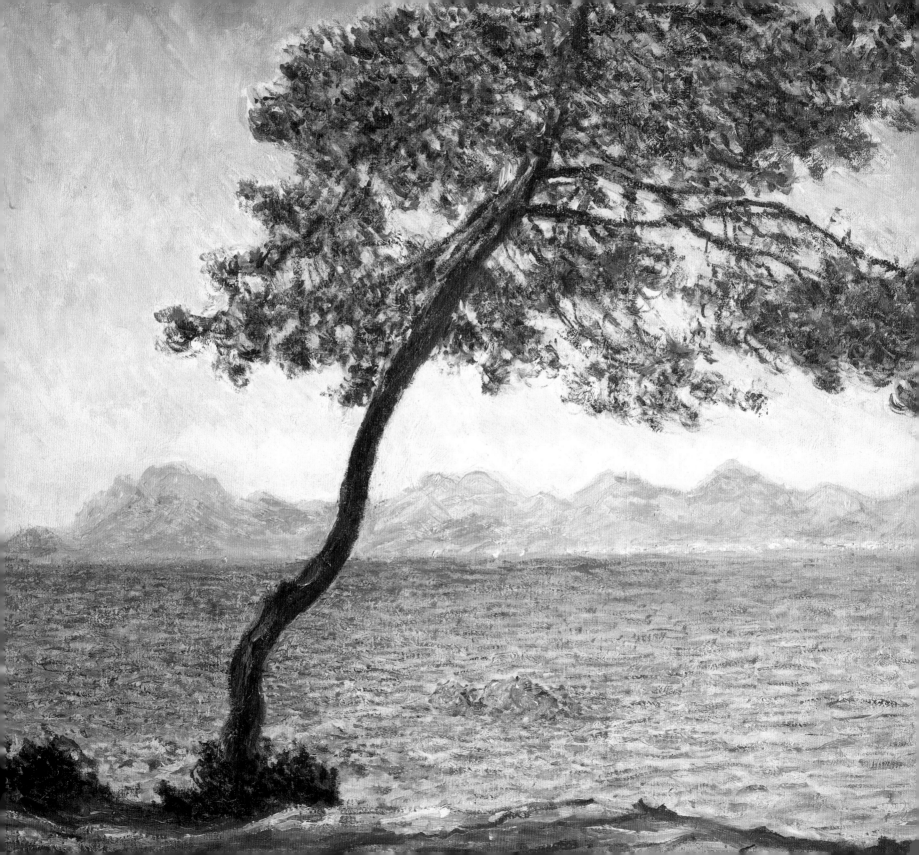

Left: ANTIBES, *painted from the beach of Juan les Pins.*

Above right: *The same view over the Golfe Juan but probably not the same pine.*

April, and was 'left with elderly English ladies and *dames malades*'. As the weakening mistral brought settled weather, Monet entered one of his rare periods of artistic euphoria.

I get up at half past four in the morning and by half past five I am at the motif ... I have been working well since five thirty this morning; I am almost happy and I hope finally to bring back a few good canvases if I have five or six days of good weather ... The weather is magnificent, like summer, and I am working more than ever ... another few days like this, and I would be happy, very happy. I have arrived at the point where every stroke of the brush counts; it's the result of all my effort, and it would have been awful if I hadn't had the courage to stay ... I am caught up in my joy and in a fever of work. I am working flat out ... *Eh bien! Je suis très content!* This is why with the good weather I want to persist; I have a few canvases which are going to be very good, I think, progressing well, if I don't overdo it ... the weather is absolutely ideal, flowers everywhere and what perfume! The inhabitants of la Pinede have been bathing for three days now, me excepted, of course, in spite of my great desire, but I haven't got time ... It is only this painting, this satanical painting, my life and in consequence yours, that detains me here another few days, far from you. I cannot leave these canvases in this state, I absolutely have to give them what they are missing. I think they are going to be very good ...

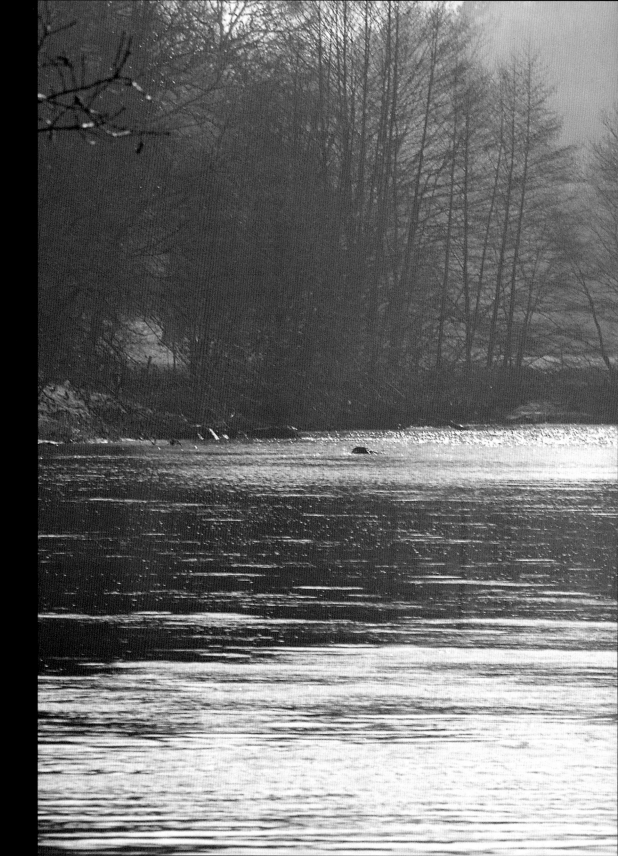

The Creuse

"I am in a *pays perdu* – a lost country – and caught up with the difficulties of a new landscape. It's superb here, wonderfully wild . . ."

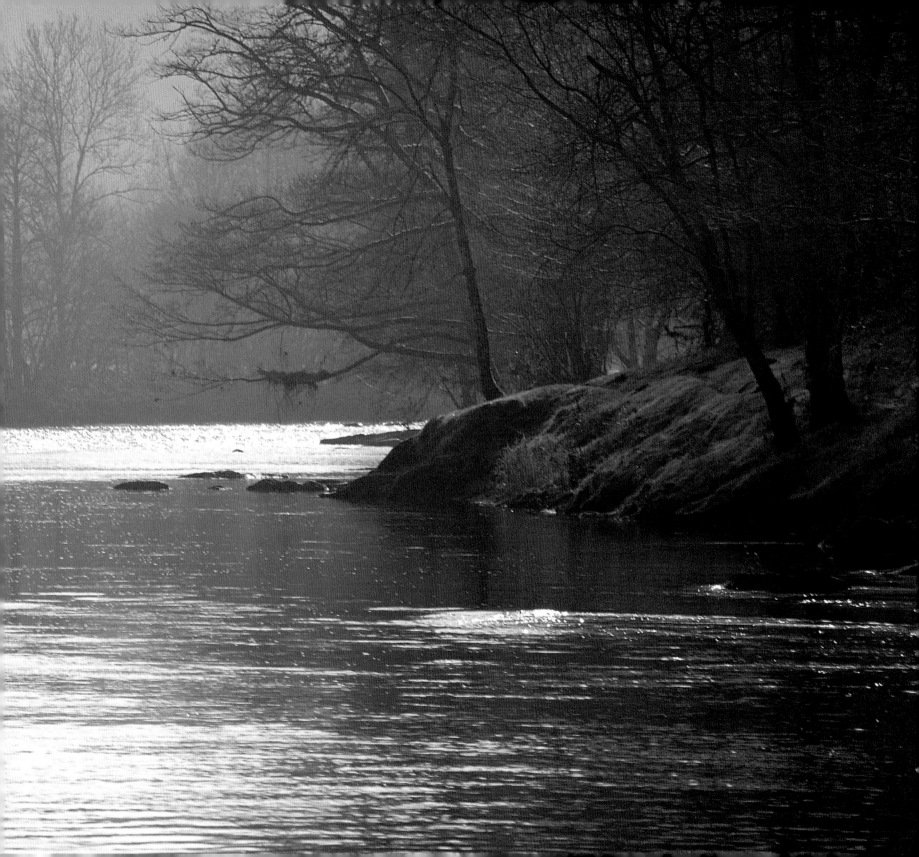

Previous pages:
The Grand Creuse, photographed in February. Monet could spare no time to have his hair cut in the village and summoned the coiffeur to cut his hair while he was painting on these banks.

Left: *The point at which the Grand Creuse flowing in from the left meets the Petit Creuse flowing in from the right. Believe it or not, the mass of trees on the top left-hand side of the photograph is the Bloc (see page 95). What a difference a goat makes!*

Above right: *The lane that descends down to the Creuse valley from the village of Fresselines took Monet past the old farmhouse on the right. He was always accompanied by Rollinat's large dogs, which in an old photograph look very much like these, who suddenly appeared.*

1889. Another year, another landscape. This one, in the heart of France, Monet came to paint entirely by accident. He had stayed at home during the winter of 1888–9 to paint snowscapes around Giverny, but by mid-February, no snow had fallen. He wrote to Berthe Morisot:

I thought it would be a beautiful winter here and rejoiced in doing effects of snow and hoar frost, but the weather is unceasingly atrocious and above all variable, so I've done nothing good, and it is too late now to leave. I am counting on the first beautiful days of spring to catch up, but meanwhile, I am very worried … I go less and less to Paris where in any case everyone is absorbed only by politics.

This, he said, was to blame for the lack of notice his Antibes paintings had received, ten of which were on show at Theo Van Gogh's gallery. It was an article by Mirbeau that finally woke up the public; and Van Gogh not only sold a few, but took the rest to London to critical acclaim.

A few days after Monet wrote to Morisot, Gustave Geffroy invited Monet to join him on a jaunt to the Creuse where, Geffroy later recalled, 'I knew he'd paint wonderful landscapes.' The valley of the Creuse, as it is called, lies south-west of Paris, halfway between Chateauroux and Gueret, and to this day

Above: *The valley of the Creuse, now a jungle.*

Right: *A statue of the poet Maurice Rollinat stands in a commemorative square in front of his former house, where Monet spent every evening.*

remains unspoiled. They went to the village of Fresselines, to visit Geffroy's friend the poet Maurice Rollinat, who had left Paris after the publication of his volume *Nevroses* ('Neurosis'), a *succès d'estime* which Geffroy had reviewed. Monet was taken to all the sights: the picturesque ruins in nearby Crozant, and to the valley below Fresselines where the Grand Creuse and the Petit Creuse rivers meet. 'Monet stopped for a long time to contemplate the shallow frothy waters,' Geffroy wrote in his biography of Monet. 'On a beach, a bleached old tree, solitary, terrible, stretched its gnarled

branches above the fracas of the two rivers which hurled like torrents. Foaming water unrolled at our feet like waves in the sea. Stony hills covered in moss and heather rose all around us, forming a sombre circus to the battle of the waters. The spectacle was *farouche, d'une tristesse infinie*, wild, and infinitely sad', exuding 'everlasting solitude, of a winter's sleep that would never end'. Monet, 'overcome' by this 'décor of grandiose melancholy' and 'by his host who was so proud to honour him', had only one thought: to hurry back to Giverny 'to put my affairs in order' and return to the Creuse as soon

as possible. 'With every passing day,' he told Geffroy, 'spring gets closer and I so want to paint that landscape as we saw it without that first flush of springtime vegetation ... if I don't leave soon I will have to forego it because it will no longer be this Creuse: naked, russet and superb.'

Monet was detained in Giverny until 5 March by Georges Petit's sudden proposal of a joint exhibition with Rodin during the Exposition Universelle that summer, 'just me and the sculptor; *une grosse affaire*': 150 of Monet's

Below: *The village of Fresselines today. The house on the corner was once the auberge of* la mère *Baronnet where Monet stayed, and across the street is the church where he often went to hear Rollinat sing and play the organ for Mass, Vespers and a First Communion. 'Every time he sings it's an event here and the bourgeois arrive from all over.'*

Right: *Further along from the farmhouse shown on page 89, the lane descends steeply into the Creuse valley.*

paintings 'in full view of the foreign public who would be in Paris' queuing up to see the newly built Eiffel Tower. Monet tried to meet up with Rodin to discuss terms before he left, but Rodin did not turn up at the meeting, so when Monet finally tracked him down, he had to bolt back to Paris within a week of arriving in Fresselines. It was mid-March by the time he could properly concentrate on the Creuse. 'If the weather is favourable I think I'll stay here fifteen to twenty days, and then go to Crozant,' he told Alice confidently, but no doubt she took this with a pinch of salt.

He lodged *chez la mère* Baronnet, who ran a small hotel on the village square, dominated by the church, but he spent every evening with Rollinat, whom he adored and who left him in peace during the day.

Rollinat respects my work and we only see each other at meals ... The only two beings who keep me company, other than my young porter, are Rollinat's two superb dogs; they have befriended me. They arrive at the auberge in the morning, scratch at my door and never leave me for a minute; I am thus well guarded and no one can come near me while I work.

Every day Monet and his entourage walked out of the village, and along a lane that took them past an old farmhouse and down a hill to the confluence. Monet set up his easel along the banks of the two rivers, and for a higher perspective, on to the hillside, which was grazed by sheep and goats then, and treeless.

'I am in a *pays perdu* – a lost country – and caught up with the difficulties of a new landscape,' he wrote to Berthe Morisot. 'It's

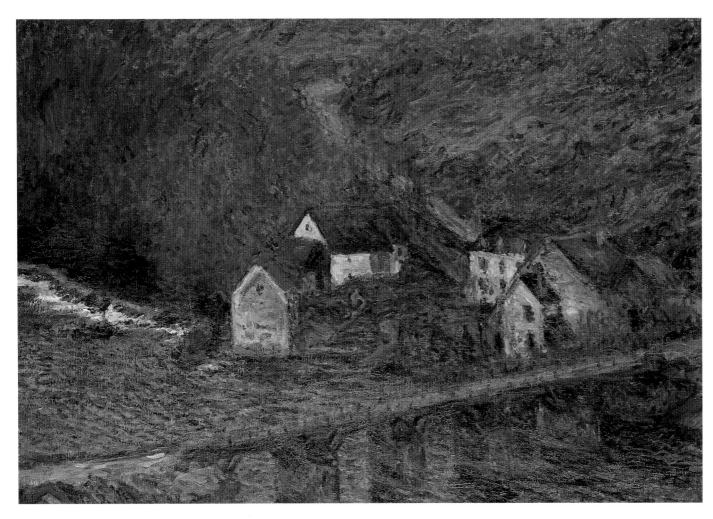

superb here, wonderfully wild and reminds me of Belle Isle.' It was now early spring but his vision of winter remained stubbornly fixed in his mind's eye. He would need to paint quickly in settled conditions to realize it, but as the weather deteriorated he soon ran into difficulties. 'I am taking advantage of this terrible weather to examine my canvases; *hélas!* What difficulty and how slow I am to express what I want ... I know I always say this, that upon my return I will find them better, but I would like to finally arrive at finding them good *sur place* – in situ.'

'The weather is more and more awful; rain and stormy wind. I came in wet, soaked, I couldn't hold out ... it's not coming at all ... the landscape is certainly difficult to grasp and can't be done at the first attempt and in such haste. I console myself a little in thinking I'll do better in Crozant after my initial attempts here.' It was always thus. The mirage of the perfect landscape shimmered on a distant, unreachable horizon. In Bordighera he had been hankering after the sea, in Belle Isle after the Brittany coast, in Antibes after Agay. The Shangri-la of the Creuse was Crozant. It is ironic that whilst he was deluding himself that the grass, so to speak, would be greener in Crozant, that somehow it would all be better and easier to do

if only he were there, the grass was indeed
growing greener beneath his feet. '*Hélas, hélas,*'
he ranted, 'this cursed rain is going to turn
everything green.'

By the end of March, he had twenty-three
canvases under way; 'it's been going much better
these past few days and I'm beginning to think
that I could bring back good and curious things.
By virtue of looking I have finally entered into

the character of the landscape, I understand it
at the moment and can see better what there is
to do with it.' But he couldn't do much of
anything as the weeks unfolded into a
meteorological nightmare. Glacial winds tore
through the ravines. It rained nearly every day.
There were days when he painted in between
showers, and days when the driving rain made
painting impossible. There were days when he
had sun, and then the sky would darken and the

wind would start up. He had snow: 'But what's
to be done with this snow, of which there is
enough to hinder me, but will not stick long
enough for me to try and do it.' He had
mornings of hard frost: 'If the sun persists, all
my sombre and sinister canvases will be done
for.' To cap it all, in May there was a hurricane.

He could have coped with any of these
conditions if they had remained stable but

developed lumbago, rheumatism, sore throats and often felt so unwell he took to his bed. The bitter lesson of the Creuse was perhaps the realization that his robust health was not going to last for ever. 'It's coming slowly, little by little, but I am very tired; I feel I'm growing old; don't laugh – nothing is more true.'

Even under the sustained attack of the elements Monet courageously upheld the ethos upon which his art was based: to record nature as he observed it, precisely, meticulously and truthfully. It was, for example, 'impossible for him to work on canvases if everything was wet because it so exaggerated the hues'; nor could he work on them if they were too sombre: 'I want sombre weather, but not at this point; what bothers me a lot is that everything when wet becomes even more gloomy and I don't dare alter all my canvases because when the rain finally ceases I will have to put them back as they were …' How tempting it must have been for him to compromise his art just a little.

I am in a state of such discouragement I am ready to chuck everything in the river – the weather remains *assommant* – extremely tedious – a terribly cold wind which I couldn't care less about if at least I had my effect, but it's a succession of sun and clouds which for me is the worst scenario … in this dry weather, the Creuse is abating before my eyes and in going down she changes colour so much she transforms everything around her … I am in despair, I don't know what to do, because this dryness will continue.

'*Hélas*, all these interruptions, this is what's so awful, that despite the cold, everything is burgeoning and changing … turning green before my eyes.' 'Never have I had worse luck with the weather! Never three favourable days in a row, so that I am having to make continual modifications without making any progress,' he wrote to Geffroy. 'I who dreamt of painting the Creuse as we saw it! *Bref*, by virtue of these changes, I follow nature without being able to

seize her; and this river which abates, swells, one day green, then yellow, sometimes dry, and which tomorrow will be a torrent after the terrible rain which is falling at the moment!'

He sat by the river with his feet in the mud, painting with a hand that had become 'so chapped, so cracked by the rain and the cold, that I had to coat the inside of a glove with glycerine which I wear day and night'. He

It was now the third week of April. 'Not one canvas finished; counsel me, console me,' he begged Alice.

Opposite: *A few kilometres from Fresselines is Crozant, where Monet dreamed of going, photographed here in February. This is how the Bloc (right) would have looked to Monet, as yet uncamouflaged by trees.*

Right: THE BLOC. *It sits at the confluence of the Creuse but has completely vanished under a canopy of trees because after the war, people no longer grazed sheep or goats but kept cows in the meadows. Clemenceau adored this painting, and Monet gave it to him as a gift.*

He found solace, though, with Rollinat, a kindred spirit. 'My days finished, exquisite evenings spent listening to Rollinat', who would recite or sing his poems or those of Baudelaire he had set to music and played on the piano. 'Every day, I am more charmed; what a true artist; he is by moments full of bitterness and sadness, precisely because he is an artist and from the start never satisfied and always unhappy.' Rollinat was writing furiously, engaged in the daily struggle of creativity, and they could commiserate together: 'He sees my pain and the trouble I take, and the two of us in unison, lament the difficulties of our art.' There were jolly evenings too, when they played the ubiquitous card game *cuistre* 31, joined by Monsieur *le curé*, the notary and the local chatelain. Alice forwarded the reviews from

Above: THE PETIT CREUSE RIVER.

Opposite: *The confluence as it looks today. The Bloc is on the left and the old oak has long gone.*

London on Monet's Antibes paintings, which they all pored over, but they could not fathom whether they were favourable or not because 'no one here speaks any more English than I do'. Theo Van Gogh finally sent extracted translations from the articles, 'where it is said', Monet related gleefully to Alice, 'that I am actually *the real hero of art*'.

Rollinat played the organ in the village church during Mass and Vespers which Monet loved, and he went to hear his evening rehearsals of the canticles and songs for a First Communion that was taking place: 'Every time he sings it's an event here and the bourgeois arrive from all over … It was superb,' he reported afterwards, 'and the joy of the *curé* was curious; he was saying that nowhere else are masses sung like this.'

By the end of April Alice was beginning to put pressure on him to return home, implying that it was Rollinat's companion, Cécile, an actress, who was detaining him. 'Can I never be near a woman without you having these ideas?' was his exasperated reply. 'You will never know me. My only care, my life, is Art and you.'

May brought sunshine, but he was dismayed to find, as he had feared, his effects completely transformed. He had to abandon a whole series that he had not been able to paint for three weeks, because the sun reflected on the water like 'spangled diamonds' and blinded him, and he had to relinquish yet another series because all the trees had been cut in the interim, and bonfires were burning at the very place he had set up his easel.

The most powerful image to emerge from Monet's Creuse campaign is of the cliff known as 'Le Bloc'. In reality the Bloc is no more than ninety metres high, but in Monet's painting it acquires monumental proportions, symbolic perhaps of the problems he was having. The letters he had been writing to friends and Durand-Ruel asking for the loan of his paintings for his exhibition with Rodin all met with refusal. Convinced he would have nothing to show for three months of agony, he panicked, telling Alice:

Notwithstanding the wind, the sunny spells and formidable downpours, I give three strokes of the brush to one canvas, and the same again to another … and then I immerse myself in the scrutiny of my canvases, that is to say, in the continuation of my tortures! Eh bien! If Flaubert had been a painter, what would he have written, Bon Dieu! And every day a letter from you, hurrying me, reclaiming me … I am doing the possible and impossible to make my return a possibility.

And he was true to his word. In the final days of his Creuse campaign, Monet was driven to the brink of artistic insanity.

It is decreed [he wrote on 6 May], that all the

been busy with it since yesterday. Isn't it a feat to finish a winter landscape at this time of year? … This sketch which I started three days after the storm and the yellow Creuse will perhaps be my best thing as I have been able to work on it for three days in a row.

The rape of the oak tree was the act of a desperate man, prepared to manipulate nature rather than compromise his art. The tree recovered, its leaves on the tree grew back – Rollinat told him so; but Monet returned from the Creuse with more questions in his mind than he had answers to. If his aim was to study and record nature, how could he reconcile that with the rape of the tree? And was this the kind of life he had envisaged for himself, going from landscape to landscape, always isolated, always under pressure to return, and just when he was beginning to understand and develop the techniques to render it, having to leave, promising to return but rarely doing so? He never returned to Bordighera, Belle Isle, Antibes, Venice or the Creuse.

The Creuse marked a turning point in his career and changed the course of his art. The crisis he faced seemed as unsurmountable as the Bloc of the Creuse itself and would take him over a year to resolve.

efforts I make will be useless. The weather is horrible again – a thunderstorm lasted all night, torrential rain, and this morning, *everything, everything* is green, the Creuse has overflowed and is like mud. I have to resign myself to losing it all. Don't think that once I've returned I'll find my canvases good – it isn't possible … I have just been to do a large sketch of my poor oak with the Creuse yellow. You can imagine the rages and difficulties I had. I have lost my will.

The next day:

I am going to try to offer the proprietor of this tree fifty francs to have all the leaves removed without which I can't do it … I have five canvases where it appears, and in three of them it plays the main role, but I fear defeat because he's a rich man, not very friendly, who already wanted to stop me going into a meadow of his, and it's only thanks to the intervention of the *curé* that I could continue to go there. *Enfin*, it is the only way to salvage these canvases.

9 May:

I am overjoyed – permission to remove the leaves of my beautiful oak has been graciously accorded! It was a huge job bringing large enough ladders into this ravine. *Enfin*, it is done, two men have

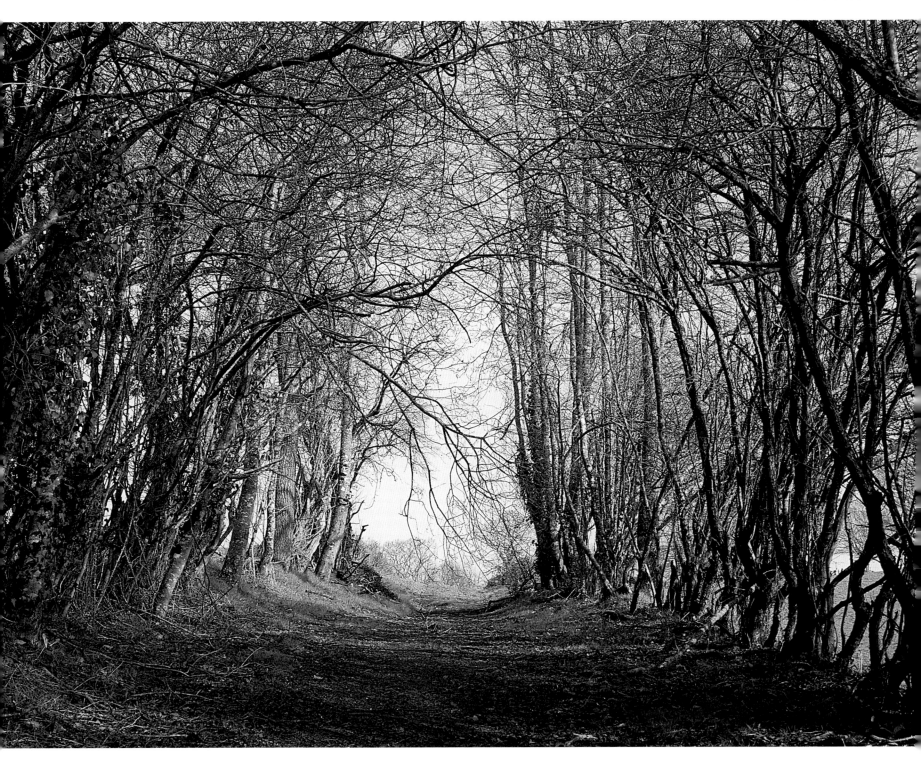

Giverny

"A landscape hardly exists at all as a landscape, because its appearance is constantly changing . . ."

Monet did not have time to dwell on the implications of the travesty of the oak tree, as he was preoccupied on his return in May in soliciting the loan of 145 canvases from reluctant lenders for his joint exhibition with Rodin, which opened on 21 June. It was a twenty-five-year retrospective of his work from 1864 to 1889, which included paintings of Etretat, Bordighera and Antibes, as well as those paintings of Belle Isle and the Creuse, some on show for the first time. In theory, the counterpointing of flat luminous colourscapes with marble, plaster and bronze sculptures was a wonderful idea, but in practice it all went wrong. Once again Rodin failed to materialize on the day he and Monet had arranged to co-ordinate the hanging of the paintings and the placing of the statues, in consequence of which Monet returned on the day of the opening to find that Rodin had

insensitively positioned all thirty-six of his statues with no regard for Monet's paintings, sticking his *Bourgeois de Calais* group right in front of what Monet considered '*mon meilleur tableau*' so that no one could see it. Monet was furious, and did not stay for the opening.

He was also vexed to find that three of his paintings chosen to celebrate the last century of French art at the 1889 Exposition Universelle, which marked the centenary of the French Revolution, had been hung in the entrance hall to the pavilion at the foot of the Eiffel Tower almost as wallpaper, to be glanced at *en passant* before moving on to more serious work inside. Manet's *Olympia* was the star of the show, and John Singer Sargent learned that an American dealer was about to offer Manet's widow 20,000 francs for it. Berthe Morisot, Manet's sister-in-law, appealed to Monet for help to preempt the sale, and Monet agreed to try and raise 20,000 francs by subscription to buy the painting and donate it to the Louvre. He who hated writing wrote dozens of letters to artists, writers, friends and patrons soliciting contributions, and entered into complicated negotiations on the conditions of the gift.

The hiatus in Monet's painting over the next year has been attributed to his intense involvement with saving *Olympia* for France, but in truth Monet had reached an impasse. Clearly, he could not continue to serve two masters: Alice and his art if he was to stay sane. The oak tree incident had driven that point home. He was physically worn out and mentally exhausted. These new landscapes were difficult enough for him to grasp and grapple with as he translated them into art, without the inconsistency of the

weather, the constant pressure from Alice forever reclaiming him and his own desire to be *chez lui*. He always felt wrenched from something he was just beginning to do well and left with a sense of work aborted. 'I spend my life starting things I can never conclude, which, in the end fills me with disgust, seeing all too clearly *hélas!* that it was impossible for me to have done any more than I did …' On the other hand, his art had made a splash in recent years by virtue of the novelty and variety of these panoramas. There was a real need to be seen to be doing new things – he who had been so radical in his youth had to hold his own against the competing tide of younger artists like Seurat and Odile Redon who were much talked about. But what could he offer as an alternative to these breathtaking adventures into colour and light? How was his art going to evolve, and continue to stun the world? His rural scenes in and round Giverny were gentle, beautiful, bucolic; but they had none of the exoticism of the Riviera, the drama of monumental rocks or the momentum of the sea. If he was now to be consigned to staying at home, how was he going to pull off the shock of the new from his own doorstep? How could he look upon Giverny, so familiar to him, with fresh eyes, and somehow make it as startling? Monet sank into despondency. '*Allons, allons, mon cher ami,*' Mirbeau counselled him in July, 'don't think about this too much now. Take your boots, your beret, your easel, and plunge yourself into work.'

It must have been late in the summer when he took up his brushes again, painting flowers, he said, and a figure in the studio. This was a portrait of a wistful Suzanne Hoschedé seated by a table, looking sad, her head framed by a

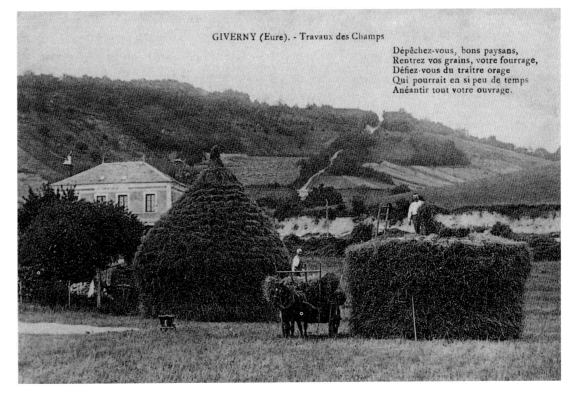

GIVERNY (Eure). - Travaux des Champs

Dépêchez-vous, bons paysans,
Rentrez vos grains, votre fourrage,
Défiez-vous du traître orage
Qui pourrait en si peu de temps
Anéantir tout votre ouvrage.

halo of three sunflowers. It has always been interpreted as an eerie symbolic portent of her early death, but given Monet's state of mind it is more likely to be an unconscious expression of his own melancholy. 'I have worked a lot,' he wrote to Geffroy on 9 October, 'but *hélas!* without success; the weather is so variable and I have just scratched out everything I had undertaken. Did I not set myself up to paint outside in the night? I have failed but will start again … *enfin*, I would like to progress, do better and never can.'

Monet became more and more depressed, reaching his lowest point during December. Darkness pervaded his language and psyche. He took to his bed and lay there all day, he told Mirbeau, for days on end. 'The weather is beautiful but I am not taking advantage of it, as I am more and more *dans le noir* and disgusted with everything … my state of mind appals me, never have I been like this.' His anguish was acute. Long spells spent lying in his room in a state of paralysing inertia were punctuated by periods of frenzied work. On 22 December he wrote:

There is a chance it might turn cold. Here everyone is sighing for it so they can skate, and me so I can paint because I continue to despair at

not being able to do anything with the variable weather we have had for so long. Oh! I can say I am worried about it. I have to work continuously, otherwise, if I have the time to examine and judge myself, I am done for darkness overwhelms me and I become as miserable and disagreeable as it is possible to be; also I feel myself ageing and I despair of all this wasted time.

If his landscapes were no longer to be new, his interpretation of them had to be. Monet had to reinvent himself. The person who helped him do this was his friend the poet Stephane Mallarmé, the most articulate exponent of the literary movement called symbolism. Mallarmé was an uncompromising poet who taught

English in various lycées in Paris, and as he did not live by his pen, he could write to please himself. He was younger than Monet by only two years, and the shared hero of their youth had been Baudelaire, who, with his love of the modern, wrote imagistic poetry that echoed the light and movement of life of the Impressionists, and also expressed the most fugitive shades of feeling and sensation. Mallarmé was to take on the mantle of Baudelaire, as Paul Valéry would later take on his, and push the frontiers of poetry further still to awaken the world of the unconscious and express what is dreamed.

Mallarmé sought a form of expression that was

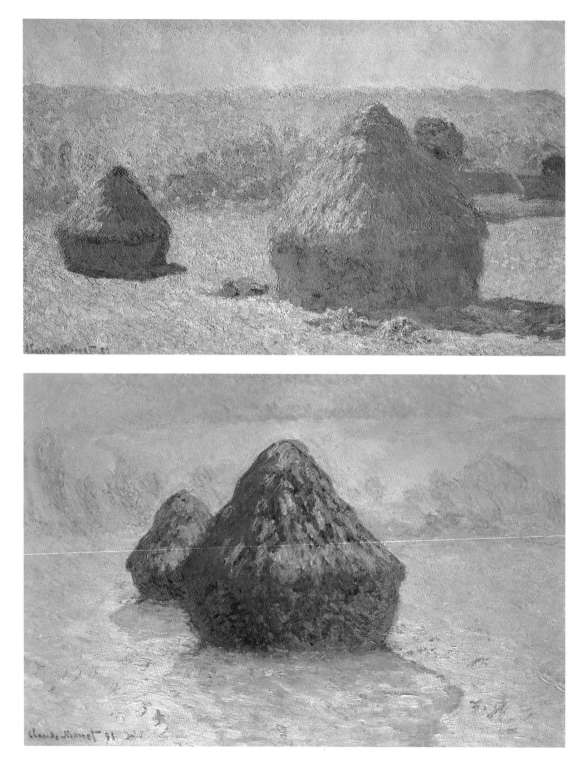

Monet's haystacks were like sundials, charting the course of the sun by the shadows they cast.

Left, above: HAYSTACKS AT THE END OF THE SUMMER, MORNING EFFECT.

Left, below: HAYSTACKS, SNOW EFFECT.

Opposite: *Monuments to agriculture, the haystacks remain the symbol of the harvest.*

suggestive rather than descriptive. The image was not drawn, but implied: a presence evoked by means of a shadow. He strove to capture and isolate the most elusive impressions, and then intensify them and give them resonance by setting them in a wider context. His 'expression', wrote an early critic, 'had to attain a form of extension, to be universal, eternal and all-inclusive'. There was a 'need for synthesis of the highly individual with the universal and that was the Symbol'. In December 1887, Mallarmé had approached Monet to illustrate his prose-poem, 'La Gloire', one of several to be published in a volume under the title *Le Tiroir Laqué* ('The Laquered Drawer') for which he had secured promises of other illustrations from Berthe Morisot, Renoir and Degas. Ostensibly intended to evoke the glory of autumn, the prose-poem is seeped in anticipation, in the minutiae of the narrator's departure from a train station he never leaves.

Although Monet and Mallarmé respected and admired each other's work, collaboration between them might have proved difficult. Monet dithered over the illustration to 'La Gloire' for nearly two years, and in the end,

withdrew from Mallarmé's project, excusing himself by saying that he was dissatisfied with what he had come up with, and 'couldn't do anything worthwhile with crayons, and would have preferred oils'. His efforts, he said, 'were unworthy to accompany your exquisite poems'. 'La Gloire' was perhaps too abstract, too obscure, too ahead of its time to be interpreted by Monet, whose art was based on reality. In fact, of the group only Berthe Morisot produced an illustration for the book and the project was dropped. In the middle of a lecture Mallarmé gave at Berthe Morisot's house for the Impressionist clan, Degas, who in his dotage had taken to composing sonnets and was ironically the only poet amongst them, lost patience, stood up and walked out muttering that it was utterly incomprehensible. The problem was that Mallarmé wrote in a kind of code that was baffling to all but a narrow circle who knew how to decipher it.

However, while the written word is limited by its appeal and accessibility to the intellect, music and painting reach the conscious and unconscious simultaneously, and can, initially be experienced on a purely sensory level. Monet realized that what was difficult to communicate with words could be more easily expressed and understood in art. As the Japanese aesthetic had inspired Monet towards bolder compositions, so symbolism helped liberate him from his obsessive quest for new geographical landscapes to explore the inner landscape of his emotions. Mallarmé's fearless innovation may have given Monet confidence in his own instincts, expressed all those years ago in Etretat when he was only eighteen, that 'my work will have the merit of resembling no one else's because it will be

an expression of what I personally feel ... the more I go on, the more I realize we never dare honestly express what we really experience.'

Monet's art during the early part of the summer of 1890 acquired a resonance it never had before, in his portrait of the doomed Suzanne, which he resumed, and in a new motif of the dreamy world of the underwater rushes of the River Epte.

The rushes, though, he said were 'impossible to do'. 'I am completely discouraged,' he told Berthe Morisot on 11 July; 'this satanic painting tortures me and I can't do anything. All I do is

scratch and destroy canvases. I know well that having gone for a long time without doing anything, I had to expect this, but what I'm doing is worse than anything.' He was hampered by continuous wind and rain: the rushes either swayed back and forth in the undercurrent, or the surface of the water became so ruffled that it was no longer transparent and he could not see the rushes at all. Ten days later, he was back

dans le noir and profoundly disgusted with painting ... Don't expect to see anything new – the little I've been able to do is destroyed, scratched or lacerated. You cannot imagine the

appalling weather which hasn't ceased for two months. It's enough to make one *fou furieux* when one is looking to render time, atmosphere, ambience. With this, all kinds of ills; here I am stupidly stricken by rheumatisms. I am paying for my *séances* in the rain and the snow, and what devastates me is to think I will have to abandon braving all weathers and working outside only in fine weather. *Quelle betise que la vie!*

He was brought to a complete halt on this new motif, cut literally from beneath his feet by the *riverain* who scythed the riverbed. What he needed to push the frontiers of his painting further was a motif that would not disappear overnight.

It was customary for Monet's near neighbour, the farmer Queruel, to begin harvesting his wheat in July and construct haystacks in a paddock to the west of Monet's house called Le Clos Morin. The wheat, cut and bound by hand into sheaves and moved by horse and cart, was stacked, in the time-honoured way, into beautiful architectural forms, six metres high, as craftsmen might lay stones to erect a cathedral – and in their own way they were just as solid, as they had to be able to resist the winter. Monet had painted the haystacks many times before – they appear in his canvases during seven of the previous nine years – first portraying them in classic picture-postcard compositions as he did with Etretat and Rouen cathedral, as a hunter circles around his prey, before closing in. He had made them the primary focus of a trio of 1888 paintings, which he infused with the shimmering light of the Mediterranean, still fresh in his mind, and he now picked up where he had left off. This

Left: '… *not only did the painting grip you, but it also imprinted on the conscience an indelible mark and that, in the most unexpected moments, one saw, in all its detail, floating before one.'* – *Wallisky Kandinsky.*

Right: GRAINSTACK (SUNSET), *smouldering in the setting sun.*

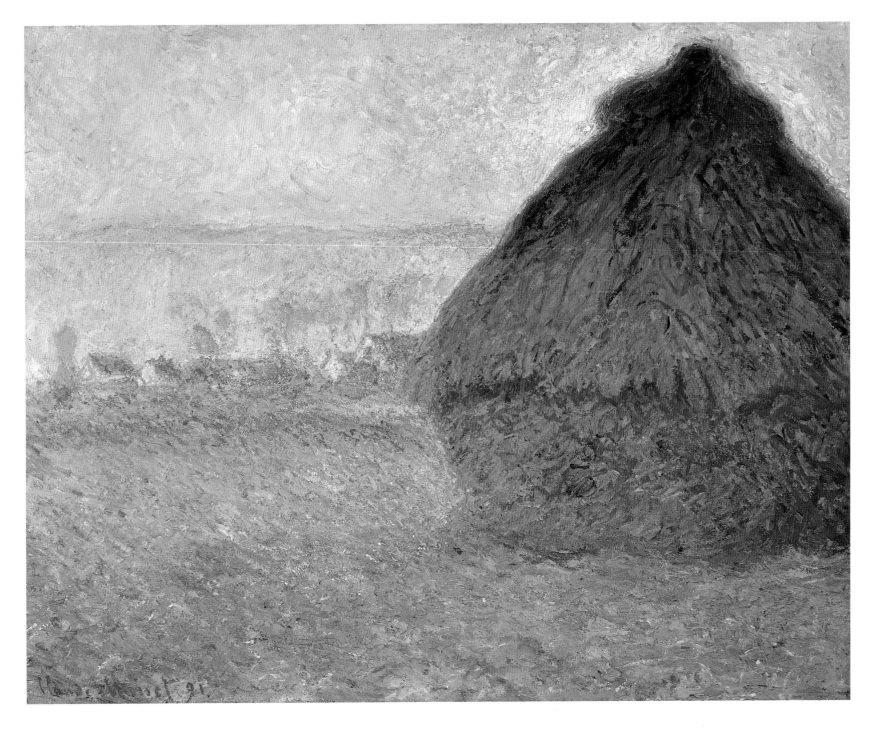

ability to return to the landscape time after time was precisely what he needed to extract its essence.

He must have started on the haystacks late in August and become quite excited at the prospect, because in early September, a heartened Mirbeau wrote to him; 'I am very happy that you have pulled yourself together, stronger than ever, and that you have renewed confidence in yourself. In any case, I was sure you would. You have a solid soul and a solid back.'

Whilst other painters depicted workers in fields, Monet distilled the universal theme of the harvest into an elemental symbol and projected his own sensations on to it by bathing the haystacks in a heightened, exaggerated, beatific light.

I am working a lot, having obstinately fixed myself on a series of different effects of haystacks, but at this season the sun is sinking so quickly that I can't follow it … I am becoming so slow in my work it is despairing, but the more I go on, the more I see that one has to work a lot to arrive at rendering what I am looking for: 'instantaneity', above all *l'enveloppe*, the same enveloping light spread everywhere, and now more than ever, easy things done in one go disgust me. *Enfin* I am more and more driven by the need to render what I feel and fervently wish to continue living without too many infirmities because I think I will make progress.

It was the most optimistic he had sounded for years.

Monet had emerged from the darkness, and

light flooded his canvases as never before. The strong radiant beauty of his work reflects his own new-found strength and stability. His house had come up for sale in October, and as he wrote to Durand-Ruel: 'I will be obliged to ask you for quite a lot of money, as I am on the verge of either buying the house where I live or leaving Giverny which would bother me a lot, as I am sure I will never find a similar set up nor so beautiful a landscape.' Three days over the milestone of his fiftieth birthday, 'I am finally happy, here I am now, a homeowner, and will certainly stay in our dear Giverny.'

Monet's glorification of these haystacks was possible because of the incomparable light with which Giverny was blessed and the snow that fell throughout December and January; the haystacks also allowed him to work in perfect, settled conditions for once, from home, in a landscape whose every nuance he had explored many times before and to which he now belonged. 'I am in full spate, outside from morning to night … the weather is so beautiful that I want to make the most of it,' he reported in December, and again in January, 'I am frantic with work, I have masses of things under way … wanting above all to take advantage of these splendid winter effects.' 'These canvases breathe contentment,' said Pissarro.

Monet worked on the haystacks throughout the winter, in sun and hoar frost, until one by one they disappeared and by the end of January 1891 he was forced to stop. The paintings were intended to be seen as a series, and from February to May he harmonized them in his studio. Fifteen went on show from 4 to 16 May 1891. 'A landscape hardly exists at all as a

landscape,' he would tell the Dutch critic Byranck at the exhibition the following May, 'because its appearance is constantly changing; it lives by virtue of its surroundings – the air and light which vary continually.' Monet sold all his haystacks within three days of them going on show, all for 3–4,000 francs each. The critics were almost unanimous in their praise. 'You have dazzled me recently with these haystacks, Monet, so much!' Mallarmé told him, 'that I surprise myself looking at the fields through the memory of your painting; or rather they impose themselves on me in the same way.'

Monet's journey into the liberation of his sensations took him into the realms of visual abstraction. 'When you go out to paint,' Monet told his friend and summer neighbour the American painter Lilla Cabot Perry, 'try to forget what objects you have before you, a tree, a house, a field or whatever. Merely think here is a little square of blue, here an oblong of pink, here a streak of yellow, and paint it just as it looks to you, the exact colour and shape, until it gives your own naïve impression of the scene before you.' He said, Mrs Perry remembered, 'he wished he had been born blind and then had suddenly gained his sight that he could have begun to paint in this way without knowing what the objects were that he saw before him.'

Monet was yearning for visual innocence, for a deconstructed perception of the world uncorrupted by conventional ways of seeing. His haystacks were so futuristic that when the young painter Wallisky Kandinsky walked into a gallery in Moscow five years after they were finished, and saw Monet's *Meule au Soleil*, he did not know what it was. He recounted in his

memoirs: 'Suddenly for the first time I saw a painting. It was the catalogue which informed me it was a haystack. I was unable to recognize it as such … and I noticed … that not only did the painting grip you, but also imprinted on the conscience an indelible mark and that, in the most unexpected moments, one saw it, in all its detail, floating before one.'

In Monet's time, the haystacks elicited comparison with giant sundials, to gems, to fulcrums, to pyramids, to extinguished stars, to the earth orbiting in space, the visual references of the era. What would a modern urban child who had never seen a haystack, still less a Monet haystack, with a visual world informed by science fiction movies, computer games and special effects, make of them today? Would he or she be as baffled as Kandinsky? To such a child, they might resemble alien spacecraft, vibrating with light and energy.

Monet had extracted from Le Clos Morin, he told a critic, 'everything it was capable of giving'; he had drenched his canvases in atmospheric effects to the point of saturation, which must have become oppressive, even to him. And so, still looking to reinterpret what he had around him in a new way, he brought the poplars that had always served as a kind of arboreal backdrop for his Giverny scenes, to the fore – wispy columns that were as if the cosmic haystacks, with their fiery energy, had finally lifted off the ground leaving vapour trails in their wake.

In turning to the poplars, Monet was returning to the simple graphics and airiness of the Japanese aesthetic. During 1890, he had made

Opposite: *Today, the Epte is as muddy as the Nile. The straggly abandoned poplars which line its banks, uncoppiced, and choked with ivy, bear no resemblance to Monet's exquisite trees. But just beside the Epte, in the Marais de Limetz where Monet painted, a sward of green grass cuts through a plantation of tall willowy poplars like a river, and gives a fleeting impression of how they might have appeared to Monet sitting in his boat.*

Above: POPLARS ON THE BANKS OF THE RIVER EPTE IN THE AUTUMN.

mirror of water with an even, delicate lightness of rhythm, movement and flow to which the heavy, earthy bulks casting dark, wide, slanting shadows had ceded.

He was, for the second year running, in despair about the weather. 'What a terrible season we're having,' Monet wrote in early June; 'it's impossible to work.' He told Mrs Perry that 'in one of his poplars the effect lasted only seven minutes, or until the sunlight left a certain leaf,' when he took out the next canvas and worked on that. He always insisted on the great importance of a painter noticing when the effect changed, so as to get a true impression of a certain aspect of nature and not a composite picture … he admitted that it was difficult to stop in time because one got carried away, and then added: 'I have that will power – it's the only power of will I have!' It was essential that an effect lasting only seven minutes should be in the same light and produce the same effect of that of the day before; so to find the weather constantly changing drove him mad. One day he vented his rage and 'decided to give up painting altogether,' Mrs Perry recalled, and, 'overboard flew the forevermore useless paintbox, palette, brushes and so forth into the peaceful waters of the little Epte. Needless to say, the night brought counsel and the following morning he arose, full of enthusiasm, but without any painting materials!'

He also arose one day to find he was soon to be without his motif as well. On approaching the poplars, he noticed that the bases of their trunks had been marked for felling. A meeting held on 18 June by the councillors of the commune of Limetz who owned the land on which the

several trips to Paris where there were two major exhibitions of Japanese woodblock prints on show: one, in the spring, at the Musée des Beaux Arts, and the other, the autumn exhibition 'Le Japon Artistique' held by Siegfried Bing, a prolific importer from whom Monet had bought most of his collection. 'I am finally happy,' he wrote to Geffroy the day after his fiftieth birthday, adding, apropos of the prints, 'I am constantly thinking of all those beautiful things and I hope Bing has put some aside for me.' Five weeks later, the prints still very much on his mind, he continued: 'I am waiting for your study on the Japanese landscape artists … speaking of which, if you have a chance to see Bing, remember to remind him to put aside the landscapes I requested, and when

I'm less preoccupied with work, I will go and ask him for them.' Although tree-lined rivers were a common motif with Japanese artists, there is a landscape by Hiroshige amongst Monet's collection of 230 surviving prints depicting a row of pines lining a sinuous riverbank that might have been Monet's particular inspiration for his next motif.

During the spring of 1891 Monet finished his haystacks. In April he was to be found floating on the River Epte by the marshes of Limetz, two miles upstream from Giverny in his Norwegian-style rowing boat fitted with slots to accommodate his canvases. He was busy with the antidote and the antithesis to his haystacks: the narrow, pencil-thin vertical reflections on a

poplars stood had decided to put the trees up for auction on 2 August. Monet asked the mayor for a stay of execution but this was refused, so he found a timber merchant and struck a deal whereby the merchant would outbid all the other bidders, and Monet would pay him the difference if he would let the trees stand until Monet had finished painting them.

Having replaced his paints and saved his trees, he had, by September, sixteen studies under way: 'I am taking a long time but I have been and still am absorbed by what I'm doing *sur nature*, making the most of the rare beautiful days.' The boat had by now become so crowded that a bigger one was needed, and he appealed to Caillebotte for help:

Cher ami, your boat would be very useful to me at the moment. I am working on a quantity of canvases on the Epte, and am very uncomfortable *en norvegienne*. If you really don't need it, send it to me either by boat, to Vernon, or the lock gate of Port-Villez, or by railway, which will be, I think the most practical ... if the boat is stable and large enough, it could render me a huge service.

But not the paints, the trees or the bigger boat appeased him: 'I have nothing but disappointments and difficulties with my poor trees, with which I am not at all satisfied,' he reported in October, and at the end of December, after a few days in London, he told Geffroy: 'I would have been so happy if you could have seen my *Arbres* before they are dispersed. On my return, they struck me as very bad.' He had, he admitted himself, '*cette maladie* of always hoping to do better, as if,' he added ironically, 'one can do what one wants.' As if!

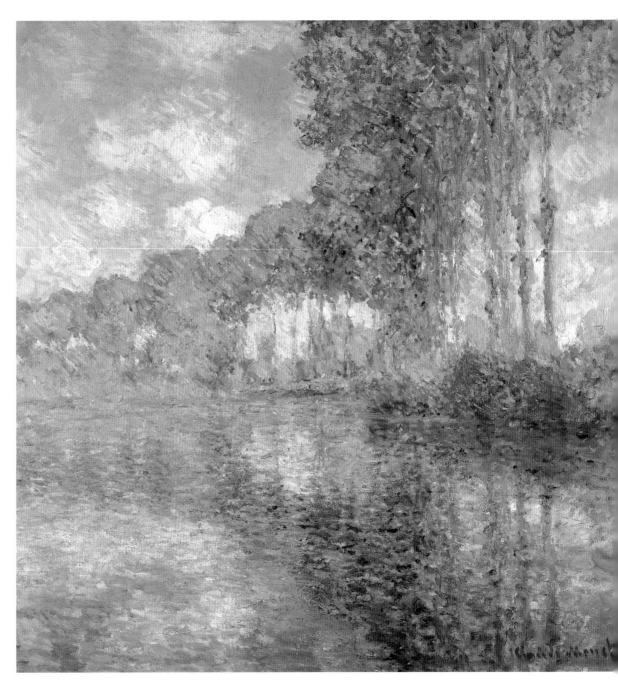

Opposite: *In the year before Monet started his poplar series, he bought many Japanese landscape prints. It is possible that this one by Hiroshige, from his collection, inspired the series.*

Above: POPLARS ON THE BANKS OF THE RIVER EPTE.

Rouen

"Everything changes, albeit stone."

After fifteen years of painting rural landscapes, Monet returned to the city. He had painted his haystacks under many atmospheric conditions, but fog was not one of them. On 5 February 1891, a week after the last of the haystacks had been dismantled, he met up with his friends at the Café Riche, and it is likely that the idea of a new motif in fog was discussed, because he sent Geffroy this telegram from his hotel the following morning: 'You know that in this fog Rouen would be astonishing to see, so you have to find a way of coming on the one o'clock train tomorrow.' Monet went to see Rouen in the fog and was excited about the prospects there, but he was unable to leave home in February, being preoccupied with finishing his haystacks, and detained there in March by Alice's absence as she nursed Ernest Hoschedé during his final illness through to his death. The Hoschedé children wanted their father buried in the churchyard in Giverny, and Monet bought the plot and made all the arrangements. The fog would have to wait another year.

He spent the summer of 1891 painting his poplars series, and took a few days off in December to attend a dinner in honour of James Whistler at the Chelsea Arts Club in what was then smoky, smoggy London. His desire to paint this atmospheric effect thus reawakened, he decided then and there to return to London in January of 1892 for a month or two. But mid-January arrived, and 'I am working in the studio, I have to get rid of a lot of canvases and I fear that this will prevent me no doubt going to London as I had planned … it is taking more time than I thought …' A week later, mindful of the lesson of the Creuse – of arriving too late in the season: '*Hélas!* The trip to London

postponed until next year.' Frustrated by his long internment in his studio, by having missed his chance in London and by having been unable to 'take advantage of the beautiful winter we have had here', Monet set off on 8 February for what he hoped would be a foggy Rouen, writing to an art critic before leaving: 'I am by nature always inclined to find everything I've done bad, and equally, when I take on something new, always thinking that it will be the most complete: illusion, efforts often disappointing but this does not deter me!'

Installed in the Hôtel Angleterre overlooking the Seine, Monet spent the first few days grumbling: 'Decidedly, these towns are not for me and I am very bored; things aren't going as I want.' No fog! He had first painted Rouen twice before from a distance, the spires of the cathedral poking out above the city, and now he moved into the centre. He began with a couple of motifs of town houses clustered around one of the towers of the cathedral, safe in the arms of the picturesque, but not very exciting by comparison to his recent work. Also, when painting from street level, his view was distorted by the tower which, irritatingly, leaned at an angle like the Tower of Pisa. So, perhaps to correct the perspective, he asked Monsieur Louvet, a shirtseller on the square, to take him upstairs to an empty apartment across from the cathedral.

As Monet stood before the second-floor window facing the cathedral a mere fifty metres from the cathedral, this great monolith rose before him, in all its Gothic majesty. He may have recognized in it elements from some of his own powerful motifs of recent years, vividly

imprinted on his own retinal screen, now superimposed on the cathedral: the monumental presence of the haystacks, the vertical lines of the poplars, the solid stony bulk of the Bloc in the Creuse. The 'landscape' of this cathedral may have been fashioned by man, but light shone and shadows fell and moved across it just the same. 'Everything changes,' Monet said of it, 'albeit stone.' His series of the cathedral would be the completion and the culmination of his visionary study of atmosphere, time and light.

'It's a colossal job, wanting to paint the cathedral; here I am embarked, I have to get there … what I've undertaken here is

enormously difficult but of great worth.' He plunged so deeply into a concentrated observation of the façade of Rouen cathedral as to lose himself in it almost exclusively for the next three years.

Happy with the perspective from the second floor, Monet initially painted from two windows in the block of buildings facing it. One belonged to Monsieur Louvet and the other belonged to Monsieur Levy, whom Monet referred to as his *marchand de nouveautés*, a purveyor of ladies' fashions and lingerie. Later on, Monsieur Levy put yet another window at his disposal. From these three vantage points Monet charted the oblique course of low winter sun as it travelled over the façade; in wet weather the façade became 'harmonies in brown', in sunny weather 'a symphony in grey and rose'. The weather on the whole co-operated, and was either wet or fine in the long stretches that were essential to his work. Unable to stop, Monet wore himself out: 'I rise before six and am at work from seven o'clock until six thirty at night, standing the whole time … It's killing, and for this I abandon everything; you and my garden,' he wrote to Alice.

Previous pages: *Detail of the façade of Rouen cathedral in all its Gothic intricacy.*

Left: *The city of Rouen pays homage 'to the painter of the cathedral'.*

Right: *Monsieur Levy's lingerie shop, now the Bureau de Tourisme. Monet painted from a second-floor window, hidden behind a screen, as it was here that the ladies' changing rooms were located.*

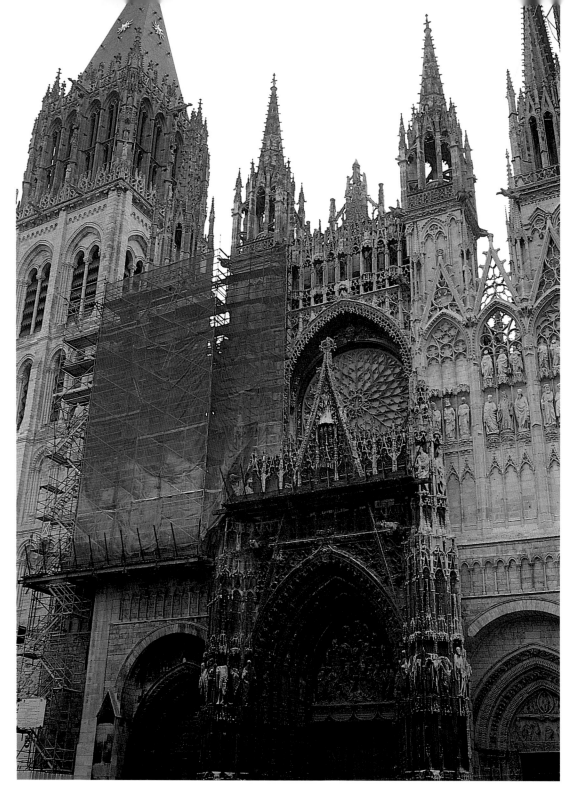

The experience of being face to face, day after day, with this great monument which floated before him like a mirage, with no reference points, must have assumed hallucinatory qualities to someone accustomed to painting landscapes with horizons, perspective and depth. His canvases were never out of his mind in his waking hours – 'I think of nothing but my cathedrals' – and haunted his dreams when he slept – 'I'm exhausted, and something that never happens, I had nightmares: the cathedral was falling on me and she seemed blue or pink or yellow …' He studied them every evening for at least 'an hour, smoking my pipe' by the light of 'an excellent petrol lamp and reflector' provided by the devoted Monsieur Depeaux, a wealthy Rouen industrialist and collector, 'and I see them wonderfully well …' Through the exploratory process of painting, contemplating, changing and, occasionally, demolishing and starting again, the strokes of paint proceeded slowly, uncertainly, towards a vision he 'felt' but did not yet know how to realize in paint, but which gradually through trial and error revealed itself. 'Every day I add or come across something that I didn't know how to see … and every day I discover new things not seen the day before and so add and lose certain things.' The cathedral paintings resonate with slow absorption and long reflection on his subject, which was of course how he arrived at distilling the mysteries of his pond.

He was working shielded from the elements in near-studio conditions with his motif just before him; he had long stretches of settled weather; he was near home. If only there had been a hotel facing the cathedral as the Hôtel Blanquet faced the Bay of Etretat, it would all have been

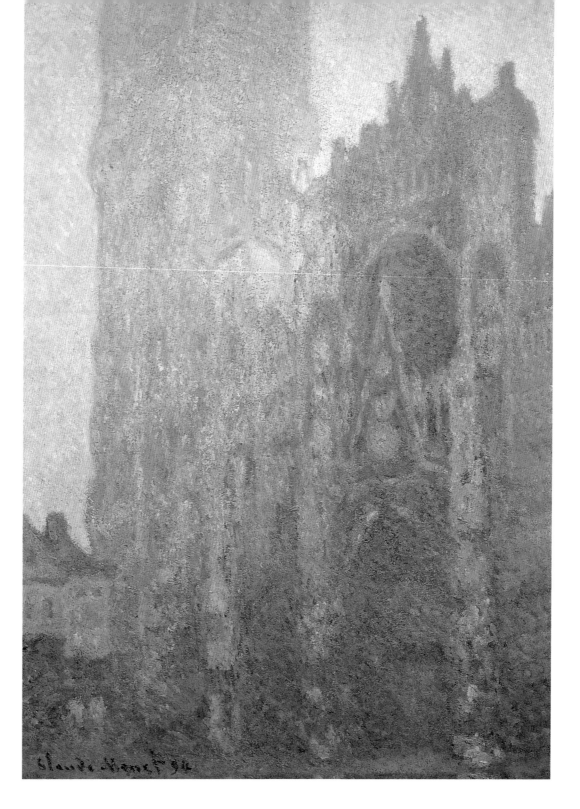

Opposite: *Rouen cathedral is being cleaned. The scaffolding will be up for the next fourteen years.*

Right: THE PORTAL AND THE TOUR D'ALBANE AT DAWN. *'Monet wanted to paint the cathedrals of France, high and beautiful like the rock of promontories.' – Geffroy.*

parfait. He knew from the beginning that he would have permission to paint from Monsieur Louvet's window for only 'a very short time' because the apartment was being renovated. He was barred entry when the painters were cleaning the floor, and when he had perfect weather for his 'red and gold motifs, I was forbidden entry by the painters acting on instructions from the architect not to let me in and remit my key to the architect'. As for the window belonging to Monsieur Levy, the *marchand de nouveautés*, which was on the same floor as the ladies' changing rooms, he fared even worse. In early April Monsieur Levy asked him not to come in the afternoons any more as his customers found his presence offensive. 'I didn't hide my dismay, offering him 1000, 2000 francs – anything he wants; he is willing to tolerate me for a few more days but I can see it bothers him.' Monet then had the bright idea of 'surrounding myself with a screen – that way I wouldn't trouble the prudery of the Rouennaises whom I was embarrassing, it seems; and my saviour, Depeaux, is sending me the said screen tomorrow.' However, knowing there was a man at the window, shuffling about hidden behind a screen, must have been as offputting for the respectable ladies of Rouen as it was claustrophobic for Monet, hiding behind a screen and probably trying very hard to keep his eyes on his canvas!

Right: *The portal. Monet would never have thought to enter it until one morning he found it 'draped in black which greatly hindered me … there was a great celebration in the cathedral … it was marvellously beautiful and I saw some superb things that could be done inside which I very much regret not having seen earlier.'*

Opposite: THE PORTAL (MORNING FOG). *'You know that in this fog Rouen would be astonishing to see … I think of nothing but my cathedrals. I'm exhausted, and something that never happens, I had nightmares; the cathedral was falling on me and she seemed blue or pink or yellow …'*

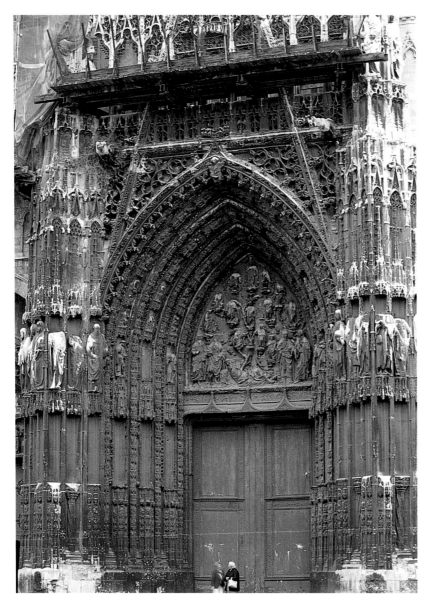

down a little.' He showed Durand-Ruel his cathedrals in May, but would not part with, or work on, or promise delivery of a single one.

Monet was overtaken by events in his personal life, and the rest of the year was marked by a long fallow period in his painting. On 16 July he married Alice, 'a union planned for a long time, but which we had to hurry along because of Suzanne's marriage, with, *hélas!* an American painter'. His official status as stepfather allowed him to give the bride away four days later, after which he went to the seaside and took the rest of the summer and most of the autumn off. 'We have been rather disturbed from our ordinarily regular and peaceful life and it has affected work so much that I have yet to pick up my brushes,' he wrote to Durand-Ruel in September and again in late October by way of explaining why he had nothing to offer him: '… this year, I have been in a state of complete lethargy, which I admit, frightens me.' By December, though, Monet was retouching and delivering old, long-promised canvases; in January, Giverny was gripped with ice and he was out painting the ice floes, but when a sudden thaw put a stop to that, he was back in front of his cathedral on 15 February 1893, and this time he had fog.

In all his previous campaigns away from home, Monet's letters habitually dwelt on the pain of separation, the difficulty of tackling a new subject and the weather which was never ever right; he placated Alice's jealous fits, worried about money, about his garden, his children, his dealers. But it was a different story now: Financial worries were a thing of the past; Rouen was less than two hours by train to

Frustrated by difficulties of access and by his inability to translate his vision – '*enfin*, I am searching for the impossible' – Monet left Rouen in mid-April: 'I am absolutely discouraged and dissatisfied with what I've done here; I wanted to do it too well and have managed to damage what was good,' he wrote to Durand-Ruel on 13 April. 'I don't even want to unpack my canvases, I only want to see them in a while; I will let you know when I've calmed

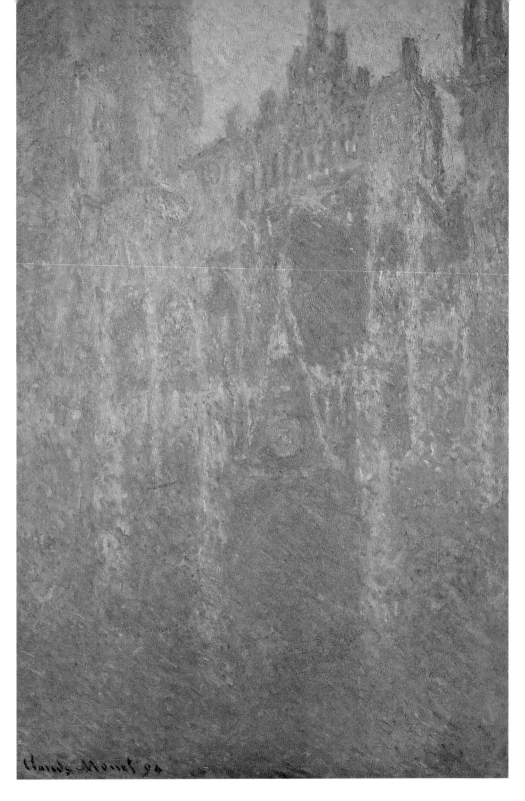

Giverny, so he went home most Saturday afternoons, returning on Monday mornings. Alice had no suspicions because he dined with his brother Leon, who lived there; his son Jean, who worked in Leon's chemical factory in Rouen; or with Monsieur Depeaux, who courted Monet in order to have first choice of his cathedrals: one to give to the Rouen museum, and one for himself.

But he never stopped struggling with his art. The letters Monet wrote during the second and final phase of his Rouen campaign are tightly focused on the highs and lows of his day-to-day struggle, and also provide revealing insights on his thoughts about painting exactly mid-way through his career.

16 February to Alice: 'I have started two canvases and here I am immersed in my subject … and as I see my effects from last year return, I will be able to work on them with confidence.'

22 February to Alice: 'How difficult this minx of a cathedral is to do!'

25 February to Alice: 'Weather foggy, filthy, very Rouenesque. I am very happy to have come back.'

3 March to Alice: '… I will get to the end with this cathedral, but I need a lot of time. It's only by dint of working that I will arrive at what I want; it wouldn't be surprising if it weren't definite again this time and that I am obliged to return next year … in any case I don't want to immortalize myself here or transform my canvases as the sun gets higher.'

9 March to Alice: 'Tonight, I wanted to compare what I've done with the old canvases, which I've avoided looking at too much so I don't fall into the same errors of my ways. *Eh bien!* The result is that I was right last year to be dissatisfied; they're horrible, and what I am doing this time is also bad, but just bad in another way, that's all. One must not want to do this quickly, but try, try again, to do it again once and for all … *sacrébleu*, those who find me a master are short-sighted – of good intentions, yes, but that's all. Happy are the young who think it's easy; I did, but no more; and yet, tomorrow at seven o'clock, I will be there.'

15 March to Alice: 'This cathedral is wonderful, but it's terribly arid and hard to do, and it will be a delight for me, after this, to paint *en plein air*.'

23 March to Alice: 'It is nine o'clock and I haven't been able to see my canvases today. I work so much that my palette hand (the thumb) is hurting me and is swollen. I am sending for another palette, as mine is too heavy.'

Throughout the months of studying the façade, incredible as it may seem, he had no curiosity about going inside, until:

I was interrupted today, and instead of working on twelve canvases, as I had hoped, I only worked on ten. There was a great celebration at the cathedral, the inauguration of the monument to the former archbishop Bonnechose. A sung Mass performed by 300 who had come from Paris … *bref*, since this morning the portal was draped in black, which greatly hindered me; so I wanted to go to this mass, but the seats at five francs had been sold out the day before; luckily, Madame Monier was able to obtain an invitation for me and I was wonderfully placed. It was marvellously beautiful and I saw some superb things that could be done inside which I very much regret not having seen earlier.

Perhaps this was just as well.

23 March to Paul Durand-Ruel: 'I am working to the point of being crushed by fatigue. It usually has to be like this for me to arrive at a good result.'

24 March to Alice: 'I am delighted with this weather – it's a pleasure to be able to follow one's studies with regularity. I don't dare say that I'm happy, but I am working fruitfully.'

28 March to Gustave Geffroy: 'My stay here progresses. This does not mean that I am ready to finish my cathedrals. *Hélas!* I can only repeat this: that the more I go on, the more difficult it is for me to render what I feel; and I tell myself that he who says he has finished a canvas is terribly arrogant. Finished, meaning complete, perfect. I work flat out without progressing, looking, groping, without arriving at anything much but the point of exhaustion.'

29 March to Alice: 'Fourteen canvases today; this has never happened to me. If I lived in Rouen it's now that I would begin to understand my subject … the lighting is changing enormously. It is no longer the oblique light of February – every day it's whiter …'

4 April to Alice: 'The weather has stayed the same but *hélas*, it's me and my nerves which change with every interruption in my work. When I looked at my canvases this morning, they seemed atrocious with the changed light. *Bref*, I won't be able to achieve anything good. It's a stubborn crust of colours, and that's all, but it isn't painting … What fatal destiny possesses me to slave like this in pursuit of studies beyond my powers.'

19 April to the painter Paul Helleu: 'I have finally returned to Giverny where I am resting. I worked, like never before, but I have so much difficulty now arriving at what I'd like. *Enfin*, I am less dissatisfied than last year, and I think that a few of my *cathèdrales* might be all right … I would be very interested to see your interior of the cathedral, it must be very good …'

He considered the twenty-eight canvases of Rouen cathedral as work in progress until he finally signed and dated them in 1894, and left the fog to find snow.

Right: *'It's a stubborn crust of colours, and that's all, but it isn't painting … what fatal destiny possesses me to slave like this in pursuit of studies beyond my powers.'*

Norway

"What beautiful things I see,
and what beautiful effects
that I didn't know how to see
at the beginning."

Left: *Monet's journey to Norway took five days travelling by trains and boats.*

Right: *Postcard of skating on the Christiania fjord: 'it's a craze, that's all they think about, tiny tots as well as the grown-ups, and everyone in those delicious costumes which make them look like Laplanders.'*

On 4 January 1895, Monet's stepdaughter Germaine noted in her diary that Monet 'often expresses his desire to visit Jacques'. Jacques was Germaine's brother, the eldest of Alice's children, who had gone to Norway a few months earlier to learn Norwegian, with a view to pursuing a career as a shipbroker. Six years had elapsed since Monet's arduous campaign in the Creuse, and he had confined his *plein air* painting to the familiar environs of Giverny, Rouen and the Channel coast. Perhaps he felt that for now, he had exhausted the possibilities there; perhaps he felt the old wanderlust stirring. He had always hoped for cold hard

Previous pages: *'It's impossible to see more beautiful effects than here – I am speaking of the effects of the snow, which are absolutely stupefying, but of an unbelievable difficulty … above all because of this immense whiteness.' The Sandvika fjord leads to the large island of Ostoya. It is a three quarters of an hour walk on foot; Monet travelled by horse and sleigh.*

winters in Giverny to paint the effects of snow, but here he was in January, and none had fallen. The prospect of rendering an immense white landscape on a scale he had never experienced before excited him, and with Jacques in Norway, the isolation and the distance there seemed less formidable, less daunting.

Monet left Giverny on 28 January, bound for the fiery Nordic sunsets of Munch, and the austere literary landscape of Ibsen, whose plays Monet had read in French translation. The journey took five days of continuous travelling, an expedition conducted in a seemingly interminable series of short hops and long leaps; first by train, from Paris to Cologne, Cologne to Hamburg, Hamburg to the Danish port of Kiel. In Kiel he boarded a boat, bound for Korsor, on the Danish island of Sjelland, and as he left port he entered a world of ice and snow that would engulf him for the next two months.

I took a very good cabin, and falling over with fatigue, I fell asleep immediately [he wrote in his first letter to Alice], but at two in the morning I was awakened by a strange noise. It was hail hurtling on the boat, an infernal battering, then nothing. The boat stops. I was going to get dressed and go out on the bridge but was halted by men entirely covered in snow and frost, a wonderful sight. Other passengers also woke up and we learned that there was such a blizzard the captain couldn't see anything and we couldn't continue. We dropped anchor and with that more rolling and pitching, and then the siren. *Enfin*, big dramas and then all of a sudden we're off again, and the snow ceases. I go back to bed. This happened twice in the night, but in the end it was like being rocked in a cradle, and I slept for four hours.

The voyage took nine hours instead of five in these appalling conditions, and the *sang froid* with which this 55-year-old painter describes this hazardous journey is quite remarkable. In Korsor he climbed on a train and crossed the

island of Sjelland to the port of Helsingor, where he was to catch another boat to the Swedish port of Helsingborg. Having missed his connection, he sat down and wrote to Alice whilst waiting for the next boat:

Here am I safe and sound … It's a hard journey when one is no longer twenty, but a good scrub and a good night's sleep, and I will be *d'aplomb* … Where I am in Helsingor, it's delicious; one can see Sweden, twenty minutes away by boat, the sea with snow in the foreground. *C'est épatant* – it's stunning, it's divine, and for the first time I'm seeing something really beautiful; for up until now, I've been a little disappointed.

When he disembarked in Helsingborg, he ran to the railway station to find he had also missed his connection to Christiania (now renamed Oslo). This was to be the final leg of his journey, another twenty-four hours of travel, but at least it was direct. By way of compensation he went directly to the '*le plus chic*' hotel in town – 'delicious, and entirely our taste' – for a good wash and hot food which was mediocre but comforting. He consoled himself, he told his wife, 'by writing these lines to you, and by telling myself that from eleven o'clock on, I will sleep like a log, and the day will break just as we enter Norway.'

Even though it's evening, the town is very gay, entirely different to Denmark; there are only sleighs and sledges of all kinds, rich and poor, kids of five in tiny sleds and all this accompanied by the tinkling music of sleigh bells. I am feeling in a whole other world, and I'm still twenty-four hours away from Christiania. Up until now, as I told you earlier, I was most vexed about all this upheaval

for so little that was new, thinking that between Calais and Dover there is a big difference; one senses by this, that in time, all the countries which don't have a special conformation will resemble each other; in things and people.

Have we here the intimations of an early Euro-sceptic, forseeing the loss of national identity and character in the inevitable integration of Europe – all that is save England?

At Christiania he was met at the station by Jacques, who had cleverly averted a welcoming party of local dignitaries by pretending he did not know the arrival time of Monet's train. Jacques had taken a room for Monet in his own modest lodgings where in the first few days he

recouped from his marathon journey. It was bitterly cold: minus ten degrees at noon, minus thirty at night. As Monet acclimatized himself to the bracing air, he and Jacques explored the town, ate out and lingered in bars, and Monet soaked up the atmosphere.

I will give you my impressions of Christiania [he wrote to Alice two days after his arrival]. The great beauty of the fjords is the water and the sea, only now they don't exist; it's only smooth ice, and you traverse it on foot, and by sledge, which is marvellous, but what is really delicious is the life here; going everywhere by sleigh, enveloped in

Below: A molten Nordic sun sets on the Oslo fjord.

furs, it's exquisite; and the famous dogs.

He revelled in the Norwegians' enjoyment and participation in their snowbound landscape:

It's a craze, that's all they think about, tiny tots as well as the grown-ups, and everyone in these delicious costumes which make them look like Laplanders. It's a great joy for me to see them; and that's all you do see, groups leaving with their sacks; they go off into the mountain, night and day, at night with torches.

Four days after his arrival he and Jacques too set off on an excursion, into the fairytale wonderland of the mountains, the heart of the landscape of Nordic folklore. The image of him 'covered in ice, eyelashes frozen, decked out like Laplanders, and enveloped in enormous bearskins' travelling by horse and sleigh hour after hour through forests carpeted in deep snow is breathtakingly cinematic. He could almost imagine himself in a scene from Ibsen's dramatic poem *Peer Gynt*, and given his penchant for breaking into song, he probably could not resist humming the lyrical tunes that Grieg had composed for it twenty years before. Sadly, there were no trolls, but

the bears are not a myth – we travelled in superb pine forests which were filled with them but they are hidden and never come out in periods of great cold ... what beautiful things I have seen from the heights of these mountains which rise perpend-icular to immense lakes entirely taken up and covered in snow! There we had more than a metre over which our sleigh glided, the perspiring horses covered in hoar frost and ice like us. I've also seen hundred-metre waterfalls entirely frozen. It's

extraordinary ... And all this is stored in my brain.

He described himself as being in a state of 'perpetual marvelment' at all that he saw in those early heady days discovering the land of the midnight sun. And then the fatal words: 'I think I shall start working Monday or Tuesday.' With this sentence the euphoric dream evaporated and the familiar spiral of his anxieties began to uncoil. He and Jacques returned to Christiania to begin looking for motifs, but as it began to snow, the mist and fog

moved in and he could not see a thing. Whilst Jacques had been there long enough to make himself understood in Norwegian he had not

Opposite: *A traditional Norwegian cabin on the shores of the island of Ostoya, across the fjord from Sandvika.*

Below: THE RED HOUSES AT BJORNEGAARD, NORWAY, *at the top of a hill in Bjornegaard north-west of Sandvika where Monet stayed. The houses are still standing but it was impossible to reach them by car as the snow was so deep.*

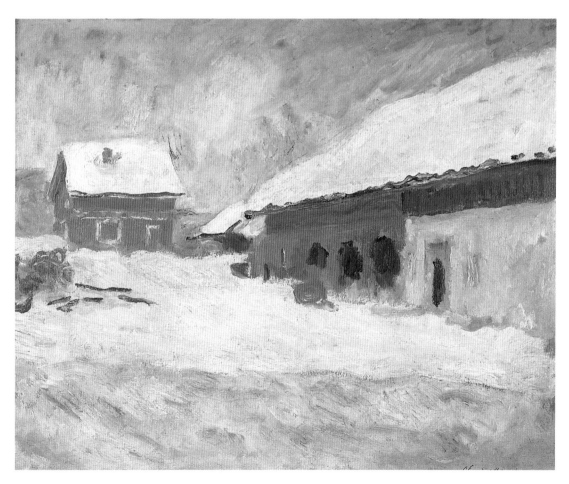

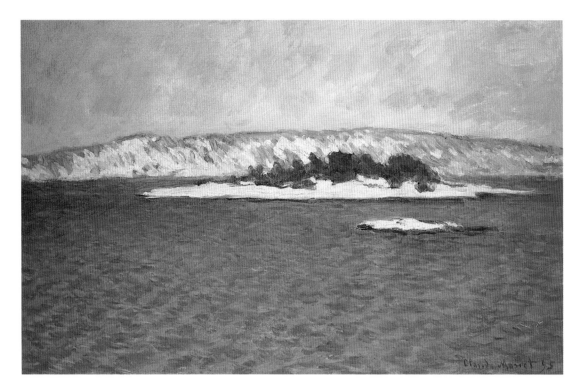

for places to paint on the outskirts of the city, which he and Jacques reached by train. The motif had to be near a railway station as he and Jacques had to carry his easel, canvases and paintbox, and because neither of them could ski, they had to find something he could paint from a cleared path. 'I have to find my motifs on paths already traced, because if you veer away from them you sink in three metres of snow.' The snow was enchanting to look at, but a real problem when it came to painting. Monet began to lose heart. '*Je vois la chose trop difficile*' – it is too difficult. 'The time it takes to set up the equipment, the daily comings and goings from Christiania are a great loss of time and render working impossible.' And as always when he was frustrated, he found fault with everything else. On 13 February he poured them all out to Alice. Where everything had been marvellous, everything was now dreadful. His mood, he said, was sombre. Giverny was under snow and ice and when he thought of all the motifs he could be getting on with, he regretted not being there. He was worried about his garden, and the newly planted flowers around his recently enlarged pond. He had seen enough of Norway, as he had no desire to see more of a country he could not paint. What was more, he was too old to embark on such journeys to foreign lands; in France everything was to hand, and one could be housed and work according to one's wishes and make the most of one's time. He was accustomed to his Giverny routine of an early breakfast, lunch, dinner and bed to make the most of the early light, and the Norwegian timetable of late meals and rising late did not suit him. To eat outside the customary hours of the country was impossible and he could never find a restaurant open when he was hungry. The

been there long enough and perhaps was not curious enough to show Monet anything but the well-known sites. As they explored Christiania together, Monet was recognized in cafés and restaurants because the press treated him as a local celebrity and reported all his movements. The town officials wanted to honour him with a banquet but Monet resisted. 'I told them I was accustomed to living modestly and whilst I was very flattered, made them understand that I didn't like this kind of thing.'

The fog cleared, but he still could not decide what to paint. He could not absorb the landscape fast enough and was bewildered by the choice. Nevertheless, he began to make preparations. He armed himself against the cold, 'for one

needs to be hermetically sealed', by purchasing boots, coats and hats, and as he went round the shops he noticed 'all manner of furs' and enquired after the price of a blue fox. 'The silver fox seemed very expensive to me … it's shocking how much of it one sees – everyone is swathed in it.' The Norwegians, accustomed to seeing foreign visitors during the summer months, were as impressed by Monet's braving their frozen winter as they were astounded by his resistance to the cold. For his part, Monet was equally astonished to discover that the Norwegians felt the cold, and took such a childish pride in his own hardiness that he mentioned it to every person he wrote to.

Monet had lodgings in Christiania but looked

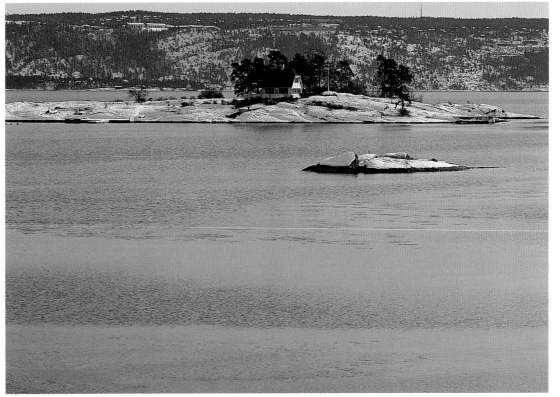

Opposite: THE CHRISTIANIA FJORD (OSLO). *'It is half an hour away from here; you go by sleigh and arrive just at the point where the fjord is no longer frozen (above) … and I have there a delicious motif, small islands, skimming the water, entirely covered in snow and in the background a mountain.'*

Right: *The wooded isle of Krokholmen and the Nesoddtangen peninsula beyond.*

houses were all overheated. They were very amiable people, but they were getting on his nerves. 'And all this because I can't work.' He was ready to pack his bags and go home.

What a grump! But he was not one for giving up: 'and whilst being very discouraged and very very close to taking the boat for Le Havre, I still want to try and find a corner in which I could install myself.' Then a local artist he had met suggested he move out of town to the boarding house of Fru Bjornson, former wife of the noted Norwegian playwright, which had become an unofficial artists' colony for writers and painters. The boarding house was in a tiny village on the

outskirts of Sandvika, three quarters of an hour from Christiania by train and sleigh, and Monet and Jacques went to see it. Upon their arrival they were immediately recognized and whisked off on a two-hour tour of the countryside by sleigh. What Monet saw delighted him so much that he immediately retraced the whole tour on foot. 'I shall wire you with my new address. Here I am, cheered up. I think I'll start tomorrow.' Those terrible words again.

Monet was much happier in his new quarters: 'comfortable bed and very good food. At Christiania I would have ended up losing weight.' But in the pension, everyone ate

together, and Monet had to comply if he was to eat at all, and 'afterwards we retire to the salon and there's no end to it'. Giverny was still gripped in ice and snow and he feared great losses in his garden. His imprudent gardener Kleber had not protected the bulbs, and all the jobs that needed to be done would be delayed by the freeze. Defeated by Norway, his ineptitude made him cross and he was tormented by 'what I could be doing now in Giverny'. But he did not speak of leaving. Instead he went on to describe another dazzling event, the great annual ski race, for which he had to reserve a sleigh and horses ten days in advance. The whole population of Christiania and for miles around,

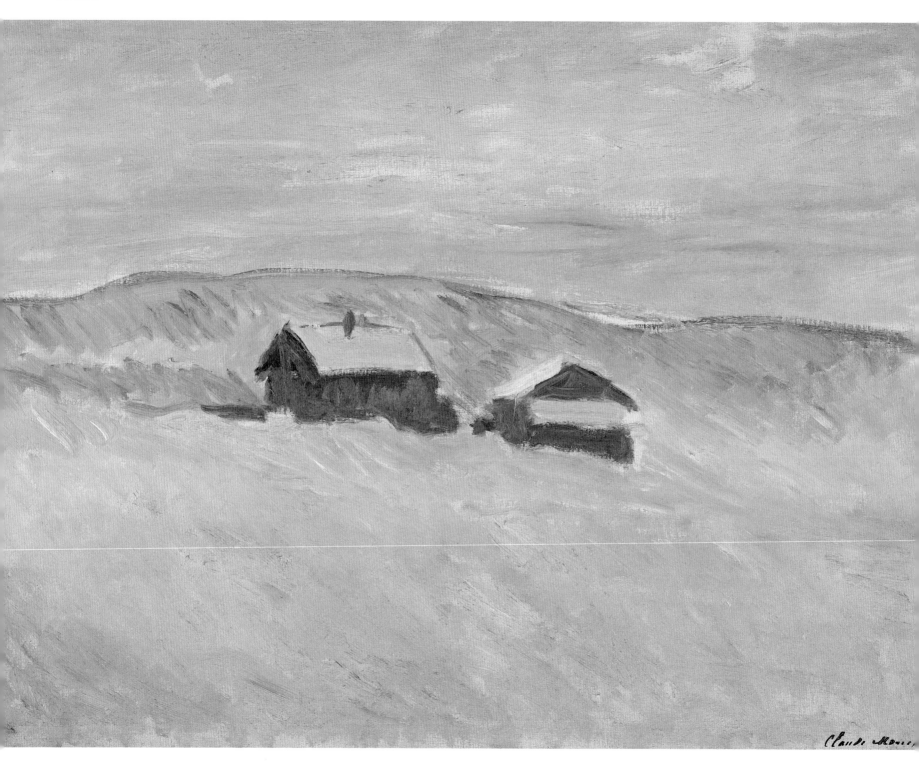

Left: NORWEGIAN LANDSCAPE, THE BLUE HOUSES. *Outbuildings of a farm near Bjornegaard used by the engraver Werenskold to illustrate a fairytale by Asbjorsen and Moes.*

everybody in sleighs, sledges and sleds, or on foot, gathered at the top of the highest hill behind Christiania around a 150-metre piste which was punctuated by jumps 20–25 metres high, to watch the race. Afterwards, he watched thousands of people, sleighs and horses make their way home across the frozen lake; 'this will give you an idea of the ice …Today, for the first time, I have realized what the fjord of Christiania is,' he said, the motif of the fjord already forming in his mind.

The beauty of the landscape and the intract-ability of the snow ran circles around him:

I see so many different things to do here, and that's what infuriates me the most, because it's impossible to see more beautiful effects than here. I am speaking of the effects of the snow, which are absolutely stupefying, but of an unbelievable difficulty and as the weather is constantly changing in a way unknown to us, and above all because of this *immensité blanche* **– immense whiteness … I am ever hopeful of getting down to it, but you need a lot of time to understand and see things clearly … It's a wonderful country, but too far to return, and from this stems my sadness and discouragement, seeing the days pass without having been able to do anything. What is so regrettable and stupid is having got it in my head to bring something back; you can't come to a country as different as this and just start painting point blank.**

Time and again he set off '*avec armes et bagages'* – lock, stock and barrel, Jacques being led round like a donkey to return with nothing. At the same time, he knew only too well how infuriated he would be if he were to return to Giverny with nothing to show for all this time, effort and expense. One may wonder why Monet was having so much trouble getting started. Perhaps he was no longer interested in painting beauty for beauty's sake. He had broken new ground in the past five years with his pioneering haystacks, poplars and Rouen series, having mastered a light that was almost second nature to him. New work was now expected of him, and he wanted to be daring, but what was he to do with all this whiteness?

Finally, on Thursday 21 February, three weeks to the day after his arrival, the two words everyone at home had been waiting for: '*Je travaille'* – I am working. He had at last settled on two small barns on the crest of a hill above his pension, the same two that were used by the engraver Werenskold to illustrate a fairytale by Asbjorsen and Moes. By the end of the week he and Jacques had liberated themselves from the tyranny of the public paths with a solution so simple that it is a wonder they did not think of it sooner. 'Today, we armed ourselves with shovels and cut paths in the snow, in certain places where I thought the motifs would be better than on the established paths where there is always something in the way.'

And with this start, incidents that would have irritated him now amused him:

Here there is always a party; I have been able, because of my discontent, to escape some of them.

Above: *Detail of a wooden cabin from Hokusai's woodblock print* SUMIDA RIVER IN SNOW.

Below: *Detail of a Norwegian cabin on the shores of Ostoya. The cabins struck Monet as being Japanese.*

Left: *The Lokke Bridge spans the small coastal river of Sandvikselva. Unfortunately, the brick buildings which have sprung up beside and behind it during the last century bear absolutely no resemblance to a Japanese village.*

Right: SANDVIKEN VILLAGE, IN THE SNOW, *showing Lokke bridge with the hills of Lokkeasen overlooking few of the houses in Sandviken. 'I have under way a view of Sandviken, which resembles a Japanese village ...'*

The other day, they had guests, and everyone stood up to make a toast 'to the painter Claude Monet, a glory of France', and clinking their glasses immediately began to sing the 'Marseillaise'. You can imagine the expression on my face. It concluded with a deafening 'hip hip hourra'. Thankfully I resisted the drink these people imbibe in great quantity, a mixture of wine, milk and beer – *quelle bizarre nourriture* – what bizarre nourishment ... I am going to muster all my courage and will power to give myself a good start tomorrow morning. My canvases are ready; I know where I must go at different hours, weather permitting, as there are places I've seen in grey weather which aren't possible in the sun, as the sun is so brilliant and blinding – nearly everyone here wears glasses.

He was resolved and poised for action, and fortune finally smiled on him; his three main motifs were fixed and almost simultaneously under way within forty-eight hours. He had found an angle, a way into interpreting the Norwegian landscape by finding similarities with the landscape of his Japanese woodblock prints. It had taken a whole month to make

the connection, and on 1 March he described it to his stepdaughter Blanche, a keen amateur painter herself:

Yesterday, I was finally able to see the sea; no, not *le large* – the open sea, but a part of the fjord where there is no longer any ice. It is half an hour away from here; you go by sleigh and arrive just at the point where the fjord is no longer frozen. It was marvellous and gave me enormous pleasure and I have there a delicious motif, small islands, skimming the water, entirely covered with snow and in the background, a mountain. It's like Japan, which is moreover very frequent in this country. I have under way a view of Sandviken,

which resembles a Japanese village, and I'm also doing a mountain that one sees from everywhere here, and which makes me think of Fuji-Yama. I had to start six canvases of the latter, so variable are the effects, but will I be able to finish them?

The first motif he described to Blanche was the little islands off the much larger island of Ostoya, which he would have glimpsed from his view of the fjord on the day of the great ski race. The second motif he described was a view of the Lokke Bridge in the Japanese-style village of Sandviken. Confronted by the vast monotony of white, he infused whatever colour he could into his canvases, finding red, yellow

and blue wooden houses, azure skies, molten sunsets. The third motif, of which he brought back twelve studies, was Mount Kolsaas, which rises above Sandviken. Frankly, by comparison to the elegant conical configuration of Mount Fuji-Yama, it is a bit of a lump, but it was the way it dominated the local landscape that reminded Monet most of this legendary Japanese mountain.

Settled on his motifs, he seemed happier and more confident. Blanche was supervising the garden at Giverny, which alleviated that worry, and he was even talking about bringing back some native plants from a special botanist. His fellow lodgers had finally understood his need for privacy and now left him to it, and he for his part was relaxed enough to join their sledging party one evening on his return from work. He went up the hill on a horse-drawn sled, and flew down 'at such a vertiginous speed' that he was catapulted off the sled and pulled a muscle in his leg, 'to the great *desespoir* of the *demoiselle* who was driving' him. He had to be energetically massaged the next day and even then could barely hobble about.

He had all the usual problems we have come to know so well: he was never in the right place for the right motif under the right conditions; if he had canvases in sun, the sun would not shine for ten days; and as soon as he changed them, the sun would come out. 'Today we had fog, sun, snow, it was clear, it was black, and none of it at the hours it would have suited me. *Enfin*, I am determined, at whatever the cost, to bring back a few pieces of Norway.' He worked in all weathers: 'You should have seen me, entirely white, my beard covered in stalactite icicles.'

Only heavy snow could stop him, when it was impossible for him to find a sheltered spot or an umbrella wide enough under which to paint; and when it stopped falling, when he would

Opposite: *Hokusai's* The Tama River in the Province of Musashi *– Mount Fuji seen above mist on the Tama River.*

Above: *View from Ostoya over the fjord. 'I was finally able to see the sea; no, not le large – the open sea, but a part of the fjord where there is no longer any ice … It's like Japan, which is moreover, very frequent in this country.'*

have loved to have captured the blanketed trees and pines, the effect swiftly vanished: 'One hour of sun or a little wind, and everything will fall …'

I am working, but so much of my time is wasted. *Bon Dieu*, every day there's a hitch, every day I have to start over … I start new canvases all the time and can never find the same effect twice; I really don't know if I will manage to finish even one of them … I have lost courage, I need your *appui* and encouragement more than ever.

Alice admired, encouraged and sympathized as best she could, but she had troubles of her own. Underlying the whole correspondence is the ever-lengthening dark shadow of the declining health of her daughter Suzanne who had developed complications after the birth of her second child. Whilst she knew all too well that Monet's cycle of doubt and despair had only to run its course before it bore fruit, she had grave doubts about the recovery of her daughter.

To spare Monet and prevent an immediate return home, Alice delayed telling him of the death of Berthe Morisot until after she had attended the funeral. Monet was devastated by Morisot's death: 'I can't think of anything else. She was so intelligent, so talented that I can't stop thinking about it. How I regret not seeing her before I left.' He had painted the ice floes on the Seine during the epic frozen winter following Camille's death, and here he was again before a frozen landscape haunted by the deaths of so many others since: Manet, Sisley, his dear friend Gustave Caillebotte only the year before, and now Morisot. 'It's very sad, and very hard to see all one's friends leave so early. Of our little group, how many of us are left, *hélas*?'

A journalist asked him if he would agree to exhibit his Norwegian landscapes before departing from Norway. 'You can imagine how warmly received his suggestion was,' he noted drily. 'All the painters are dying of curiosity to see what I am doing, but so far I have refused; if they saw my canvases in their present state, they would be stupefied and very disappointed.' But he must have been quite pleased with them because he wrote to Paul Durand-Ruel asking

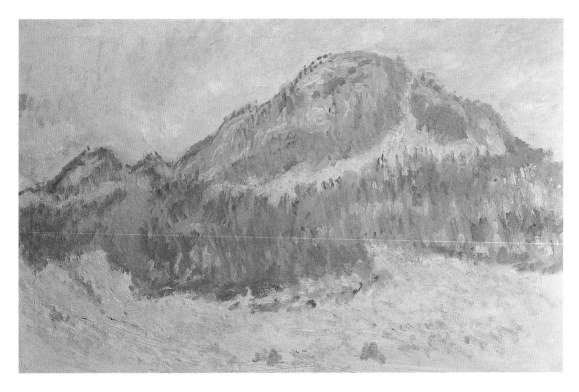

only he were there for longer.

I am always starting new canvases without being able to get back to them a second time, and meanwhile I know that I am better able to see and understand how to render this nature, but I would need months for this … one would have to live here for a year to do something good and even then, after having seen and got to know the country … What beautiful things I see, and what beautiful effects that I didn't know how to see at the beginning. It's now that I realize what needed to be done, and how I should have come a month earlier, and certainly this country is worth taking the trouble to return to.

But it was too late now to start new canvases and for the ones he had under way the sand was coursing through the hourglass. Painting on the island of Ostoya on the fjord came to a halt on 12 March because vehicles could no longer travel over the ice safely. 'If I am a bit late in writing to you,' he wrote to his wife that evening, 'it is because I have been contemplating these poor canvases of mine which will be neither impressions nor canvases *un peu poussée* – progressive. And it's so beautiful here! What bad luck to have been here in March as it is always the same.' As in the Creuse, he should have arrived a month earlier.

He stopped painting on 27 March, and left the pension for Christiania, where he spent a few final days going to the theatre to see Ibsen and Bjornson, and received a visit from Prince Ernst, son of the King of Norway and an amateur artist himself, with an entourage of painters and journalists who came to see Monet's local landscapes, which he had consented to show

if he could delay the planned exhibition of his Rouen cathedral series by a fortnight so that he could include a few of his Norwegian landscapes. He was working successfully enough to describe himself as being 'in his element'. He had even managed to persuade Fru Bjornson to give him breakfast at six o'clock in the morning. She asked him to return the favour by attending a ball she was giving for one of her helpers, but, he wrote, 'I knew I would be the prize catch. And as nice and obliging as you know me to be, I refused, saying work above all else, unless it was bad weather. I could tell by their demeanour they found me decidedly ungracious.' To the delight of the *pensionnaires*, it snowed heavily and Monet came. '*Enfin*, ball, dinner, from two in the afternoon until one in the morning. It is now 11 a.m. and they have started dancing again. The waltz is all the rage with the Norwegians.'

Committed now to exhibiting his Norwegian work, he made a spurt to the finishing line, and with that came despair at the threat of an imminent thaw: 'the days are lengthening so rapidly that by June there will be virtually no night; the sun is getting hotter'; the very snow he was painting was melting before his eyes. His greatest anxiety now was the 'fear of waking up to hear water running everywhere'.

As with all his landscapes, Norway grew ever more wonderful the longer he was there and he could do ever more wonderful things with it if

them after all. 'I can't imagine what he is going to make of these violent, unfinished canvases.' But he need not have worried. 'Everyone is full of admiration. All the newspapers are talking about it; they are really not very demanding, but I have to confess that I am touched by their endorsement, which appears sincere.'

And then, just before his departure, Monet discovered something he would have liked to have painted most of all. The captain of the port of Christiania took him out to the extremity of the fjord in a new boat designed to break up the melting ice. 'We spent the day amidst the ice in utterly beautiful landscapes. I am *émerveillé* – wonderstruck, but also in despair at not having been able to see this earlier. I stood on the bridge in this invigorating air all day and I am tired, and also annihilated by the emotion of all I have seen.'

He was scheduled to leave two days later, on 1 April; 'it will be a difficult moment for poor Jacques, but as I imagine a few artists will be at the station, to say *adieu*, he will have friends there and it will be less hard for him.' The patient, solicitous Jacques had been at Monet's side throughout, and as his porter had occupied himself while Monet painted by teaching himself cross-country skiing, or by building himself little snow houses in which he sheltered

to study Norwegian. Their falling-out over money after Alice's death fourteen years later would blight Monet's happy memories of their companionable battle with the snow.

Monet returned to Giverny by boat and train, via Copenhagen, and immediately wrote to Durand-Ruel on 7 April. 'Here I am, finally returned: I am going to rest one or two days and then organize and finish the canvases I am going to exhibit for the exhibition towards 10 May. P.S. I am not too unhappy with what I've brought back.'

His Norwegian landscapes, however, would be completely eclipsed by his series of Rouen cathedral and none was sold. He put them into storage and forgot about them for the next eighteen years.

When Alice died in 1911, he said the painter in him had died with her, and stoutly maintained he would never paint again. After two years of deep mourning his family insisted he accompany them on a trip to the Alps. He had not seen such immensity of whiteness since Norway, and yes, there he was looking at another frozen landscape in the wake of yet another death. But he found it so beautiful that on his return to Giverny he fished out his Norway paintings, perhaps to reassess them, and he found them so hideous that he promptly announced he was gathering up his brushes and setting off for the Alps, and this time, he would get it right. The First World War intervened, and he did not go, but he had been given the impetus to start painting again, and in the next few months he was busy with the great opus of his water-lily panels.

Venice

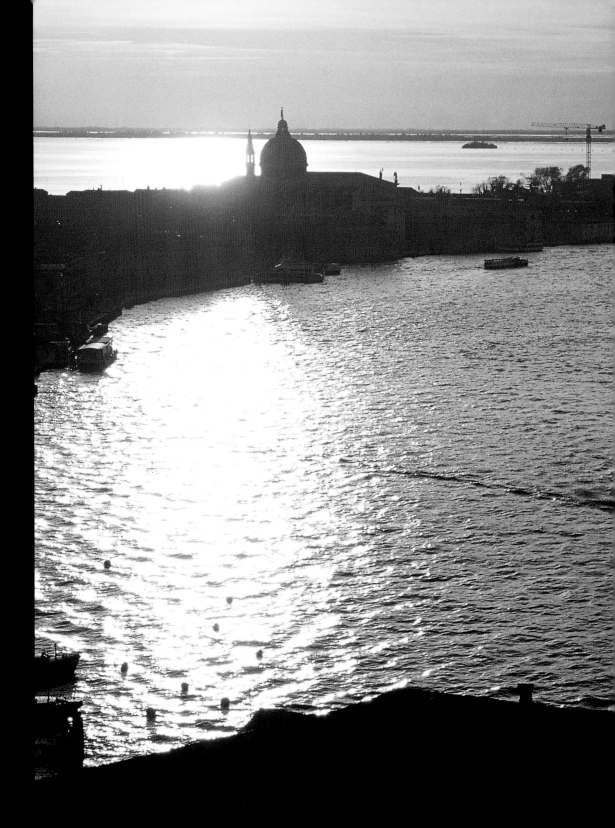

"... we go out alone, Monet
and I ... always by gondola; it's
so delicious, I never tire of it."

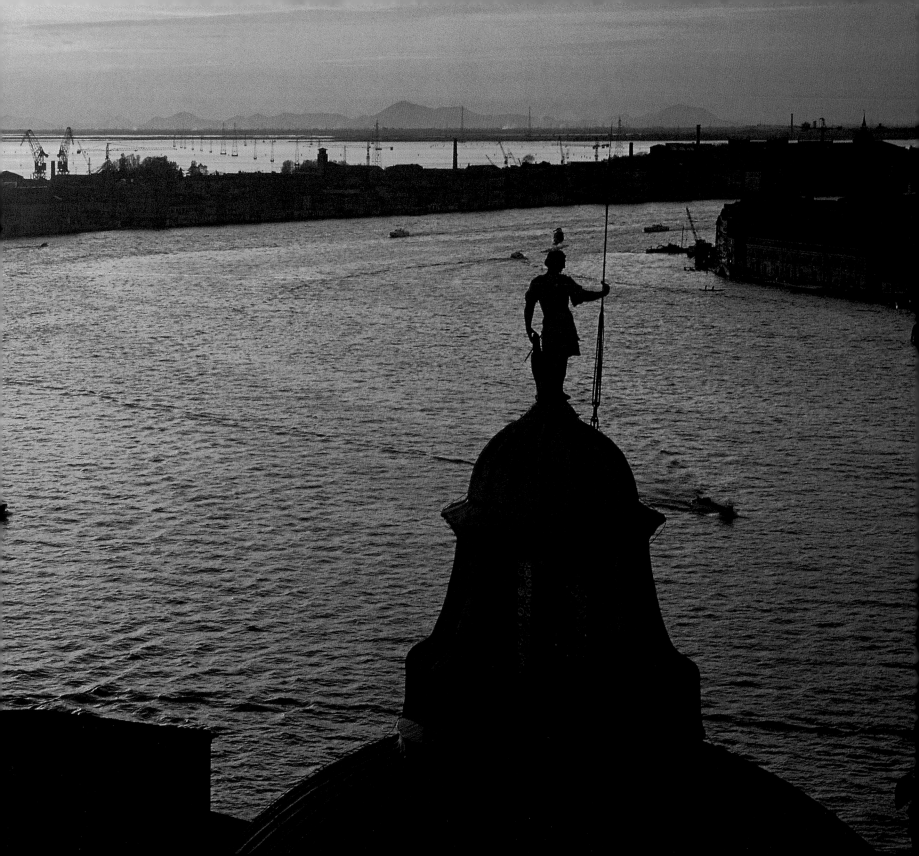

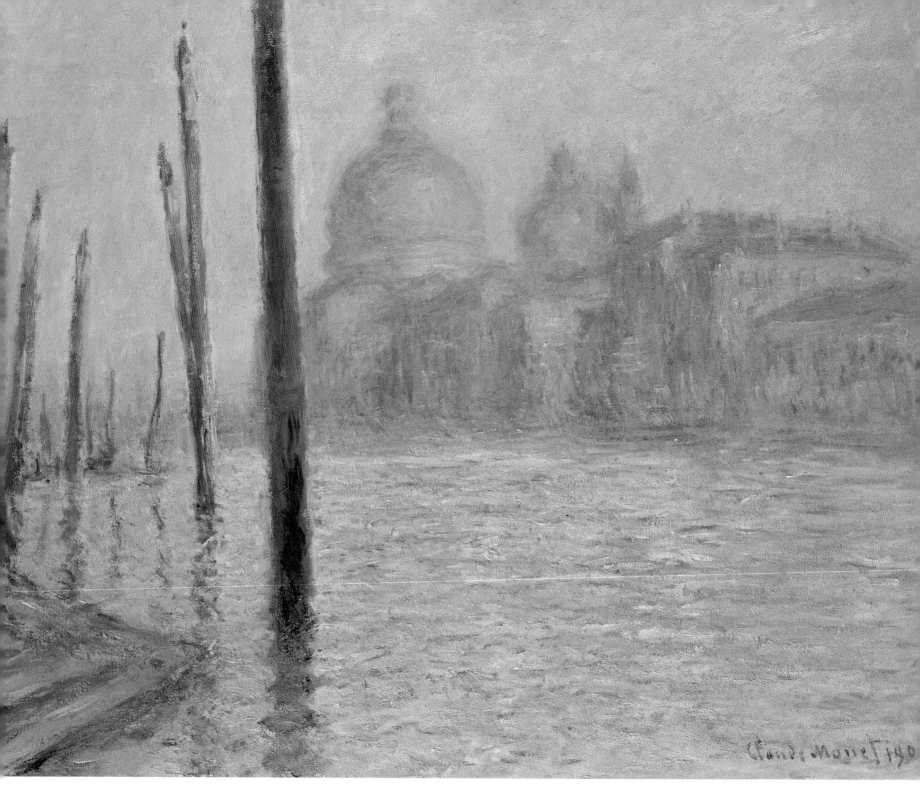

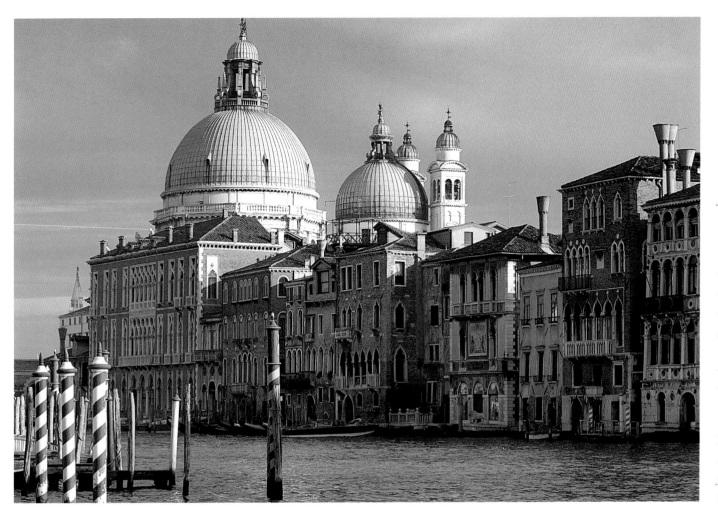

Opposite: THE GRAND CANAL. *The distinctive cupolas of the Basilica di Santa Maria della Salute, painted from the Palazzo Barbaro where Monet and Alice first stayed, and which Henry James called his 'home away from home'.*

Left: *The view today. But the famous pali (poles) used for mooring gondolas seem to have got shorter!*

Having been cloistered in his Giverny water garden for six years, and stale and exhausted from sustained concentration on the motifs of his water-lily pond, Monet was ready for a change of scene. The cool nights of September brought the flowering of the water lilies to a close, and during a spell of unsettled weather, a letter arrived from Monet's friend, Mary Hunter, inviting him and Alice to Venice as her guests. Monet had long resisted the exhortations of his friends to paint there. They insisted that he and Venice were made for each other; but what was a painter's paradise for them had for Monet become a painter's cliché. After all, who at one time or another had not painted there? Canaletto, Manet, Whistler, Renoir, Signac, Turner, to name a few; even his old mentor, Boudin, had made three visits during the last six years of his life. But of course Venice is like a spider who hypnotizes every fly that crosses its web.

The steady roll of Monet's elemental wheel of light, water, earth and stone had slowed somewhat during the prolonged scrutiny of his minute pool. He was ready to lift his gaze to contemplate a wider horizon. But prising Monet away from his pond, to which he was fixed like an oyster in its shell, was not easy. No sooner had the Monets accepted the invitation than the sun shone on Giverny and Monet began vacillating. '*Voilà*, as I expected,' wrote Alice to

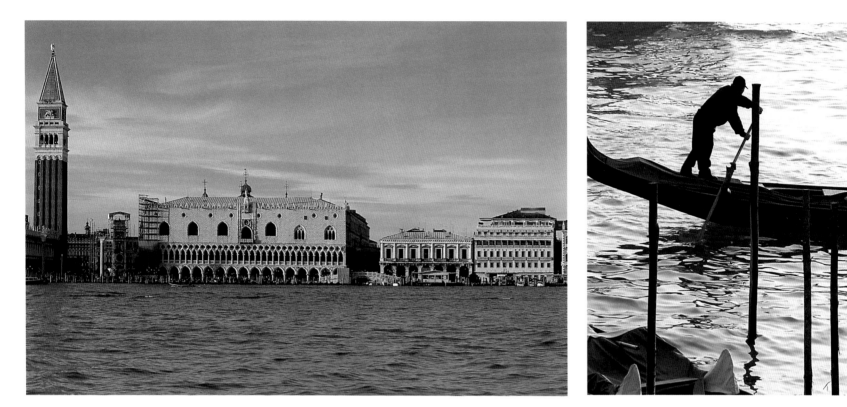

Above: *Monet painted the Doge's Palace (Palazzo Ducale) from a gondola and threw a tantrum one afternoon when the gondolier could not locate the exact spot.*

her married daughter Germaine Salerou, 'now that good weather has returned, he can't decide whether or not to abandon his pond and his flowers. Since yesterday, I've had such an earful that it really spoils the pleasure of the trip.'

But then Monet decided they would go after all, and his canvases, easel and painting materials were sent on ahead. They had planned, on their return from Venice, to call in on Germaine, who was living near Renoir, in Cagnes in the south of France. 'Don't think that I can stay there for more than a day,' Monet impatiently informed

his wife before their departure. 'A day is enough for me,' Alice gamely told her daughter, all the while hoping Renoir would be there to detain him.

They left for Venice by overnight train from Paris, on 29 September 1908, rising at 5.00 a.m. to admire the 'marvellous landscape' as they crossed into Italy via the stunning Simplon Pass, stopping briefly in Milan before continuing by train to Venice.

Monet was to write only a handful of mainly

business letters during his stay and it is Alice's candid letters to her daughter Germaine that chronicle their trip.

'I am living in a dream – this arrival in Venice, so marvellous, the calm that steals upon you, the solicitous attention of Madame Hunter, this wonderful palace – a real fairy tale,' Alice enthused in the first of her daily letters. 'As soon as we disembarked, Mme Hunter was there, and immediately took us by gondola through the canals, large and small, to admire the sun setting on St Mark's Square; all of it

Above: *Monet also painted the Doge's Palace (the Palazzo Ducale) from the terrace on the island of San Giorgio Maggiore. 'From eight in the morning we are at the first motif – San Giorgio, facing St Mark's Square … it's alarming the amount of painters here, on this little square of San Giorgio. There are five, plus a woman and Monet …'*

Right: THE PALAZZO DUCALE FROM SAN GIORGIO MAGGIORE.

unforgettable.' After twenty-five years of living together and raising eight children, Monet and Alice finally had their honeymoon in the time-honoured way of a Venetian idyll. Hour after hour in those early days the two of them glided around Venice in sublime weather, alone in the silent, mysterious, 'perpetual enchantment' of its canals. Curiously, this very silence so horrified Manet that he vowed never to return to a city where not a single noise could be heard. They breakfasted at 7.30 a.m., 'and we go out alone, Monet and I, by gondola until eleven thirty; lunch is at twelve thirty, rest until three

thirty and a new promenade, always by gondola; it's so delicious, I never tire of it.' Their tryst was especially poignant because it was also to be the swansong of their marriage. Soon after their return, Alice's health began to fail and three years later she was dead.

The Monets had befriended Mary Hunter in London whilst Monet was painting there, introduced by John Singer Sargent, with whom she had a long relationship, which although platonic, was much gossiped about. Mary Hunter had married into Charles Hunter's coal-

mining fortune, and during her sparkling career as a society hostess spent every penny of it. Generous and charismatic, she courted the eminent writers and artists of her generation – Henry James, Edith Wharton, Vita Sackville-West and Bernard Berenson, amongst them; Rodin made a bronze of her head. As one of many venues for her sophisticated entertaining, she rented the fabled Palazzo Barbaro from the Daniel Curtises, expatriate Boston Brahmins and cousins of Sargent. The Palazzo Barbaro was a haven for a cosmopolitan array of creative minds in the late nineteenth century.

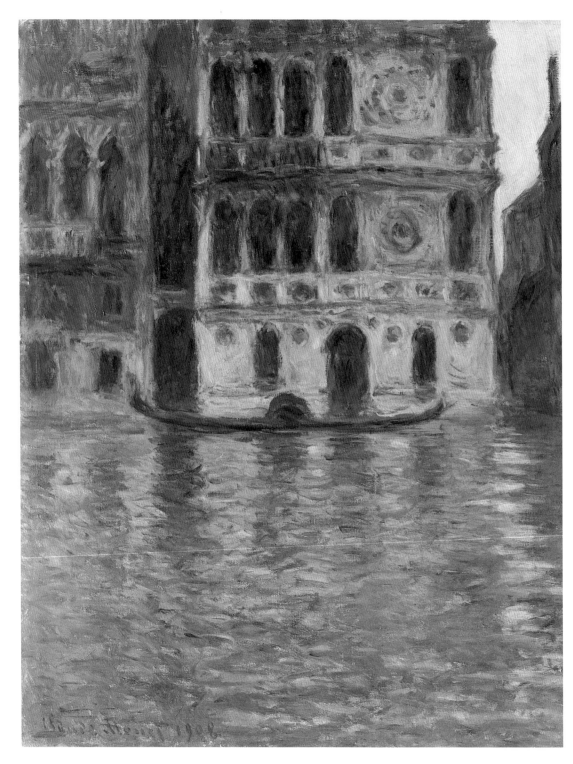

Inspiration was in the air. Henry James set his novel *The Wings of the Dove* there and wrote *The Aspern Papers* during one of his frequent long stays. Alice described life in the Palazzo, whose opulent interior was painted by Sargent, as a place 'where your wishes were executed as you are forming them' and life was lived in '*le grand luxe*' but 'simple and easy, exquisite food, perfect comfort, and in such total freedom that one would think one was *chez soi*.' She was much impressed by Mary Hunter – her marvellous clothes, her elegant simplicity. Aside from the mosquitoes, there was only Mary Hunter's sister, whom they found a bit of a trial: the formidable Dame Ethel Smythe, redoubtable *grande dame* of English feminism, music and eccentricity. The Monets did not know what to make of her, and although she struck them as very odd, Alice said, 'I haven't found her all that disagreeable … but what a character, a real caricature; talkative but intelligent. Since she has fallen out with all Mme Hunter's friends, we receive nobody, which is better for us.'

Waiting in the first week for Monet's canvases to arrive from France, equipped with John Ruskin's guidebooks, he and Alice explored Venice on foot across the small bridges, little canals, visiting churches and museums, and then on to the lagunas, to the Lido, and as far as the open sea to which Monet was always drawn. They saw the great landmarks of St Mark's and the Doge's Palace, decorated by the huge mural of Tintoretto, whose scale it has been suggested, may have prompted the large water-lily murals still to come. They had their pictures taken outside St Mark's, cloaked in pigeons, and had these made into postcards to send to the family.

Every evening they slid around the canals, floating on a mirage of stone reflecting on water marvelling at the changing light: the smouldering sunset, the theatrical glow of its lamps, the silvery moonlight. 'The hours slip by, as swiftly and as gently as the canal.' Together at last, free from family cares, financial worries behind them, they had a thirst for these tranquil hours which was unquenchable and they performed this evening ritual daily until the last day, even when they had already spent the best part of the day in a gondola. 'What a joy,' wrote Alice prophetically, 'to be able to add to the end of one's life hours as luminous as these.' For his part, Monet was transfixed by Venice, murmuring that 'it is too beautiful to be painted', 'it's untranslatable' and no one 'has ever given the idea of Venice'. Alice was longing for Monet to start painting, and as the days passed and the canvases did not materialize, she became concerned: 'I fear that the first impression – all in the flames of ecstasy – will, upon reflection, cool.'

Monet's canvases finally arrived on the day Dame Ethel Smythe gave a recital at the Palazzo in which she played and sang her own compositions for the *beau monde* of Venice, attired in lavish, extraordinary costumes, including the Princesse de Polignac, who had bought one of Monet's paintings of the Dutch bulbfields all those years ago. In the midst of that glittering tableau, Monet and Alice must have struck an incongruous chord, but they were too enchanted by Dame Ethel's musical soirée to care: 'This spinster, who seemed to me so ridiculous, has transfigured herself into a genius. The few compositions that she sang and played are really remarkable works ... at

Opposite and above: THE PALAZZO DARIO. *The Renaissance palace renowned for its multicoloured marble fascia on the Grand Canal. Monet set up his easel on the opposite bank and concentrated on the water, always the water.*

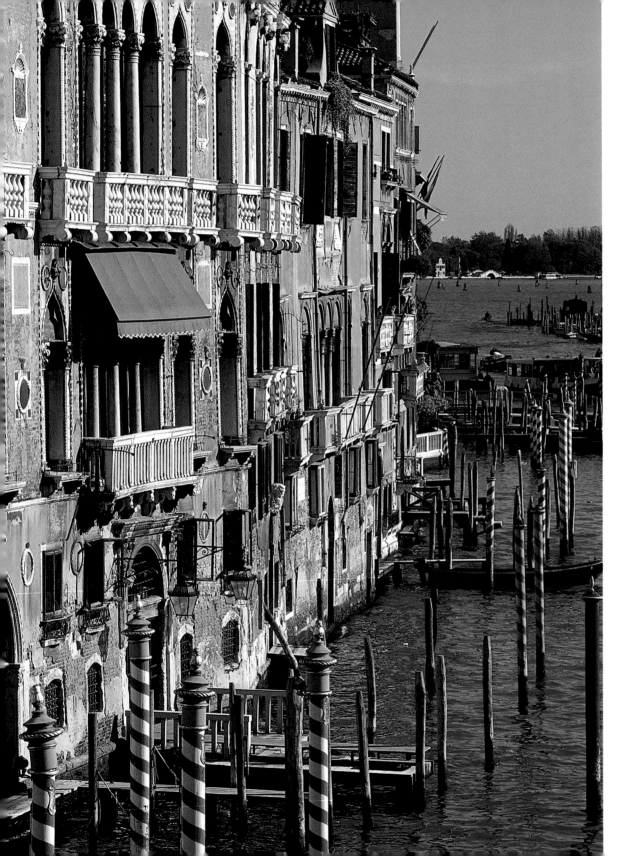

midnight, we were in bed, souls enraptured by the *chef d'oeuvre* we heard.'

The new dawn brought good news: 'Monet is going to work; you know what joy there is for me in this word – but (life always has a but) the sky, so immutably pure since our arrival, has a few clouds while I write this; every minute, I go to the window to inspect it.' Monet, having decided he was going to start work, now 'decided he is going to abandon it completely' for the good reason that 'he is "too old to paint such beautiful things"; it's a real sadness.' But that night, Dame Ethel sang and played for Monet and Alice alone, all evening – 'a real treat' – and, inspired by this singular muse, Monet started painting the next day. 'From eight in the morning we are at the first motif – San Giorgio, facing St Mark's Square; at ten we are in St Mark's Square, facing San Giorgio. After lunch, Monet works on the steps of the Palazzo Barbaro – then at three *au gondole*; we go for a tour to admire the sunset and return at seven.'

Overwhelmed by the architectural glory and light of Venice, Monet fixed himself upon the well-known landmarks of Venice as his main motifs, all of them either on or in close proximity to the Grand Canal, each one classically composed. He relied on his old formula of working out how to interpret the light in the context of a wider picture first, saying that these canvases were only 'trials and beginnings'. These would pave the way for his return the following year when he would render Venice as it had never been interpreted before.

The sojourn at the Palazzo Barbaro was to last

only two weeks. On 14 October, Mary Hunter left Venice to take the waters in Aix-les-Bains, buying up, it seemed to Alice, half of Venice to bring with her – 'You can't imagine her purchases, *c'est fantastique*.' Alice rued the departure of 'this delicious woman' and was eternally in her debt for persuading '*mon cher* Monet to paint marvellous things here! And what a miracle to get him to abandon his garden! How happy I am! Her sister left this morning, and I miss her too, in spite of her peculiarity; a true genius. *Quel malheur* to no longer hear this divine music; but dreams can't last for ever.'

The Monets moved into the Grand Hotel Britannia, further along the Grand Canal towards St Mark's Square with a better view opening on to the island of San Giorgio: 'You couldn't dream of anything more beautiful and it's all for Monet …' In the evening, illuminated gondolas circulated in the distance, and echoes of the serenading gondoliers drifted across the water. The hotel was pristinely clean and the food was not too bad, but what they found absolutely amazing was the novelty of electric lighting. For the first time, 'Monet can see his canvases – it's delicious and makes you want to install it at home.' Which, upon their return, they did.

Once embarked on his canvases, Monet was gripped. Full of enthusiasm, he started new canvases every day, 'which will take us far if the beautiful weather we are having continues.' Alice began to realize just how taxing his campaigns were: how difficult the task, how exacting the taskmaster. 'At 8.00 a.m. every day, we are installed at the first motif until ten; so we have to get up at 6.00 a.m.; then another motif from ten till noon. From two to four in the canal; from four to six from our window – you see how the hours are filled, and, really, I don't know how, at his age [he was sixty-eight], he does this without tiring … He constantly tells me that he wishes it was next year already to take up his motifs again. So it's absolutely certain we will return, which gives me great joy … how happy I am to see Monet so taken; he is so happy and it gives me such pleasure to see this. He now has twelve canvases under way and is more and more impassioned, so we are here for a while yet.'

The autumn equinox brought a foretaste of

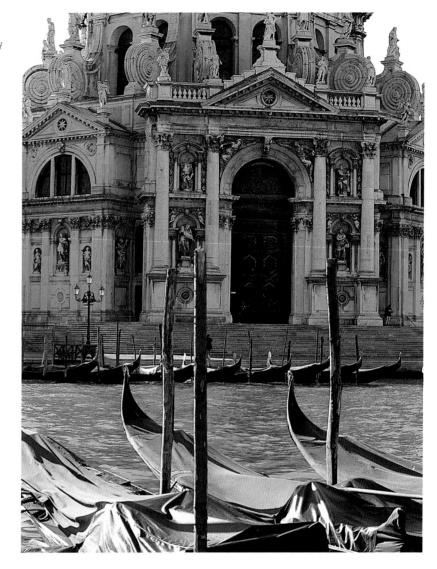

Opposite: *The Palazzo Barbaro with its red-striped pali, taken from the Academy Bridge (Ponte dell'Accademia), looking down the Grand Canal.*

Right: *The Basilica di Santa Maria della Salute.*

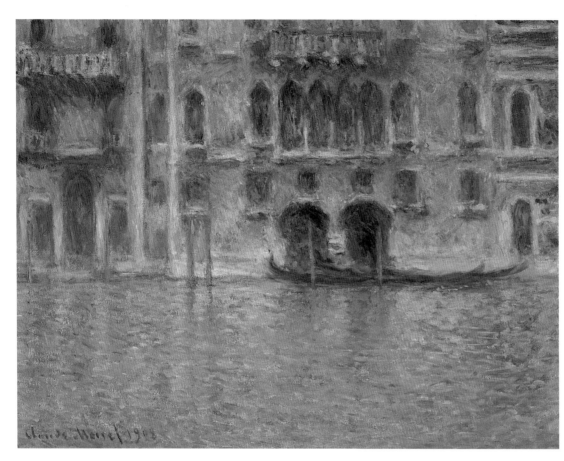

Left: THE PALAZZO DA MULA, *on the same side of the Grand Canal as the Palazzo Dario, near the Peggy Guggenheim museum.*

Right: *The Grand Canal in the afternoon sun: 'The hours slip by, as swiftly and gently as the canal … what a joy to be able to add to the end of one's life hours as luminous as these.' – Alice Monet.*

needed the same summery conditions in which he started to finish them: 'We have to hope that this Venice of divine reflections, of unique light, *enfin*, this city of splendours will return.' October was drawing to a close, but neither Alice nor Monet were happy with the prospect of leaving Venice with half-finished canvases; Alice was unhappier still with Monet's idea to store them in Venice until his return the following year to avoid repeating the nightmare of Italian customs. So the pair sat out 'cruel hours' in the intermittent days of torrential rain, of storm, of mist, of wind; days of sun and cloud when the temperature soared wildly between that of the Sahara and that of Siberia. With so much stopping and starting, Monet lost his momentum. To Alice's consternation, when fine settled weather returned, he spoke only of leaving, and it took all her powers of persuasion to convince him to carry on.

Alice, his prop and stay, never left his side, describing their lives as that of 'two hermits in our dear and perpetual *tête à tête* … our life is as regulated as a piece of sheet music, the best way for working'. In the morning, she wrote her letters, during the sessions on the island of San Giorgio, 'where I can sit next to Monet on terra firma'; '*c'est effrayant* – it's alarming, the

winter. A glacial wind tore through the canals, shattering the calm mirror-like surface of the water; white-capped waves rocked the gondola. The cold was bearable when painting in the sun, but unbearable in the shade. Monet and Alice scoured the shops for warm jumpers, and hired a gondola with a black cabin, a '*vrai catafalque* – funeral bier – but at least we are shielded from the wind'. Monet had to peer through the windows of his cabin to paint his motifs. Venice began to empty, and Alice imagined that before long they would be the only two left in the hotel. The proprietor made 'economies' with the

food; Alice seemed to live on toast and butter, and fantasized about her cook's delicious homemade leek soup, mentioning it on three separate occasions to her daughter. Monet chivvied the hotel owner into heating the huge dining room, which he said was colder than the temperature outside. Also staying at the hotel was a young English amateur painter who lent Monet his fur coat when he left, which protected Monet from the biting wind but did nothing to warm his frozen feet and hands.

With so many canvases under way, Monet

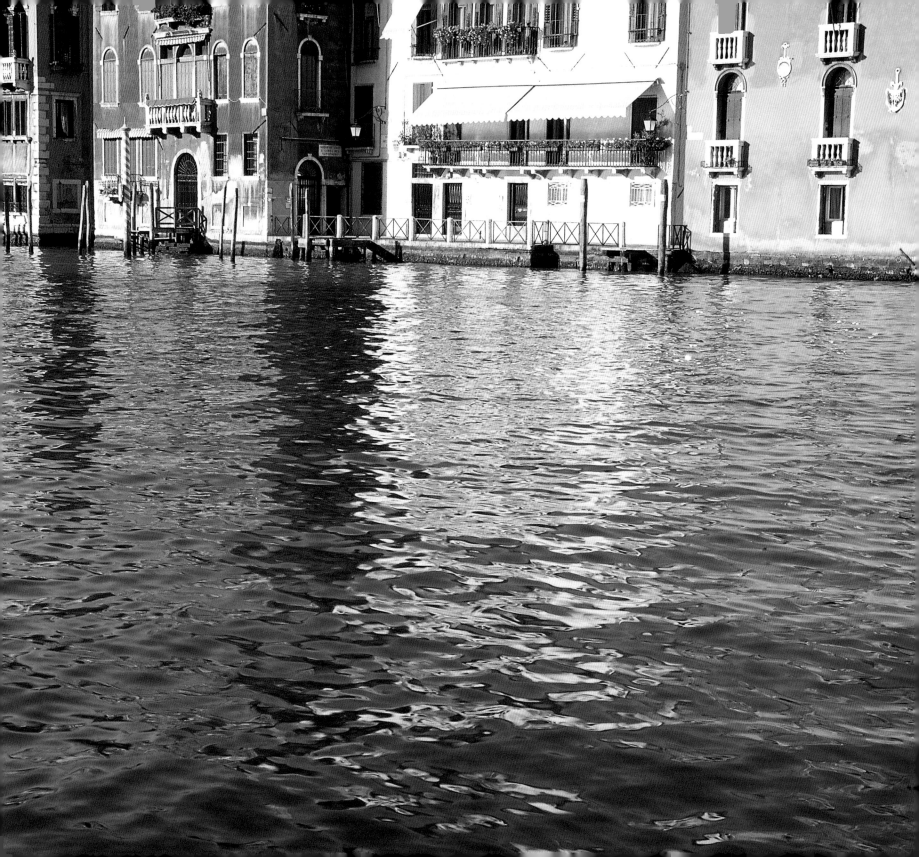

amount of painters here, on this little square of San Giorgio. There are five, plus a woman and Monet … it's so beautiful and tempting, but who can render these marvellous effects? I can see that it's only my Monet who can do it … At the moment, while I scrawl these lines, Monet, despite all his grumbling, has taken up painting, I am watching a real procession of coloured fishing boats with their wonderful red and blue sails … and here comes a huge one with three masts, and great ships calling in on their way to Egypt to pick up passengers … what a spectacle

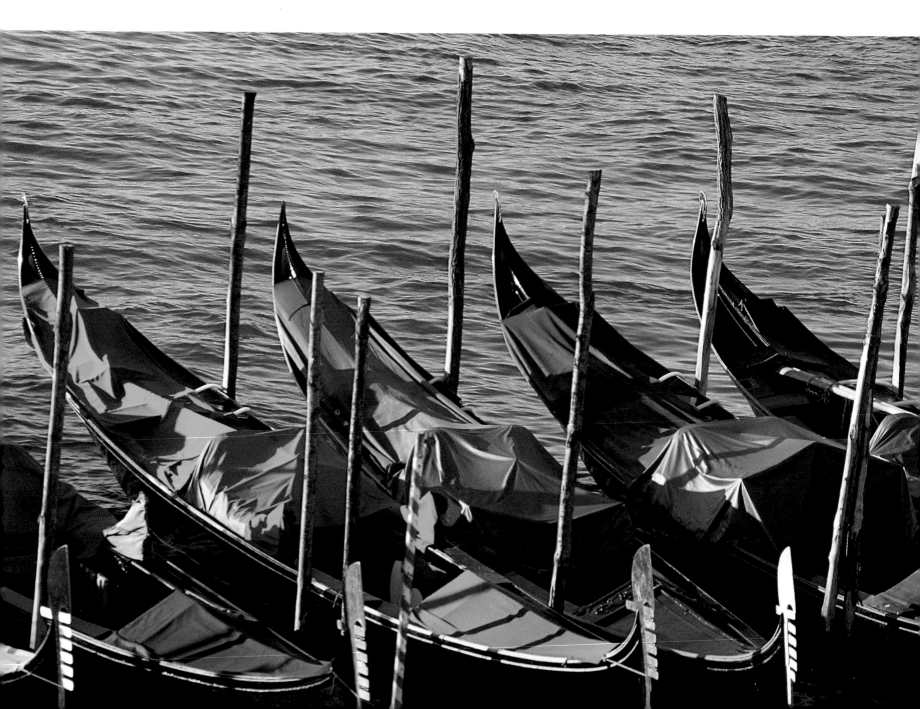

and the reflection of it all in the pearly water; it's so untranslatable that I understand Monet a little.' From two until six thirty she sat next to him in the gondola, gently rocked by the wash of the boats which pass; 'I can't do anything, or even move, while Monet paints. Thus the hours pass in contemplation.'

But it was not all smooth sailing. Monet could be very difficult. As Alice said herself, 'Monet is a man of extremes: from wonderful to ugly, from good to bad … When Monet can't find his motifs again, he is infuriated. Yesterday when the conditions were just right for him to resume one of his canvases of the Palace of the Doges, where he works from an anchored boat, the gondoliers having failed in three attempts to find the right spot, he abandoned the session and returned to the hotel absolutely furious and then regretted, but too late, his impatience. I require, I assure you, a great deal of fortitude to put up with such assaults of high excitement or despair that I can't see an end to it … Monet is exasperated with himself, his work, etc. certainly there isn't an artist on this earth as hard on himself as my poor husband … *Ma foi* – goodness, with Monet there really is no knowing what we're going to be doing. How many times has he told me to pack our suitcases, that he wasn't going to touch another brush, and an hour later, he is working, and sometimes is even starting another canvas … He fears the cold, and has a bit of rheumatism in his arm or rather the fatigue of excessive work and then says that his arm is going to be paralysed; *enfin*, you know him … and I require, I assure you, great energy and a strong dose of courage alone like this, it's difficult; him at his work, me in my thoughts.' Her thoughts touched on her children

Opposite: *We go out alone, Monet and I, by gondola until eleven thirty; lunch is at twelve thirty, rest until three thirty and a new promenade, always by gondola; it's so delicious, I never tire of it', wrote Alice in the week while they waited for Monet's easel, canvases and paints to arrive.*

Right: GONDOLA IN VENICE. *Monet's last sketch of Venice, which he made on the morning of his departure, 3 December 1908. He never retouched it.*

and grandchildren, but it was Suzanne upon whom they dwelled 'above all (forgive me) and the dear grave, where in my daily visits, I talk to my adored daughter. Just think, nearly two months that I've been so far away. Since her death, ten years ago, I have never been so far from the cemetery; no, I am happy to see Monet so full of *ardeur*, doing such beautiful things,

and between us, something other than those eternal water lilies, and I think it will be a great triumph for him.'

Towards the middle of November, beautiful settled weather returned, and Monet painted feverishly. On a good day he could work on nine canvases, from eight until five with only an hour

for lunch. It worried Alice to see him so tired: 'at his age *il faut plus se ménager*, but he is so happy.' As November drew to a close, Monet could not tear himself away and for once with Alice there, he did not have to. Having intended to stay for a month, they were now in their ninth week, their departure constantly postponed because of the fine weather. Now it was Alice's turn to write appeasing and apologetic letters to Germaine, as Monet had so often done to her. Renoir, impatient to see his old friend, wanted to know the date of their arrival in Cagnes. 'It's an impossible thing and will not be fixed until the boxes of *toiles* are sealed with lead; then, it will be the real

departure.' Like all driven men, Monet could be ruthless and egotistical in the pursuit of his interests. Alice was desperate to see her daughter Germaine who had given birth to a stillborn child only a few months earlier. 'Monet,' wrote Alice crossly, 'is becoming indifferent.'

On the last day of his ten-week stay, in a letter to Geffroy, Monet finally wrote about Venice:

Mon cher ami, so taken up with work, I haven't been able to write to you, leaving my wife to send you news. She will have told you about my enthusiasm for Venice. *Eh bien!* It has only grown, and as the moment of leaving this unique light approaches, I am sad. It is so beautiful ... I console myself with the thought of returning next year, as I have only been able to do *des essais, des commencements*. But *quel malheur* not having come here when I was younger, when I had *toutes les audaces! Enfin!* ... But I have experienced some delicious moments, almost forgetting that I wasn't *le vieux* – the old man that I am.

On the morning of their departure Monet made a quick sketch of a gondola. The couple slowly made their way to Giverny, calling in on Bordighera because Alice wanted to see where he had lingered for so many weeks, and then to Cagnes to see Germaine where, in the end, Monet did consent to stay for several days. It was the last time he and Renoir saw each other, because Renoir died a few months later. Not one of Monet's Venice canvases was

finished, and he put them away, intending to complete them the following year. But he never returned to Venice. His canvases remained in storage until 1912, a year after Alice's death, when he could bring himself to look at them again, and he completed them in his studio. He never retouched the quick sketch of his gondola. It was a memento of shared hours and perhaps also a symbol of a shared life which had weathered all the storms in all the landscapes.

Opposite: *The Basilica of Santa Maria Della Salute in November evening light.*

Above: *Monet and Alice had photographs of themselves taken in St Mark's Square, which they made into postcards and sent to their family.*

BIBLIOGRAPHY

Aitken, Geneviève, and Delafond, Marianne, *La Collection d'estampes Japonaises de Claude Monet* (Bibliothèque des Arts, Paris, 1983)

Alphant, Marianne, *Claude Monet: une vie dans le paysage* (Hazan, Paris, 1993)

Claude Monet au temps de Giverny, exhibition catalogue (Centre Culturel du Marais, Paris, 1983)

Geffroy, Gustave, *Monet, sa vie, son temps, son oeuvre* (2 vols, G. Crès, Paris, 1922; new edition 1980, with an introduction by Claudie Judrin)

Mirbeau, Octave, *Correspondance avec Claude Monet* (Editions du Lerot, 1990)

Rewald, John, *The History of Impressionism* (Museum of Modern Art, New York, 1973)

Stuckey, Charles F, *Claude Monet 1840–1926* (Art Institute of Chicago, 1995)

Wildenstein, Daniel, *Monet, catalogue raisonné* (1st edition, La Bibliothèque des Arts, Lausanne-Paris, Vol. I, 1974, Vols, II and III, 1979; Vol. IV, 1985, Vol. V, 1992; and 2nd edition, Vols, I, II, III and IV, Benedikt Taschen Verlag GmbH, Germany, 1996)

INDEX

Numbers in *italics* refer to illustration captions

A
Agay 77, 78, 81
Alphant, Marianne 7
American Impressionist exhibition 41, 50, 62
Amerika Igirisukoku (Shigetoshi and Shigekiyo) 7
Antibes 74–85
Antibes 85

B
Baudelaire, Charles 103
Bazille, Frédéric 12
Belle Isle 60–73, *70*
Bing, Siegfried 110
Bjornson, Fru 129, 137
the Bloc *89, 95*, 97
Bordighera 18–37, *21, 24, 31*, 155
Bordighera 21
Boudin, Eugène 11–12, 64, 143
The Bridge at Vervy 92
Brittany 62, 64
Bulbfields and Windmills near Leiden 56

C
Cagnes 144, 155
Caillebotte, Gustave 21, 32, 67–8, 111, 136
Carnaval de Nice 29, 81
Castle at Dolceaqua 29
Cézanne, Paul 78, 79
Château de la Pinede 77, *77*, 78, 80
Chaufferette, Madame 42
Christiania (Oslo) *124*, 125–9, *129, 131*, 137
Claude Monet Painting by the Edge of a Wood (John Singer Sargent) *4*

The Côte Sauvage 68

Courbet, Gustave 14

Creuse 86–99, *89*

Crozant 90, 92, *95*

D

Degas, Edgar 104, 105

Dinard 64

Doge's Palace (Palazzo Ducale) *144*, *145*, 146

Dolce Aqua 28, *29*

Durand-Ruel, Charles 81

Durand-Ruel, Paul 14, 17, 21, 22, 24, 32, 36, 41, 42, 44,
 49, 50, 62, 79

E

Ernst, Prince 137

Estournelles de Constant, Baron d' 54

Etretat 8–17, *13*, *15*, 38–51, *42*, *49*, *51*

Etretat, Rough Seas 13

Exposition Universelle 1889 90, 102

F

The Falaise d'Aval at Etretat, Sunset 49

fog motif 70, 114, 118

Forges les Eaux 62

Fresselines 90, *91*

G

Geffroy, Gustave 56, *62*, 68, 79, 89–90

Giverny 7, 17, 21, 41, 42, 49, 50, 54, 59, 71, 72, 90,
 100–11, 124, 128, 129, 134

Gondola in Venice 153

Grainstack (Sunset) 106

The Grand Canal 143

H

Harpignies, Henri 77, 78, 80, 82

haystacks *103*, *104*, 106, 108–9, 114

*Haystacks at the end of the Summer, Morning Effect
104*

Haystacks, Snow Effect 104

Helleu, Paul 79, 81, 120

Helsingor 124–5

Hiroshige 110, *111*

Hokusai, Katsushika *64*, *131*, 135

Holland 52–9

Honfleur 11

Hoschedé, Alice *see* Monet, Alice

Hoschedé, Blanche 134

Hoschedé, Ernest 7, 13–14, *15*, 50, 114

Hoschedé, Jacques 124, 125, 127–8, 129, 131, 138

Hoschedé, Suzanne (later Suzanne Butler) 102, 105, 118,
 136, 153

Hunter, Mary 143, 145, 146, 149

I

Impressionism 11, 41, 103

Italian Academy 36

J

James, Henry 145–6

Japanese aesthetic 12, *64*, 105, 109–10, *111*, *131*, 134, *135*

Jongkind, Johan Barthold 11, 12

Juan les Pins 77, *78*, 82

K

Kandinsky, Wallisky *106*, 109

Kervilahouen *64*, 70

L

Le Bloc 95

Le Clos Morin *103*, 109

Le Havre 14

Le Palais *64*, 70

Leroux, Monsieur 81

Lokke Bridge *133*, 134

M

Mallarmé, Stephane 103–5, 109

Manet, Edouard 77, 102, 136, 143, 145

Manneporte *11*, *44*, 47, 49

The Manneporte, Reflections on the Water 41

The Manneporte Seen from the East 11

Marius, Michel 42

Maupassant, Guy de 17, 42, 44, 77, *78*, 82

Menton 26, 36

Meule au Soleil 109

Mirbeau, Octave 64, 71–2, 73, 89, 102, 108

Monet, Alice (2nd wife) 13, 14, 15, 17, 23, 26, 29, 31, 35, 42,
 47, 50, 51, 62, 67, 114, 144, *155*

 death 7, 139, 145

 jealousy 26, 30, 35, 42, 62, 67, 72–3, 97

 letters to Germaine (daughter) 144–5, 146, 147–8, 149,
 150, 152–3, 154–5

 marries Monet 118

 and Suzanne's death 136, 153

Monet, Camille (1st wife) 12, 13, 55, 136

Monet, Claude

 artistic euphoria 12, 22, 85

 attempts to save Manet's *Olympia* for France 102

 and Berthe Morisot's death 136

 collaboration with Mallarmé 104–5

 depression 103

 escapes drowning 47

 financial difficulties 15, 24, 32, 41, 44, 72, 81

 ill-health 94, 115

 and the Japanese aesthetic 12, 105, 109–10, *131*, 134

 joint exhibition with Rodin 90–1, 97, 102

 letter to Blanche 134

 letter to Helleu 120

 letters to Alice *13*, 15, 17, 22, 23, 26, 28, 29–32, 35–6, 42,
 44, 49–51, 65, 67, 70, 72–3, 77, *78*, 91, 94–5, 97–8,
 115, 119–20, 124–5, 127, 136, 137

 letters to Berthe Morisot 89, 91–2, 105

 letters to Caillebotte 67–8, 111

 letters to Durand-Ruel 21, 41–2, 62, 70, 108, 118, 120,
 136–7, 139

letters to Geoffroy 94, 103, 110, 120, 155
letters to Pissarro 46, *55*
marries Alice 118
passion for gardening 54, 55, *55*, 59, 129
photograph of *7, 155*
plein air painting 11, 124
series paintings 71, 108, 114
stenographic style 12
and symbolism 105
visual innocence 109
Monet, Jean (son) 12, 55
Monet, Leon (brother) 119
Monet, Michel (son) 13
Monte Carlo 21, 27, 28, 77
Moreno, Monsieur *21*, 23–4, 26, 28, 36
Morisot, Berthe 79, 81, 89, 92, 102, 104, 105, 136
Mount Kolsaas 134, *136*
Mount Kolsaas (Rose Reflects) 136

N
Nice 77
Norway 122–39
Norwegian Landscape, The Blue Houses 131

O
Old Fort at Antibes (I) 81
The Olive Tree Wood in the Moreno Garden 36
Ostoya *127, 131, 135,* 137

P
Palazzo Barbaro 145, 146, 148, *149*
Palazzo da Mula 150
The Palazzo Dario 147
Palazzo Ducale from San Giorgio Maggiore 145
Paris Salon 77
Pelouse 78, 80
Perry, Lilla Cabot 109, 110
Petit, Georges 49, 81, 90
The Petit Creuse River 96

Pissarro, Camille 46, 55, 108
Poissy 13, 14
Polignac, Prince de 59
Poly (porter) 67, 70, 73
Ponteuil 77
Poplars on the Banks of the River Epte 111
Poplars on the Banks of the River Epte in the Autumn 109
poplars (series) 109, *109*, 110–11, 114
The Portal (Morning Fog) 118
The Portal and the Tour d'Albane at Dawn 117
Porte d'Amont *17, 41, 42*
Proust, Marcel 59
Pyramids at Port-Coton, Rough Sea 62

R
The Red Houses at Bjornegaard, Norway 127
Regnault, Alice 72
Renoir, Auguste 21, 32, 46, 64, 78, 79, 104, 143, 144, 154
River Epte 13, 105, *109*, 110, 111
The Rock Needle and the Porte d'Aval 44
Rocks at Belle Isle 67
Rocks at Port-Coton, with the Lion Rock 73
Rodin, Auguste 90–1, 102, 145
Rollinat, Maurice 90, *90*, 91, *91*, 95, 97, 98
Rouen 112–21, *115, 117*
Rouen cathedral series 114, 115–16, *117*, 118, *118*, 119–20, 139
Russell, John-Peter 67

S
St Malo 64
Salerou, Germaine 124, 144, 154–5
Salis Gardens 78, *81*
Sandviken 129, 134
Sandviken Village, in the Snow 133
Sargent, John Singer *4*, 102, 145, 146
Sassenheim 55
The Sea at Antibes 82
Seurat, Georges Pierre 102
Shigetoshi and Shigekiyo 7

Singer, Winnaretta 59
Sisley, Alfred 136
Small Country Farm at Bordighera 35
Smythe, Dame Ethel 146, 147, 148
Storm off the Belle Isle Coast 70
Stormy Weather at Etretat 17
Sumida River in Snow (Katsushika Hokusai) 131
symbolism 103–4, 105

T
The Tama River in the Province of Musashi (Katsushika Hokusai) *135*
The Thirty-six Views of Mount Fuji (Katsushika Hokusai) *64*
Trevise, Duc de 59
Tulip Fields 59

U
Under the Lemon Trees 33

V
Valéry, Paul 103
Van Gogh, Theo 81, 89, 97
Venice 140–55
Vétheuil 13
Villa Etelinda 24
Villa Moreno 21, 22, 23–4, 26, 27, 28, 29, 30, 31, 36, *36*
Villas at Bordighera 24

W
water lilies 143, 146
Whistler, J. A. M. 79, 81, 114, 143
Wildenstein, Daniel 7
Woman in the Green Dress 12

Z
Zaandam 55

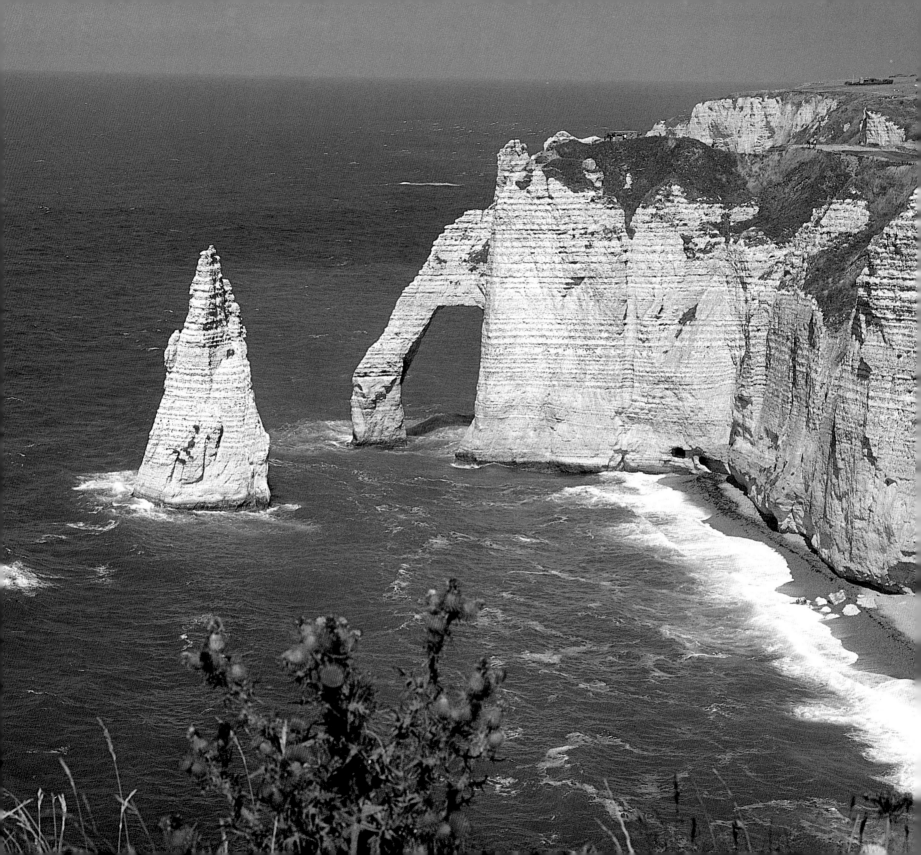

AUTHOR'S ACKNOWLEDGMENTS

I am grateful to my editor Carey Smith for allowing the book to evolve as it did and for her patience; to Anne Askwith for her courageous swim through the quotes, the brackets and the grammar; to the resourceful Sue Gladstone who conjured lions and Japanese prints out of thin air; to Andrew and Annette Gossett for their streamline design of the book; to the art director Caroline Hillier for her support; to Erica Hunningher who commissioned the book; to Frances Lincoln personally and to the whole team at Frances Lincoln Ltd for their hard work behind the scenes.

My thanks, as ever, to Madame Lindsey at the Fondation Claude Monet and for her permission to photograph Monet's woodblocks.

All photographs were shot on Fuji Velvia film, with a Leica R8. A huge thank you to Peter Melder at Leica Cameras, who winged a new camera to me when mine fell in the river Epte!

PUBLISHERS' ACKNOWLEDGMENTS

The Publishers would like to thank Anne Askwith for editing the text, Thomas Armstrong for editorial assistance, Marie Lorimer for the index, Andrew and Annette Gossett for designing the book, and Hazel Kirkman for overseeing production.

PHOTOGRAPHIC ACKNOWLEDGMENTS

Page 1 © *Tate, London 2000*; Page 6 *Archives Toulgouat/ ARTEPHOT, Paris*; Page 7 *Private collection*; Page 11 © *Christie's Images Limited, 2000*; Page 12 *Musée des Beaux-Arts, Lyon/Fine Art Photographic Library*; Page 16-17 *National Gallery of Victoria, Melbourne (Felton Bequest) /Bridgeman Art Library*; Page 20 *Courtesy of The Art Institute of Chicago (Potter Palmer Collection, 1922.426)*; Page 21 *(below) Private collection*; Page 24 *(below) Private collection*; Page 25 *Musée d'Orsay, Paris/© Photo RMN*; Page 28 *Musée Marmottan-Monet, Paris/Giraudon*; Page 33 *Ny Carlsberg Glyptotek*; Page 34 *Joslyn Art Museum, Omaha, Nebraska*; Page 37 © *Christie's Images Limited, 2000*; Page 40-1 *Musée d'Orsay, Paris/© Photo RMN – Hervé Lewandowski*; Page 42 *Private collection*; Page 45 *Sterling and Francine Clark Art Institute, Williamstown, Massachusetts/AKG, London*; Page 48 *Musées royaux des Beaux-Arts de Belgique, Brussels*; Page 56 *Stedelijk Museum, Amsterdam (on loan from Netherlands Institute for Cultural Heritage)*; Page 58-9 © *Sterling and Francine Clark Art Institute, Williamstown, Massachusetts*; Page 63 *Pushkin Museum, Moscow/AKG, London*; Page 66-7 *Courtesy of The Art Institute of Chicago (Gift of Mr and Mrs Chauncey B. Borland, 1964.210)*; Page 69 *Musée d'Orsay, Paris/© Photo RMN – Hervé Lewandowski*; Page 71 *Scala , Florence*; Page 73 *Fitzwilliam Museum, Cambridge/Bridgeman Art Library*; Page 78 *Private collection*; Page 80 *Courtesy, Museum of Fine Arts, Boston (Gift of Samuel Dacre Bush, 1927).* © *2000 Museum of Fine Arts, Boston. All Rights Reserved*; Page 83 *Kunstmuseum, Basle/AKG, London*; Page 84-5 *Courtauld Gallery, London/Bridgeman Art Library*; Page 92 *Musée Marmottan-Monet, Paris/Giraudon*; Page 95 *The Royal Collection* © *2000, Her Majesty Queen Elizabeth II (photographer Stephen Chapman)*; Page 96 *Courtesy of The Art Institute of Chicago (Mr and Mrs Potter Palmer Collection, 1922.432)*; Page 103 *Private collection*; Page 104 *(above) Musée d'Orsay, Paris/AKG, London (Erich Lessing)*; Page 104 *(below) National Gallery of Scotland/Bridgeman Art Library*; Page 107 *Courtesy, Museum of Fine Arts, Boston (Juliana Cheney Edwards Collection, 1925).* © *2000 Museum of Fine Arts, Boston. All Rights Reserved*; Page 109 *Private collection/Bridgeman Art Library*; Page 110 *Private collection*; Page 111 *National Gallery of Scotland/Bridgeman Art Library*; Page 117 *Museum of Fine Arts, Boston (Arthur Gordon Tompkins Residuary Fund)AKG, London*; Page 119 *Museum Folkwang, Essen/AKG, London (Erich Lessing)*; Page 124 *(right) Private collection*; Page 127 *Musée Marmottan-Monet, Paris/AKG, London*; Page 128 *Private collection/AKG, London*; Page 130 *Musée Marmottan-Monet, Paris/Giraudon*; Page 131 *(above) Private collection*; Page 133 *Sotheby's Picture Library*; Page 134 *Private collection*; Page 137 *Musée d'Orsay, Paris/AKG, London (Erich Lessing)*; Page 142 *Private collection/AKG, London*; Page 145 *Kunsthaus Zurich* © *2000 by Kunsthaus Zürich. All Rights Reserved*; Page 146 *Sotheby's Picture Library*; Page 150 © *2000 Board of Trustees, National Gallery of Art, Washington (Chester Dale Collection)*; Page 153 *Musée des Beaux-Arts, Nantes/© Photo RMN – G. Blot/C. Jean*; Page 155 © *Collection Philippe Piguet*